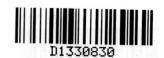

making an angel

antony gormley

gateshead council

Book Design – Why Not Associates
Managing Editor – Diana Allan

First published 1998 by Booth-Clibborn Editions, 12 Percy Street, London W1P 9FB
E-mail info@internos.co.uk, Internet www.booth-clibborn-editions.co.uk

ISBN 1 86154 0639

Printed in Bath, United Kingdom

Published on the occasion of the unveiling of the Angel of the North, 20 June 1998

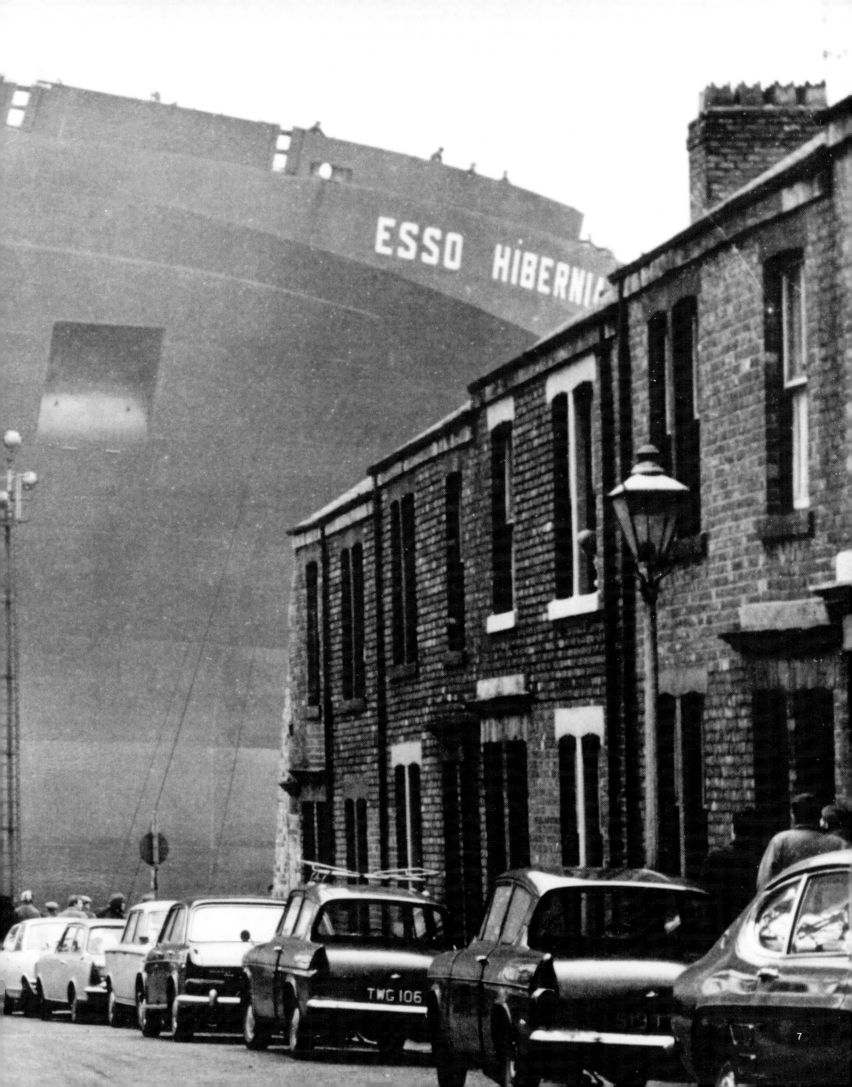

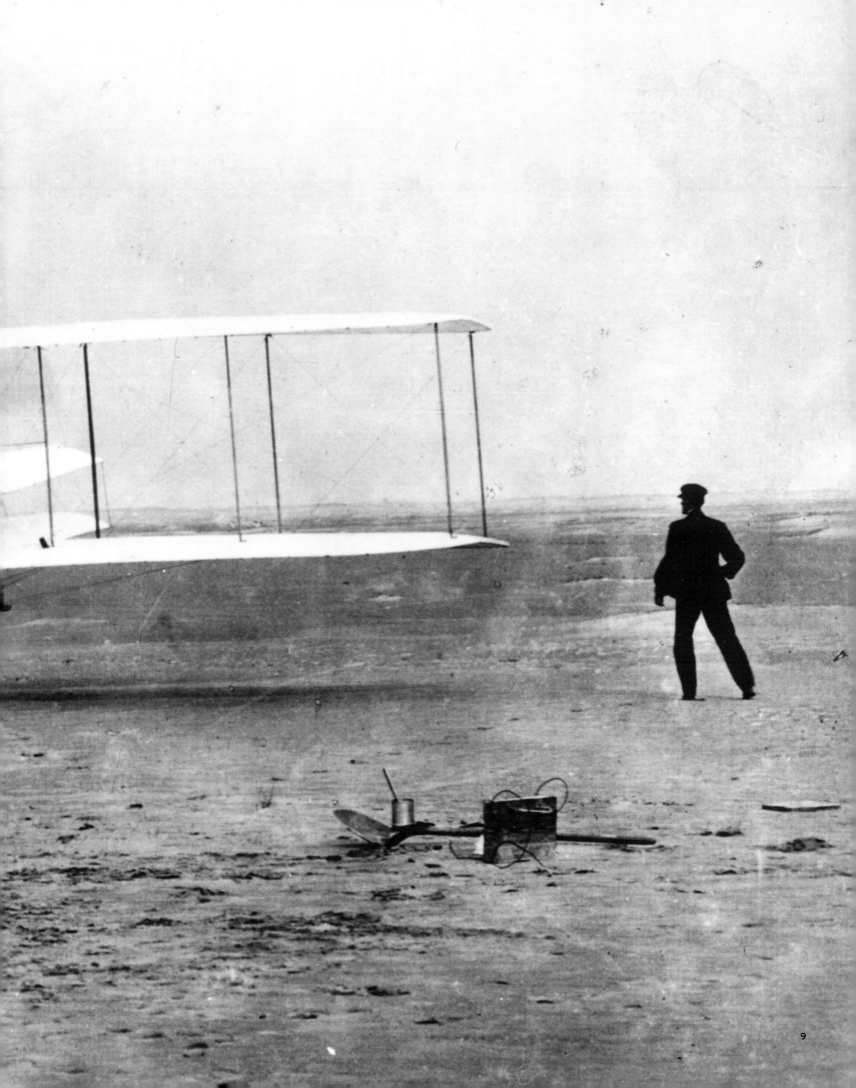

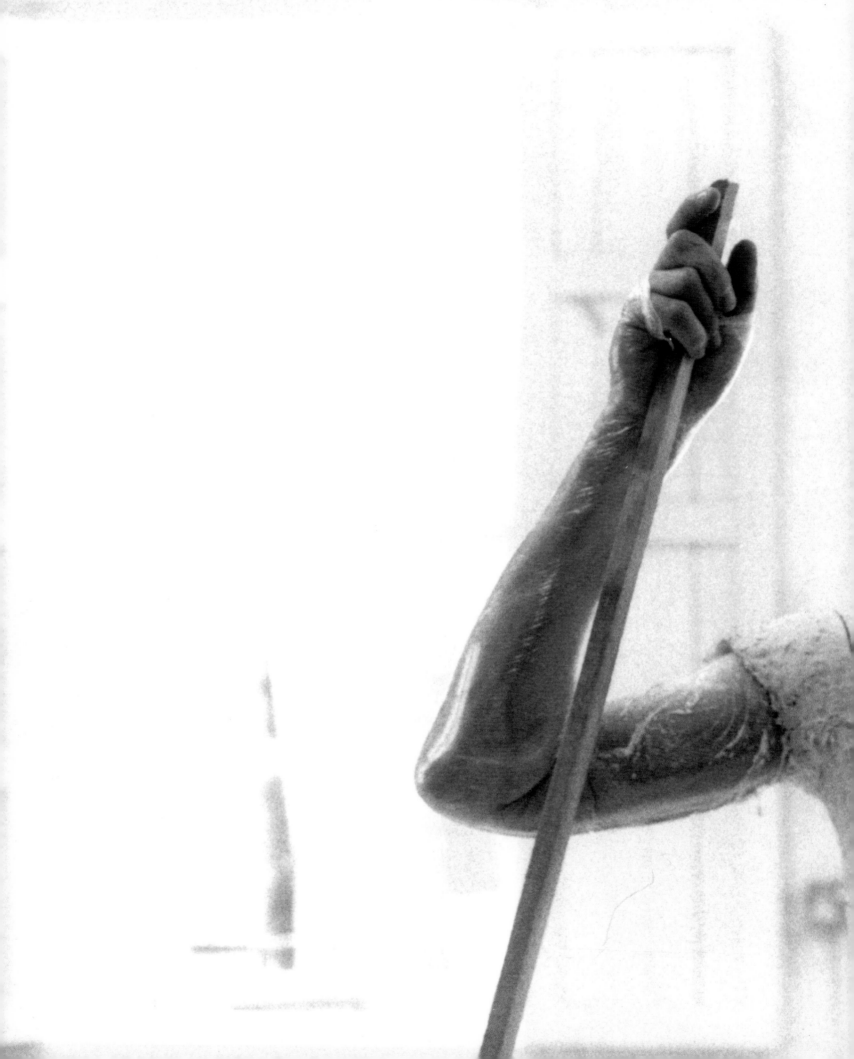

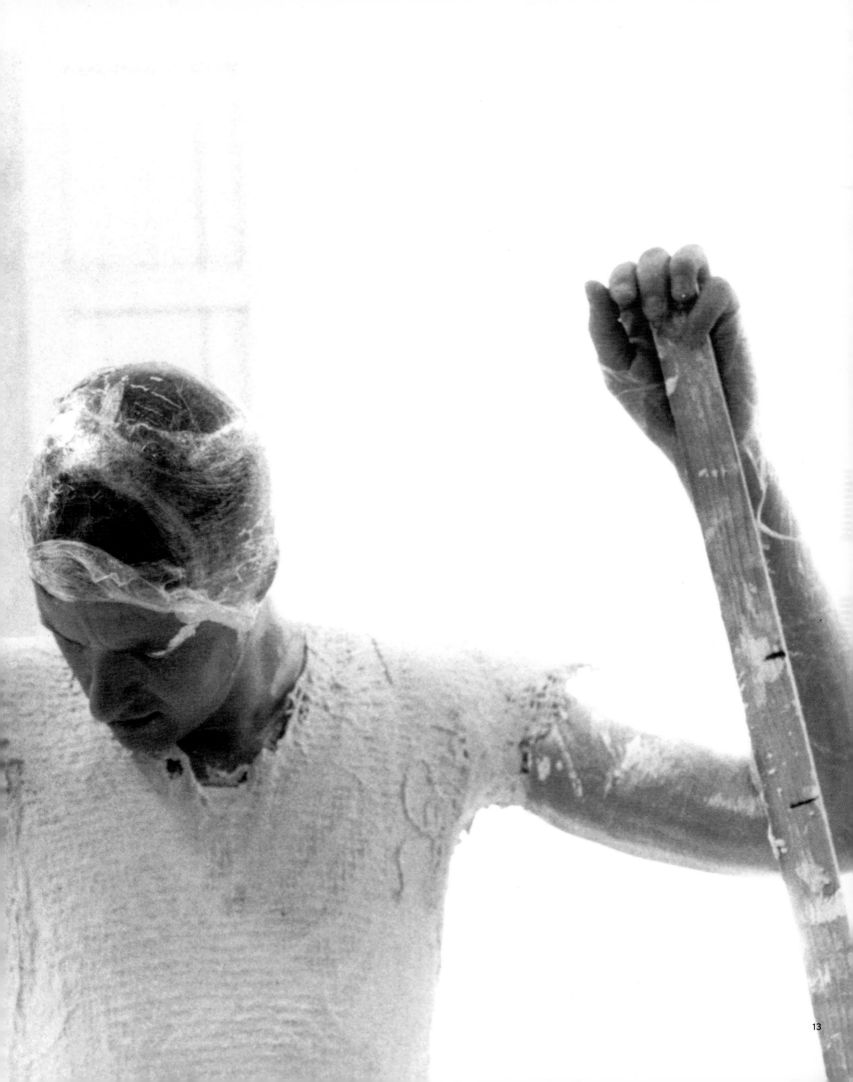

of coal and iron and ships and planes
antony gormley

The **Angel of the North** is a collective work which represents a collaboration on many levels. The full-size angel was the sixth time the work was made and involved over one hundred and fifty people in its development, through scanning and the making of the virtual model, steel profiling, welding, transportation and erection. It may have been my design but the idea for the work was Gateshead's. Many hands and minds worked on this sculpture: this inspires and humbles me. It means that even at this restless and fragmented time we can work together to make things that are not simply functional but feed our spirits: things done for the challenge of doing them.

Perhaps more than any other work that I have been involved with, the Angel exhibits sculpture's ability to endure. The work will stand through rain and shine, night and day, in storms and calm. With the ability to endure comes the possibility that it should stand for our own need to endure vicissitudes. Then there are sculpture's other constant duties which the Angel has and will shoulder: witnessing and marking in time and space, taking now into then, being a focus for life and its dreams. Our dreams.

The great difference between this work and its predecessors is that it does not only seek to commemorate the past and be a foil to amnesia. It attempts to be a probe into the future. It may be that this sculpture is an attempt to give form to the future with methods and materials of the present that may soon be past, so the material is part of the message but the meaning is an ongoing project. This angel does not seek to reinforce a dominant hierarchic social order or represent an ideology, it is an open work. The greatest thrill for me was to see how quickly the image was appropriated, not as a completed thing but as something out of which meaning can be made.

I want to make something we can live with and that becomes a reservoir for feelings – feelings that perhaps we hadn't known about until this thing was there, or feelings that couldn't arise until it was.

I think there is a natural desire within us to make creative changes to our surroundings which can act as witnesses to our lives. Something that is a place and an object. The result may serve as an energiser, focus and resonator, extending the imaginative into the physical and vice versa. It seems more important to respond to this yearning now than at any previous time, as the virtual world, television and Internet promise to make the production and reception of the work of art practically synchronic and completely displaced. With the possibility of instant communication, created by a non-space that is everywhere, the idea of place becomes very necessary. It is this idea of place that can be reinforced by collective art which in some way puts human being in a much wider context.

The Angel was designed to be seen from a moving vantage point, but it marks a place. You could call it an antenna to catch and ground the gaze. It works the opposite way to a vision of angels: it is an earthing device for roaming eyes. This angel could be inviting us to go below. When I was making the work I realised that there was a connection between how it is made and the mining that went on for more than two hundred years below the mound. Both, in different ways, connect the body and the earth and depend upon the body in tight surroundings. The image of

this angel tries to bridge the earth and sky through a body. The faster the body travels the more it has to be held. There is an uncanny similarity between the wrappings of a mummy and the space suit – both prepare the body for the passage across barriers in time and space.

It seems to me that the body is becoming for contemporary art what abstraction was for it at the beginning of this century: a ground in which all the possibility of emancipated identity is to grow. The last frontier is the inner realm. Space has been probed, but what do we really know of the body's darkness? I am talking here of the body not as an object of idealisation forced to carry allegorical, symbolic and dramatic readings, but the body as place. The body not as hero or as sexual object, but in some way as the collective subjective – the place where we all live, the place on which the pressures of society are inscribed and out of which expression, language and feeling can come.

This is a dark angel, not because it is evil, but because it comes out of the closed body of the earth. It is made of iron, a concentrated earth material that carries the colour of blood. It is a carrier of the new nature: a body extended by technology, yet actually and metaphorically rooted in the earth and the compressed geology of shale and carbon that lies there.

Maybe more than anything, this angel is an image of our relationship to our tools. If science and technology are the fruit of the tree of knowledge, this work attempts to show how they have become a burden as well as a benefit. The image we have built is one of conjunction, if not confrontation, between anatomy and aeronautics; the extension of the body through tools. If any one tool that we have made expresses the restlessness of the human spirit and this last century, it is the aeroplane. Invented in 1903 by the Wright brothers, it has undergone probably a more rapid transformation than any other vehicle. And I think it is the icon of our age. With the plane we have gone from earthbound creatures to seeing the world from a position formerly attributed to God. The aeroplane is the tool that has shrunk the globe, made the bridge between here and there and allowed the transcontinental romance. But it has also been the instrument of surveillance by which death has been meted out from the air; from which bombs have been tossed like seeds. So there is a sinister as well as a benign side to the image of the aeroplane; the use of its wings is appropriate for a work that attempts to bear witness to our time. It also makes a bridge between an era characterised by the products of the industrial revolution and our transition into an era characterised by the speed and universality of electronic communication.

This book is a celebration of a work made by many for many. I am proud of being part of its genesis. It has made me think anew about my work, and not a little about who art is finally for, how it can be made and from where it derives its energy. It has made me feel that there is still a great longing in people's hearts to see and live with things that in some way communicate with the unknown in ways that are well known. I have tried to use the human skills and connections between coal, iron, ships and planes. All lead to the future where the body will perhaps be completely immobilised and we will communicate entirely in virtual space. That will be the final sacrifice in which we are all redeemed and redeemer – master and slave.

Special thanks

Making the Angel involved lots of people. Many of their names are recorded in the list of contributors at the back of this book, but there are some who need special thanks.

Firstly, I would like to thank all the Gateshead staff. None of this would have got started without Mike White and Anna Pepperall, and having started it they never stopped. Mike got the money, steering the project through all the various administrative obstacles and together they organised the education programme. The Angel occupies imaginative as well as physical space, and the creative way in which young people were encouraged to think and make angels provided a wonderfully fertile ground for the final work.

A special thanks to Sid Henderson who is the Angel's godparent, always there to explain why, and to Bill Macnaught, who kept us on an even keel. The press, sometimes the cause of us not being, was brilliantly led and fed by Robert Schopen. Chris Jeffrey somehow kept the whole thing in budget and perspective, casting a very professional eye on the fabrication as it progressed.

The engineering component of this work cannot be overestimated, and without the assistance of the Ove Arup team we would have been lost. Thanks to John Thornton for getting us started, and to Neil Carstairs for coming up with all the right answers right up to the very end. Mike Brown was another godparent who helped with more than engineering.

We got marvellous work from Hartlepool Engineering thanks to all the welders and platers, and to Bill Stalley, Mike Wood and Dennis Rudd for taking the risk.

Newcastle University was a crucial help, with the R.C.I.D. providing all the computer programs necessary to generate the components for the sculpture; thanks to Chris Lawrence for 300 hours of his life and to Ron Jameson for agreeing to the collaboration. The Geomatics Department and John Mills provided the stereophotography scan which was the first step in the digitalising of the work.

Thanks to everyone who helped me with the plaster and balsawood work in the studio, particularly my wife Vicken Parsons, Jonathan Lakin-Hall, Richard Galpin and David Courtney.

Lastly, for their tireless creative input into this book, I would like to thank Andy Altmann and Diana Allan.

Sc. 1=4. h 20 m. W 52 m. Totatsculpture Apport
310 sq m.

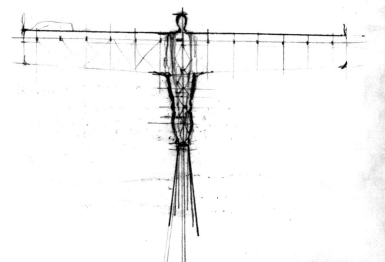

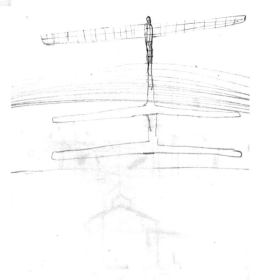

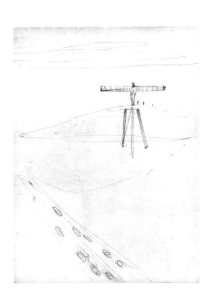

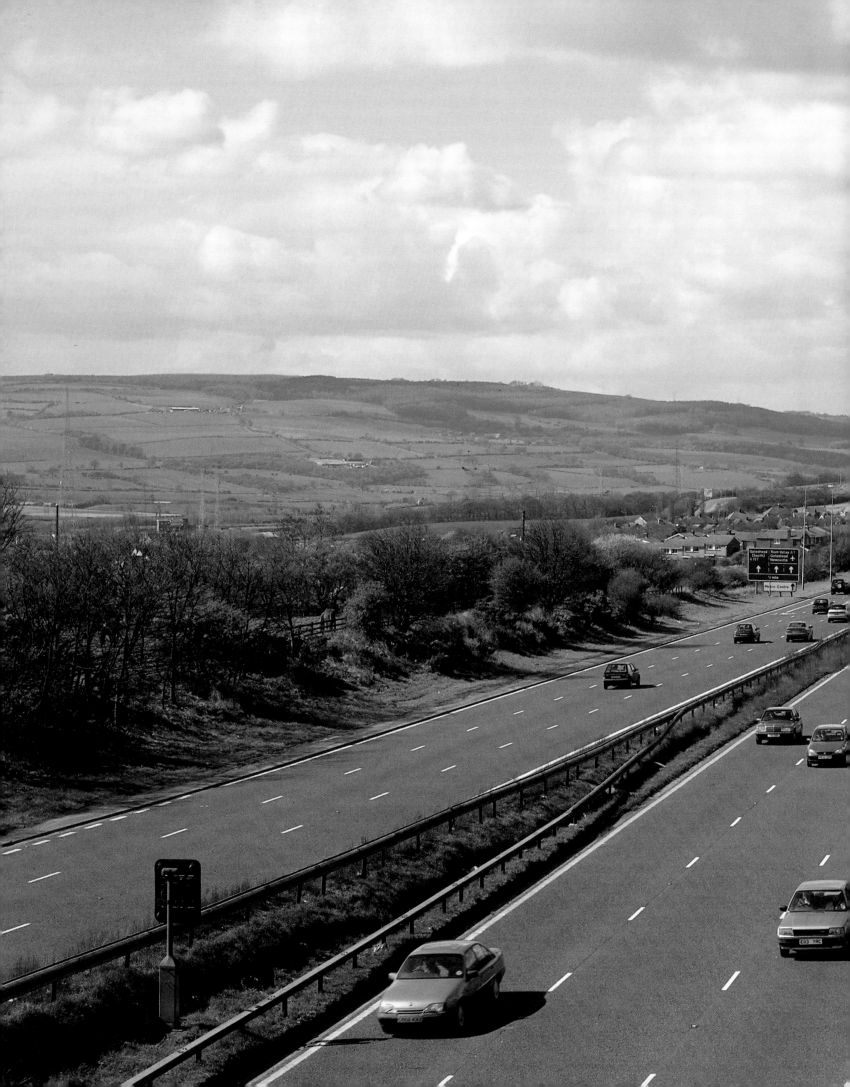

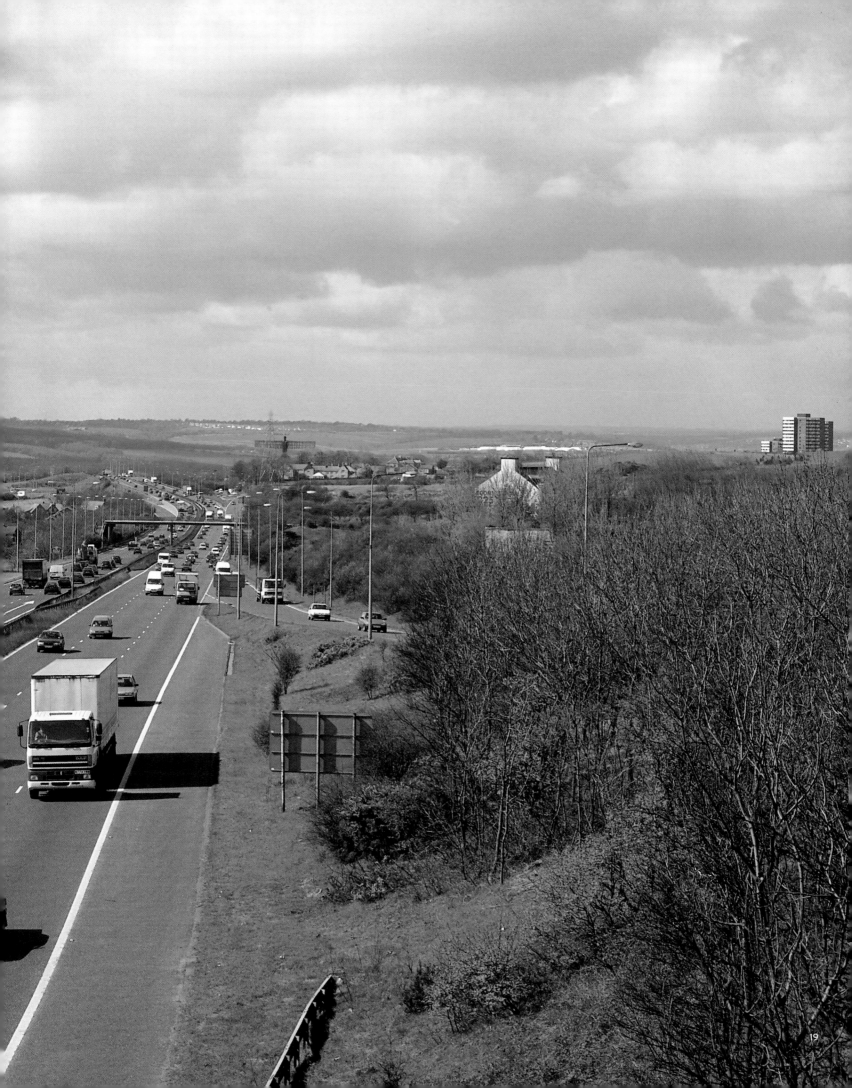

a
northern
tale

mike
white

How long does it take a borough council to put up an angel? Seven years, an almost biblical time. We did not even know we were getting an angel for the first two years of our search for a millennial image that would be a marker and a guardian for our town. A work as ambitious as this takes time – though its course was measured in the soundbites of obsessive media interest that fed on 'Wor Angel' from concept to installation. 'Controversial' was the most common adjective, but 'inspirational' is heard more now. Even amid the controversy, we never lost our resolve to complete the Angel. Gateshead Council Leader, Councillor George Gill, commented: 'When Gateshead decides to do something, we see it through to the end – no matter what the problems we may have to overcome.'

Our dream began in 1990 when Gateshead Council agreed that an artist of international stature should be considered for a commission for the A1/A167 road interchange at the main southern approach to the borough and Tyneside. The chosen site was a recently landscaped area where the former Team Colliery's pithead baths had been. Decades of grime and industrial decline had been removed, with the rubble piled into a knoll like an Iron Age barrow. We called it a 'plinth' and approached Northern Arts for a grant of £45,000 to select an artist and deliver an engineering design. Our regional arts board's support for Gateshead's proven ambition in public art was an inspiration, and the efforts of the Libraries and Arts, Planning and Engineering Departments had developed the expertise to manage public art projects – but so far nothing this large.

Gateshead's arts policy did not go unnoticed. After the National Garden Festival presented exhibitions of art in landscape, on 20 March 1990 the **Sunday Times** declared: 'If you are at all interested in art and where it is going, Gateshead is at the moment the centre of activity … a genuine attempt to wrest art out of the gallery and into our daily lives.' In that year the Riverside Sculpture Park installed site-specific works by Colin Rose and Richard Deacon. With cautious enthusiasm, Gateshead Council, sensitive to the needs and accountability of local government, was beginning to explore the possibilities of arts-led urban regeneration. Through the eighties Gateshead was making a new identity for itself with the International Stadium and the Metro Centre mega-mall. But the borough still needed a defining image – not a logo, but a real-world icon. One inspiration was Claes Oldenburg's **Bottle of Notes** for Middlesbrough, completed in 1991.

The brief was simple. Elected members on the Council's Art in Public Places panel wanted to consider proposals for a work ambitious in scale and aspect, a landmark, an emblem of the character of the region.

We sold the commission on the strength of the site: a valley scarp at the greenbelt edge of Tyneside passed by 90,000 vehicles a day, the London–Edinburgh rail line in the middle distance, and Durham Cathedral on the horizon. Over two years we researched artists, courted interest, welcomed advice, and consulted the Council. The Art in Public Places panel met three times to draw up a shortlist. Several times the members asked to view again a slide of Antony Gormley's gallery work **A Case for an Angel** (1990). They gradually formed the resolution that

'We want something like that, but not that. This has to be unique. Invite him up to view the site. And make it clear the Council has no money for this.'

When Antony was first rung about the commission his response was characteristically blunt: 'I don't do roundabout art.' Somehow Anna Pepperall, our Visual Arts Manager, convinced him this was a serious proposition. It was amusing to see the artist's insouciance change to visionary excitement the first time we climbed the hill. An envelope of site photos said little: you had to be there. Back at the Civic Centre, Antony did a blackboard sketch of what he had in mind – and the council officers blanched: it was massively challenging in both aesthetic and engineering terms.

Early sketches of the Angel appeared in the local press in August 1994. Hostility never sounded louder. Within weeks myths abounded: it would disrupt TV reception, interfere with aircraft navigation, cause pile-ups, destroy the greenbelt, get stolen by 'scrappies', and evoke the wrath of God in lightning bolts. All these matters were investigated before planning permission was granted in March 1995, after heated debate in both council and press. A 'Stop the Statue' campaign collected petitions; phone-in polls were ten to one against. On 2 February 1995 the **Gateshead Post** ran a front-page story with contrived pictures of **A Case for an Angel** alongside Albert Speer's **Icarus** statue at Doberitz with the screaming headline 'Nazi … But Nice?'

But as photos of the first 1:20 scale maquette appeared in the press in December 1994, support came from likely and unlikely sources: Bill Varley, Head of Fine Art at Newcastle University; Bill Dunlop, Chief of the Fire Brigade; Peter Sloyan, Chief Executive of Northumbria Tourist Board; and Billy G., a retired miner, who saw the significance of the sculpture in relation to the history of the site. From farther afield, letters of support appeared from the Angel Collectors' Club of America, a Swedenborgian minister, and a Manchester theological college. A handful of considered letters came from non-experts whose enthusiasm for the sculpture charmed and restored our flagging spirits. An elderly lady from Tynemouth, Joyce Hall, wrote to us in January 1995 with a real insight into the development of the artist's design:

When a sketch was first published the wings were truncated and squared off, which I thought made the figure macho. [It] also conveyed a sort of resurgence. Now the longer, narrower ends of the wings make it seem more effeminate … Is calling it an 'angel' correct? It seems more earthy. Have you a sense of humour? It seems irreverent but I can't resist it – what about 'The Colossus of Roads'?

Three years later, at the age of 80, she came to see the Angel installed on site.

In spring 1995 the National Art Collections Fund gave Gateshead the award for 'Art outside the Gallery', and we produced the first Angel brochure as a pitch for funding. In it, Antony declared: 'The most important thing is that this is a collaborative venture. We are evolving a collective work from the firms of the North-East and the best technological engineers in the world.' The proposed dimensions were staggering: 20 metres high, a wingspan of 54 metres.

Through the winter of 1994-5 Antony had worked closely with Ove Arup and Partners, who had been brought in as consultant engineers. The first wood-and-plaster maquette showed the ribbing and diaphragms that Antony had devised with Arup to harmonise the aesthetic and engineering aspects of the work and create a structure capable of withstanding winds of over 160 km/h and keeping 200 tonnes of steel standing.

For initial estimates, Arup took the maquette around fabrication firms in the North-East. As the surprisingly delicate and vulnerable mini-Angel appeared from the crate, shopfloor welders turned off their torches to get a first intrigued glimpse of the controversial figure. Their long, low whistle made clear that this was going to be an expensive sculpture.

More furore in the press and public, about the cost and the morality of such spending. We were ensuring that the project would only happen if all the funding was raised from sources outside the Council and was solely available for the arts; but that had little impact. Antony came up in February to launch the schools education programme and was bombarded by a largely hostile press. Councillor Henderson, Chairman of the Libraries and Arts Committee, seen by the media as champion of the project, was likewise under pressure. With planning permission granted, the majority Labour group on the Council took a risk in the run-up to the May elections and voted the project through.

Only by the end of 1995 did a funding package begin to emerge. Modest but welcome sponsorship came from local firms Express Engineering, Silverscreen and Ove Arup (for the schools programme). This provided leverage for a European Regional Development Fund grant of £150,000 in recognition of the tourism potential of the **Angel of the North**, as it was now known. In turn this led to £584,000 from the Arts Council's National Lottery fund in April 1996. Here business sponsorship served as the catalyst for securing the whole funding package rather than, as usual, being an extra benefit.

The other successful factor was the regionwide Festival for UK Visual Arts Year in 1996, which Northern Arts won, fending off stiff competition from Glasgow and Bradford. Early in 1996 the 1:20 bronze maquette of the Angel went on exhibition at Gateshead's Shipley Gallery. Public opinion in the visitors' book was about three to one against – some improvement. Repeatedly in the previous autumn four burly janitors had carried the bronze up the back stairs in readiness for private views by likely funders. The comic struggles of moving this heavy object seemed symbolic of our situation. It was a cross to bear, whipped on by Antony's impatient phone calls about when the project was to be realised. But showing the bronze attracted positive comment from Arts Council Chairman Lord Gowrie and Secretary of State Virginia Bottomley. The wooden maquette was also shown to Labour leader Tony Blair in summer 1995 at the Visual Arts Year launch in the Tate Gallery, London.

Research commissioned in 1996 by Northern Arts from Harris revealed that 86 per cent of the population of the North recognised the **Angel of the North** even before the sculpture was built. It was destined to be the most discussed sculpture in Britain.

A turning point in public opinion came with the exhibition of **Field for the British Isles** at the Greenesfield BR works in

Gateshead in spring 1996. Recently bought by the Arts Council with a grant from the Henry Moore Foundation, this massive work consisting of 40,000 terracotta 'Gorms' (as they were nicknamed) was created by Antony with 100 local people in St Helen's in 1993. He chose the engine shed above the Tyne for the Field's first non-gallery exhibition, a space large enough to première the entire work. Showing was prolonged by public demand, and in 10 weeks 25,000 people came. The location was perfect, though the roof leaked; the press was enthusiastic; and the visitors' book was overwhelmingly positive. The relationship of the Field to the redundant shed it filled was a portent of the Angel's linking of industrial decline with regenerative spiritual energy.

With the money to build the Angel at last in place, in the summer of 1996 Antony began to produce a second series of maquettes, this time originating from body casts and on different scales, including a delicate full-size model of the calf section made from polystyrene and plywood. Working with Ove Arup, Antony made slight but significant changes to the ribbing pattern. The softer subtleties of the body cast led in an organic development to the definitive 1:10 maquette. This was sent the following year to the University of Newcastle for 3D mapping. Thousands of scanned reference points were adapted into a digital blueprint of the assembly for use by profilers and fabricators on Teesside. The commission was progressing as fast as such a huge task could. We had missed the hoped-for start of the Angel in Visual Arts Year, but by the end of 1996 Gateshead's Director of Engineering Services, Chris Jeffrey, was drawing up the tenders for fabrication.

Meanwhile in Gateshead choirs of classroom angels were in production. The two-year education programme involved 30 schools and over 1,400 children of all ages making angels of every size and type from plaster, wood, wicker and resin. The programme was organised by the Council's arts team and involved local sculptors William Pym, Julie Livsey, Lisa de Larny and Felicity Watts. They adapted Antony's techniques of body casting, and explored the development of figurative sculpture from concept to installation. So much work was produced that it was exhibited in instalments in gallery and non-gallery venues in Gateshead, and at Sunderland's new Gallery for Contemporary Art. The bronze Angel maquette was on loan to the 'Engineering Art' exhibition at the Swan Hunter shipyard in North Tyneside, setting it in the context of the engineering history of the North-East. A visiting New York artist wryly observed, 'Gateshead's becoming Gormleytown.' Whether or not the **Angel of the North** looked like an angel was debated by locals with the fervour usually applied to a disallowed goal at St James's Park. Even the theologians chipped in after Antony's address to the 'Art and Spirituality' conference at Durham Cathedral in October 1996.

Visual Arts Year even ended with an oblique reference to the Angel. Catalan artist Jaume Plensa created a work inspired by William Blake at the Baltic Flour Mills on Gateshead Quays for the finale night of the year-long festival. A massive steel canopy laid around an underground light cannon was inscribed with Blake's proverb, 'No bird soars too high if he soars with his own wings'. For once a 20-metre-high figure looked puny, though Plensa's light beam shot 3 km up through crisp winter skies.

Meanwhile, Gateshead Council was angling for £38 million from the National Lottery to convert the Baltic Flour Mills into the largest space for contemporary art outside London. The Arts Council announced the success of the bid in June 1997. Probably the Angel was a significant factor here – those who needed to be convinced were assured that Gateshead Council was serious in its partnership commitment to deliver contemporary art of international standard. Both Plensa's and Gormley's works have championed a £200 million regeneration scheme for East Gateshead that is bringing an 80-hectare wasteland back to life. By 2000 the formidable leisure spending and cultural energy of central Tyneside will pass across a new Millennium footbridge designed by Engineers Gifford & Partners and Chris Wilkinson Architects, linking Gateshead Quays with the burgeoning quayside area of Newcastle. None of this could have happened without the National Lottery. Fittingly, this is the region that buys the most lottery tickets per head in the country.

By July 1997 something big was happening on Teesside. In a mammoth engineering shed bearing the glorious legend 'Hartlepool Erections Group' 200 tonnes of weathering steel was being cut, shaped and welded. It was an extraordinary sight: at times up to forty men crawling over and through a gargantuan figure, grinding steel in a pandemonium of sparks. Antony visited the yard almost weekly. When a sculptor of exacting precision and the ironmaster of a contract-pressured yard come together, some argument is likely. There was, but it worked, driving the fabrication contract to a quality that Hartlepool Steel Fabrications rightly became proud of. The workforce cursed their work on occasion, but by the end their eyes said something different.

The Angel's body was delivered feet first from the engineering shed in February 1997 for a trial fitting of its wings. A schools coach visit to the yard glimpsed the work before it was loaded, wings and body, onto three 48-wheeler trucks. The police-escorted convoy left Hartlepool on the evening of 14 February, heading north up a closed A1 to arrive at the site around midnight. The plinth and pile cap had been ready since the autumn, on 20-metre concrete piles sunk into the ground as a precaution against subsidence. The mound had been hollowed out and was now filled with cranes and scaffolding for the final lift.

At dawn on 15 February the body was lifted and lowered into position on fifty-two three-metre bolts. It took 20 minutes. The first wing was hoisted to adjoin the body at about 11 am and the second wing was flown into place around 4 pm, in a stiff wind. The installation of the Angel was not promoted as a public event, but several thousand eager people turned up. It became a media circus with over 20 television crews, and soon a world news story.

So now we have it: a sculpture of international renown, created by an artist of amazing talent and tenacity, commissioned by Gateshead Council with enviable boldness in the faith that the Angel's significance and public acceptance will grow as it settles into the landscape. It has the expansive ease and strength to carry the hopes and fears of our region beyond even the next century. The Angel belongs in every sense to the North-East, welcoming the world and projecting us into it.

History of the Angel and its site

1500s–	Coal is mined in the area, at the Team Colliery from the 1720s.
1939	The modern baths complex is built on the site.
1972	Mining ceases on site.
1989	Reclamation starts on the former pithead baths site overlooking the A1.
1990	July: Gateshead Council decides in principle to earmark the site for a future landmark sculpture.
1991	July: authority is given to approach the Henry Moore Foundation for help with funding.
1992	Landscaping of the site is completed.
1993	A shortlist of international artists is drawn up by Gateshead Council's Visual Director of Libraries and Arts in consultation with the Tate Gallery, Yorkshire Sculpture Park, Northern Arts, and the Public Art Development Trust. Candidates are invited to make proposals for the site.
1994	January: sculptor Antony Gormley is selected by the Council. His design proposals are submitted to the world-renowned engineering consultants Ove Arup & Partners. December: he makes the first 1:20 wooden maquette.
1995	February: Gateshead Council gives planning permission for the project. Antony Gormley meets all heads and art teachers of Gateshead secondary schools to discuss the project.
1996	January: the Angel bronze is exhibited at Shipley Art Gallery. January–March: the first phase of the Education Programme is led by sculptors William Pym and Julie Livsey in two primary and four secondary schools and Gateshead College. March–May: Antony Gormley's **Field for the British Isles** is shown at the Greenesfield BR works, attracting 25,000 visitors. April: funding of £800,000 is secured for the sculpture: £584,000 from the Arts Council's Lottery Fund, £150,000 from the European Regional Development Fund, £45,000 from Northern Arts, plus private sponsorship. May–September: the Angel bronze is shown at the 'Engineering Art' exhibition at the Swan Hunter shipyard, North Tyneside. August: the Angel project wins the Arts Council–British Gas 'Working For Cities' Award.
1997	February: the fabrication contract is put out to tender. March: fabrication contractors visit Gormley's studio to see the Angel models. March–April: the second phase of the education programme is led by artists Felicity Watts and Lisa de Larny in three primary and four secondary schools and a special school. May: a fabrication company is chosen: Hartlepool Fabrications Ltd on Teesside. July: the first consignment of steel is delivered to Hartlepool. September: Thomas Armstrong (Construction) Ltd begins work on the Angel's foundations. Digital artist Lynne Otter runs public workshops on the theme of the Angel. October: all the Angel models are exhibited at Greenesfield BR works, Gateshead. October–November: schools' work on the Angel theme is exhibited at the Central Library Gallery and at Designworks, Gateshead. December–February 1998: a series of promotional posters for the Angel are displayed on Metro stations and on billboards throughout Tyneside. Angel Time Capsule is prepared by artists Simon Jones and Nicky Taylor involving three schools and a women's group.
1998	January: the fabrication of the sculpture nears completion. February: the **Angel of the North** is set up on its site. March: the Time Capsule is buried on site. June 20: unveiling

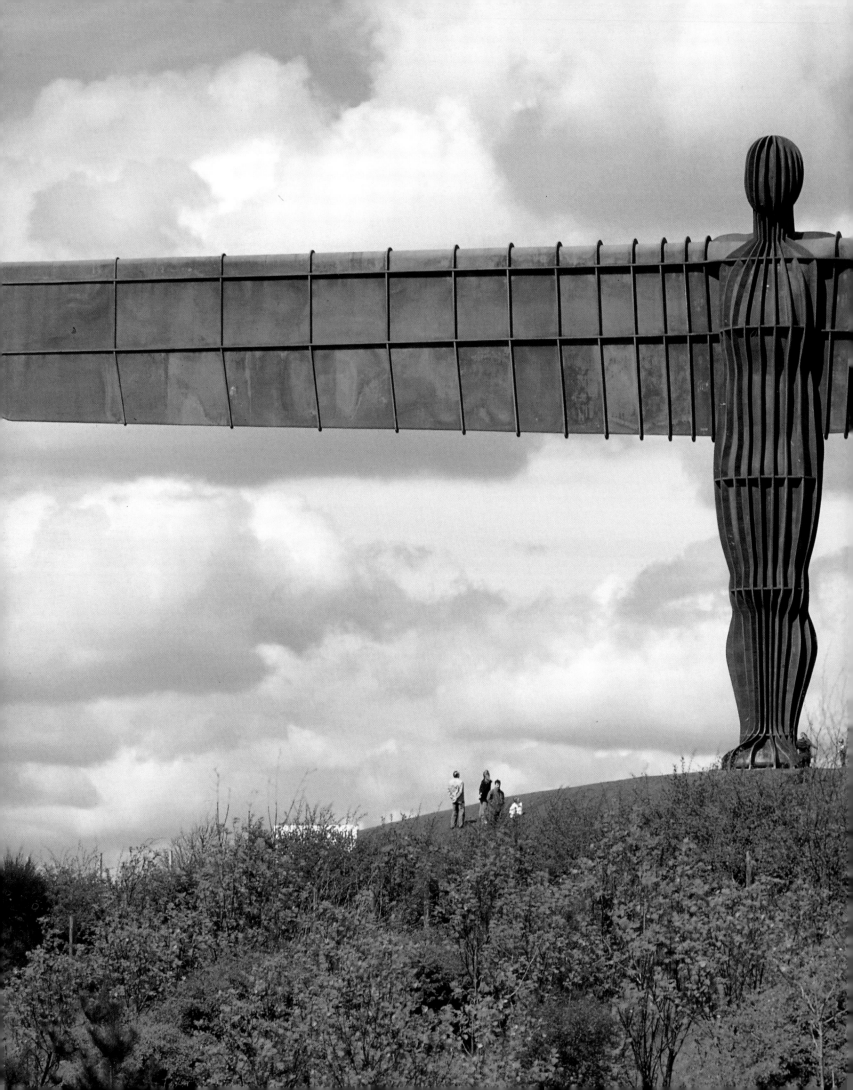

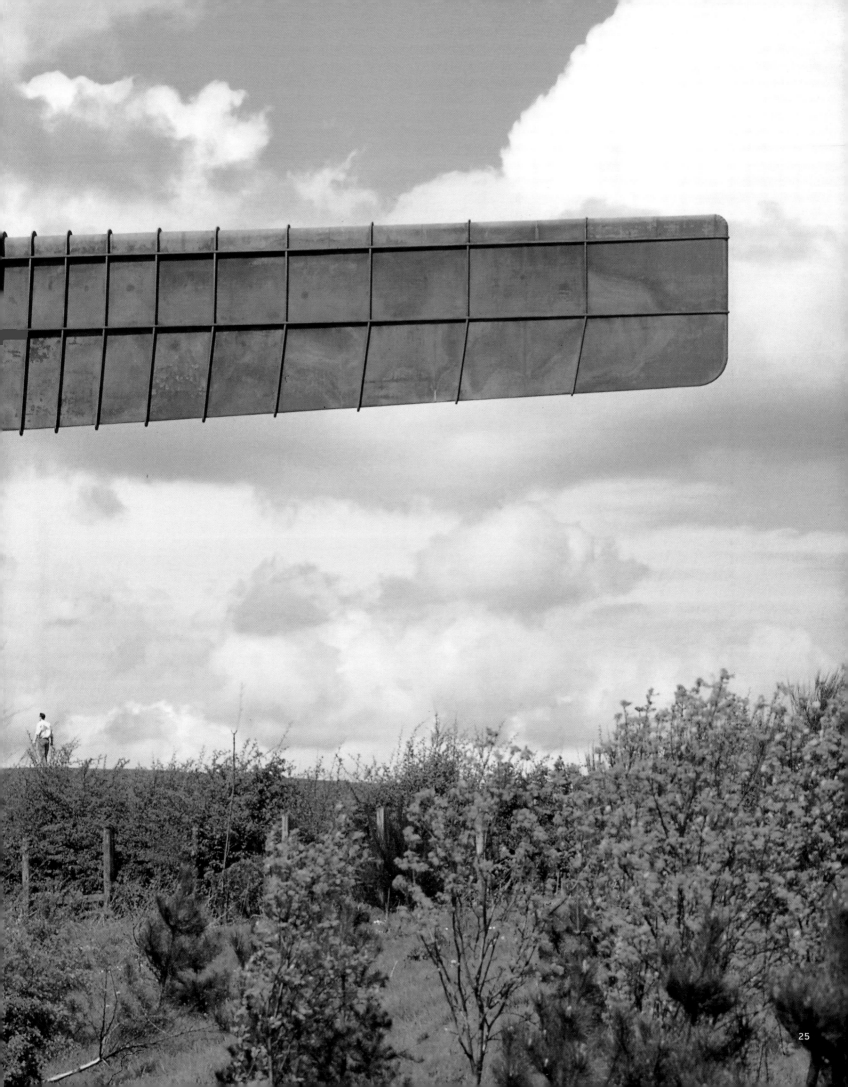

achieved anonymity

iain sinclair

My consideration of Antony Gormley's **Angel of the North** exists against an unscholarly sense of place, misremembered journeys, treks through monastic ruins, readings of the Northumbrian, Tyneside and Durham poets – Basil Bunting, Barry MacSweeney, Tom Pickard, Ric Caddel and the incomer Bill Griffiths. From the North we Southrons expect demons, not angels: Vikings, clansmen, raiders. We conjure the forms that shape our fears, images to mark the fissure, the jagged borderline where millstone grit gives way to limestone. Memorial stones and Celtic crosses (preserved or pastiched) honour the geology. The anonymous craftsmen who do not claim the title of 'artist' reject monumentality. They follow an intricately woven verticality topped off with abbreviated blades, a gesture in the direction of the cruciform. Scale that provokes awe was always present in the landscape; the rock of Durham, rising from the valley of the Wear, demands the presence of cathedral and castle. On the grass around these dark buildings memorial crosses can be seen, and the eleventh-century church presents a privileged enactment of the world: sacred architecture, burial ground, place of pilgrimage, crypt and tower, museum, library, snack bar, money magnet. Time eddies around gigantic pillars, sculptural analogues of the natural world, vines as symbols; the epic darkness of history penetrated by radiant beams of light. Such places transform us. We dissolve the carapace of the mundane as we teeter between overwhelming totality and extraordinary detail. Sepulchral aristocrats with their heads and limbs hacked off by Scots imprisoned in the cathedral reveal shining, honeyed torsos as magnificent sculptural forms.

But the Angel is not an abstraction, it exists in a particular place at a particular time. If some of the scare stories in the press were to be believed, the monster so dominated the landscape that it would would cause drivers on the A1 to lose concentration, shocked by the presumption of this tin automaton. The Angel was the rogue apotheosis of J.G. Ballard's **Crash**, a scrapyard totem pole to activate the prejudices of Middle England. It would oversee the Team Valley, arms boastfully spread like some hideously rusted invader: a fascist eagle-man boasting blasphemously of flight. Faked photos emphasised the giant's scale. Its notoriety was assured by its regular appearance in tabloids and cartoons. The 'Augusta' comic strip in the **Evening Standard**, written by Angus McGill and drawn by Dominic Poelsma, had the heroine standing on a chair, arms attached to Icarian wings, bawling: 'That angel in Gateshead gets on television and everything!' As if that was the point of the experiment, sensation; to become, through film and tape, lodged in the national consciousness. Gateshead would be distinct from Newcastle, a commissioner of significant art, a culture player, a worthy site for European investment. The Angel, as these cynics would have it, was no more than a modest successor to all those nights of gladiatorial schedule-filling at the Gateshead Stadium.

Others, recognising the mute power of Gormley's roadside figure, asserted that it affected radio waves, bent ley lines, reshaped the natural force fields of the North-East. The taproots of the Angel went through the coal levels and deep into the rock. The figure was primitive, like a Cerne Abbas chalk outline that had shaken itself free from the hillside to parade its fearful potency. A reconstituted Wicker Man, hollow, whistling in the wind for druidic sacrifice. Iron Men had been heated with coals, so that the gods of weather and sky should be propitiated with scorched human meat. A red giant to make contact with the stars.

Journalists twinned the downfall of Newcastle United PLC with the erection of the Angel: displacement, power shifting across the Tyne. The true angel of the north was Alan Shearer, the magpie stripes of his shirt now replaced by the steel ribs of Gormley's sculptural figure. It didn't matter that the artist's fee for this complex and lengthy commission – drawings, body casts, meetings, discussions, budgets, weekly trips to the North – amounted to no more than a fortnight's wages for the injured Geordie striker. ('Striker' – the word itself was melted down for use in the argument. A striker of goals must be intimately connected to the Jarrow marchers, the redundant martyrs of labour. The Milburns and the Charltons were one with the mining communities from which they had emerged. But Antony Gormley was no relation to Joe, the famously intransigent union leader.)

Seeing it, seeing the people who have come to view the Angel, walking around the hill (the site of a former colliery bathhouse), having the history of the commission outlined, with photographs, models, drawings by local schoolchildren – the modesty of the project becomes clear. Set beside the the funds pumped into the boastful fantasy of the Millennium Dome, the cost is negligible. Councils shunt such fees into flower baskets, benches, urban set-dressing to disguise the pitiful condition of the schools and hospitals. Socially, the Angel is already a success. Cars pull into the lay-by. Citizens brave the weather, tramping across soggy rectangles of new-laid turf, to climb the gentle tump. They are impressed by the size of the figure, the engineering skills that have gone into the construction. They have accepted the Angel as part of the landscape, as if it had always been there and they had never previously noticed it. It has arrived among them like Ted Hughes's Iron Man, out of nowhere, with no clear antecedents, no obvious purpose; neither malign nor benevolent, male nor female, presiding over a grassy knoll, not rearing over a high romantic cliff. The angel doesn't belong to the Wordsworthian sublime. It is a frozen frame of science fiction.

'The Iron Man came to the top of the cliff. How far had he walked? Nobody knows. Where had he come from? Nobody knows. How was he made? Nobody knows.' So begins Ted Hughes's fable. These are the questions the visitors ask. It's clear that they feel that they are getting something for nothing. The set-up is so low-key, so democratic - no parking zone, no ticket collectors, no nice ladies threatening to pistol-whip you with their pearls if you don't join English Heritage. Looking south, following the Angel's blind gaze, you arrive at skeletal abbeys, the broken residue of Cranmer's Dissolution, and realise that those picturesque ruins are little more than appetisers for the souvenir shop.

True iron is part of the meaning of Gormley's Angel. His first thought was to call the figure 'The Iron Angel of the North'. In William Blake's demonology of metals, Iron **was** the 'standing north' (as Gold was south, Silver east, and Brass west). These visionary divisions of the compass saw the North as a zone of forges, furnaces, instruments of iron that were associated with fire, cruelty and war.

They may grind
And polish brass and iron hour after hour, laborious task,
Kept ignorant of its use ...

Ted Hughes, a Yorkshireman, placed his scrap-metal giant on the edge of an abyss, 'on the very brink, in the darkness'. Savage winds 'sang through his iron fingers'. He was an anthropomorphic revenger, an instrument made from the veins and ores of the land. Those who approached could hear a 'strange, wild, blissful music', the contractions and expansions of metal, the processes of wind and weather. Gormley, with his own sense of this darkness, the unknowable space within the human body, conjures up a figure that the poets would recognise. That is what divides him from the echoing hubris of other proposals for public art, such as the Battle of Britain Monument for Docklands, devised by Theo Crosby and Michael Sandle and costed at £30 million (or 'half a Boeing 747'). An immense pillar was blended with a Disneyland sound chamber of dead voices, flags, Churchillian rhetoric. At the summit of the monument would be a Heinkel bomber crashing 'vertically downwards' with a Spitfire hurtling through in a parodic excess of cruciform symbols.

Photographs I had seen of Gormley's Angel reassured me that this was work of an entirely different order, but I was interested in visiting the artist in his Peckham studio and learning something of the background story, the questions asked of Ted Hughes's Iron Man: 'Where had he come from?' 'How was he made?'

One Friday in April, I walked from Hackney across the river to Peckham. I wanted to associate in some way Gormley's giant figure with the evanescence of William Blake's angel tree.

Alexander Gilchrist gives his account of the famous episode: 'On Peckham Rye (by Dulwich Hill) it was, as he in after years related, that while quite a child, of eight or ten perhaps, he had his first vision. Sauntering along, the boy looked up and saw a tree filled with angels, bright angelic wings bespangling every bough like stars.'

The Peckham Rye tributary roads still offer encouragement to urban wanderers, the possibility of strange discoveries, refractions of the marvellous. Gormley's office-studio-workshop is set around a yard where sculptural avatars of himself, forked and naked, stoically endure the season's showers. There is a direct lineage to earlier accounts of the artist's life, high bohemianism come to terms with art business, the ethical, philosophical and economic demands of a privileged status. Here contemplation must compete with interviews and promotion. Antony Gormley is a scholar and artist at the centre of a multinational enterprise whose product is the marketing of copies, reworkings, extensions, of his own body, cast in the workshop by his partner Vicken Parsons and his assistants. Photographs of these procedures have a fetishistic allure: yogic discipline, the bandaged whiteness of the plaster, the clingfilm body wrappings, attendants in antiseptic overalls - private rituals that service public art, each stage of the process documented. A strange business, like a premature autopsy.

Press cuttings, photographs and letters about the **Angel of the North** project are neatly filed in Gormley's office: yards of them. The Angel was 'the realisation of a dream'. Gormley's answers to my questions are considered, lengthy, delivered with long pauses as he waits for the most accurate word to present itself. He was very comfortable with the site Gateshead offered him, the fact that it was in a valley and not grandiosely on a slag cliff. He spoke of walking around the mound, which he likened to a megalithic burial chamber - relishing the way the landscape shifted, the attention moving from recovered colliery, through football pitch, bowling green, the motorway, to the distant prospect of the trading estate and Sir John Hall's Metro Centre. Gormley wanted his Angel to be 'a concentrator of landscape'. The sculpture, which begins as a peeling of self, a manipulation of that which is given, moves out into the world. It is detached from its maker and from his expectations; it will stand or fall on its own. Gormley's need to see the Angel as the final flare of an age of iron, engineering skills complemented by advanced technology, is understandable, but marginal to the presence of the thing itself. It is a Blakean archetype, a purposefully rusted automaton whose roots drop into the rock of place. Gormley sees his sculpture as the focus for a 'field of energy', the concentration of the 90,000 motorists, sealed in their 'bubbles', who drive past every day, as well as the visible extension of the metal veins running through the earth, the other hilltop monuments, rivers, churches, and ghosts of heavy industry.

A golem released from the darkness of the body; a grounded angel denied the possibility of flight. Looking at **A Case for an Angel** (1990) and **Vehicle** (1987), it strikes me that these are shapes whose elegance of structure is a punishment, a price willingly paid. They have abdicated transcendence in order to achieve essence. The Gateshead commissioners saw in these the prototypes for the figure they wanted for a roadside field, a scrap of tired ex-industrial land: **Angel of the North** was their title, generously omitting the definite article, and leaving open the possibility of kindred angels for other divisions of the compass.

On the window sill of Gormley's office is a small plaster figure, a white angel with modest wingspan. This simple, rough version exists somewhere beyond, rather than before, the public clatter, committees and convoys of the Gateshead giant. It was made, Gormley explains, for the child of a friend. But, seeing it, he decided that it belonged with him. **Angel of the North** should stand for at least a hundred and fifty years. This plaster figurine could vanish tomorrow, but its vulnerability is also its freedom from time.

The coarse-grained Peckham angel remained with me as I travelled north on the A1. Gormley had been schooled by the Benedictines at Ampleforth and his sense of England, of the placement of Angel, owed something to the journeys he took from 'sooty' King's Cross station to the Hambleton Hills in North Yorkshire. The journey erased the middle ground, the smeared landscape seen from the train window, damp fields, cooling towers, drab hamlets, the world going about its business. A genuine enthusiasm for difference, that which divides Hampstead from the moors, can sound sentimental or patronising. 'It's wonderful to have the weather,' Gormley said about the winds that challenge the Angel. 'It's what makes Northerners Northerners.'

What also makes them is a powerful attachment to the divisions of that territory, Gateshead versus Newcastle, Wear against Tees, fierce rivalries rehearsed through football wars. All of them depend, to greater or lesser degree, on the new colonialism of investment, techno-cities sited alongside motorways as the abbeys of old were found in river valleys. Northerners, wanting to reassert their identity, have asked for the Lindisfarne Gospels to be returned, brought to Durham. Gormley's Iron Man can be read as a messenger for this exchange.

Coming from the south, following the signs, the Angel is on you before you expect it. Colour hits you first, the rust against the dull green of this suddenly-famous municipal tump. It stands on the edge of things, out of tidy suburbs, its back to the flurry of the Metro Centre, facing south. There have been local adjustments. The pub across the road changed its name to the

Angel View Inn (part of Mulberry Leisure Ltd). 'Our courtyard', states the brochure, 'makes the ideal "open air" background for your celebration photographs and, weather permitting, the ideal place for that special summer barbecue. Now with the added attraction of "The Angel" which can easily be included in shots from our large car park.'

Gormley has insisted that this is the limit of commercialisation: no satellite developments, underground car parks or hot-dog stands. The site is free and open to all. And they have come, even through the squalls and wintry showers. The Angel is an emanation of the earthed-over colliery, a phantom of the shipyards. As you walk around it the character of the sculpture changes. From the A167 into Gateshead, it rears over the coarse hedge like a bird scarer. The face is blank, the wings unwieldy. Once the car is parked in the lay-by, the visitor approaches the Angel from behind and it is curvaceous, feminised. The wings become a cloak of welcome, a shape-shifter's device to envelop lost children. At the summit of the mound, the head is a blown thistle. Then, off to the side, it develops features. We see the steely blue beneath the warm patina of rust. Kids with bicycles measure themselves against a single Brobdingnagian hoof. Close again, the structure is abstract, spines and panels and riveted curves. You feel that it should be buried like a transcontinental pipeline, like Hughes's Iron Man. It is too exposed, vulnerable. The power of the thing should be returned to the earth. As you move back, crossing the football pitch to the immaculate bowling green that signals a move into suburbia, the Angel is a remote feature that gives focus to an avenue of saplings. It doesn't mean much to discuss the proportions of the wings. In profile, from the west, there are no wings. They become part of a wild salute, a callisthenic upreach. It's difficult to make the connection with the Peckham workshop where Gormley's body casts, his husks, are stored – dry chrysalides from which this great hermaphroditic presence has grown. Those are spectral, white, slender canisters of spirit. Their progeny, the Gateshead Angel, is rude, self-evident and uncomplicated. If there is a voice, it echoes the collier poet Joseph Skipsey: 'Offer me no consolation – I know there are dead down below.'

Gormley has spoken of his sculptural figures as 'fatally handicapped' by not being able to pass through a door, which he sometimes sees as a metaphor for death. If the Gateshead Angel is a messenger, it is also the contrary of Blake's Peckham tree spirits, his play of light among the leaves. The Angel is fixed, its wings a pilgrim's penance preventing flight. The figure on the hill has achieved anonymity. The measure of Gormley's achievement is that his name can be forgotten while the sculpture stands and survives as an independent provocation, a marker in the landscape.

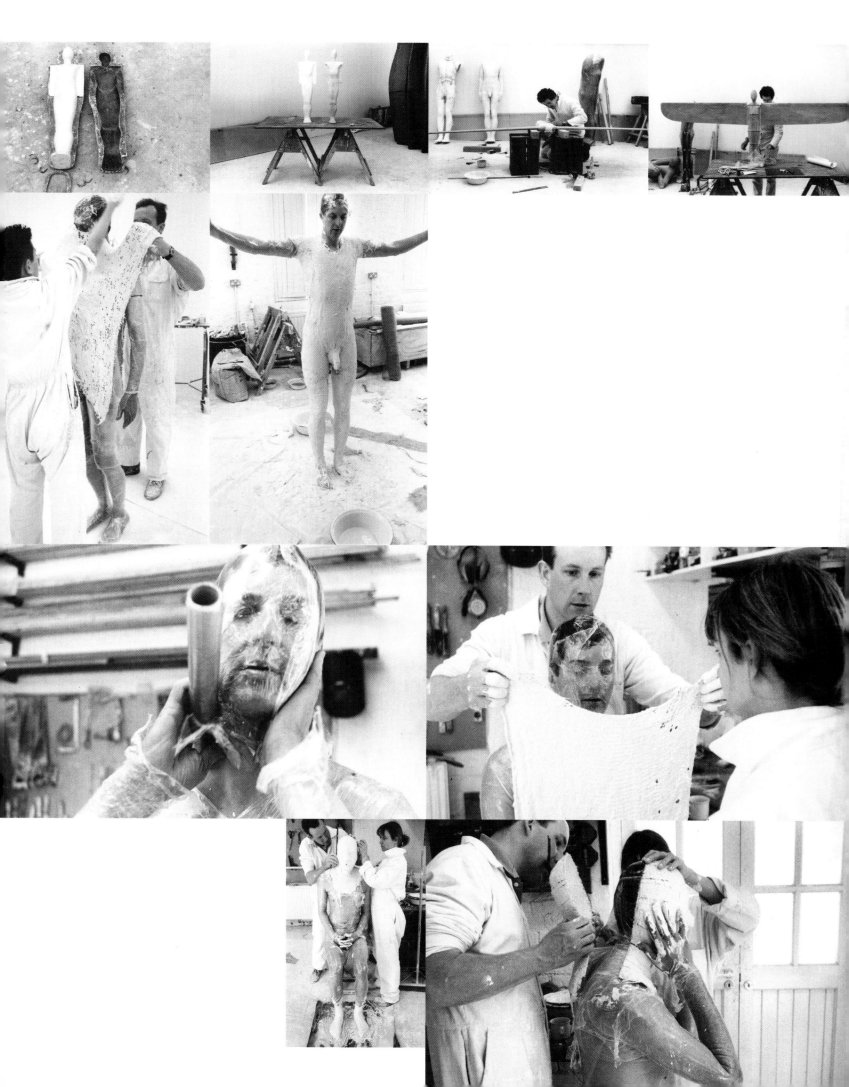

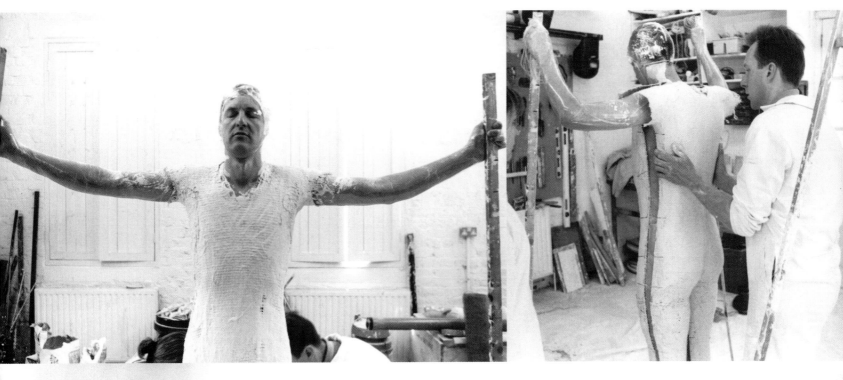

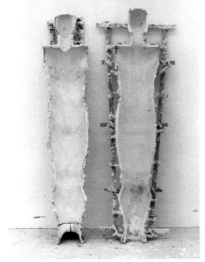

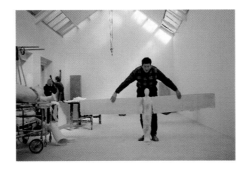

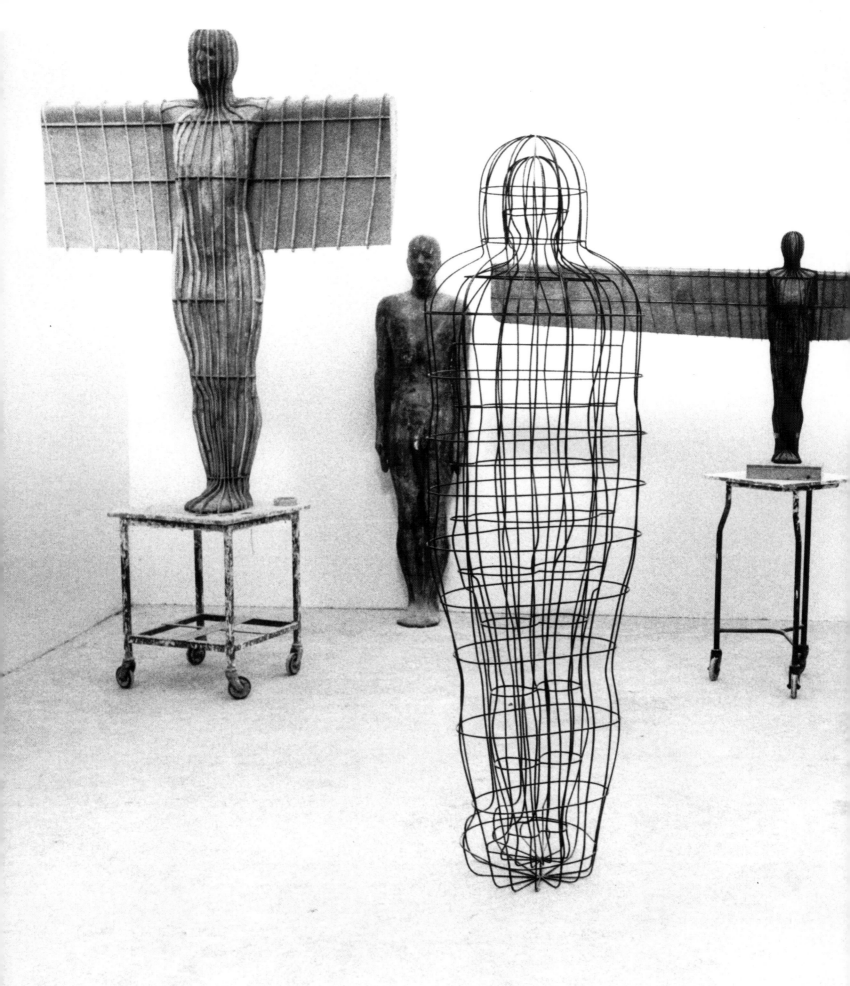

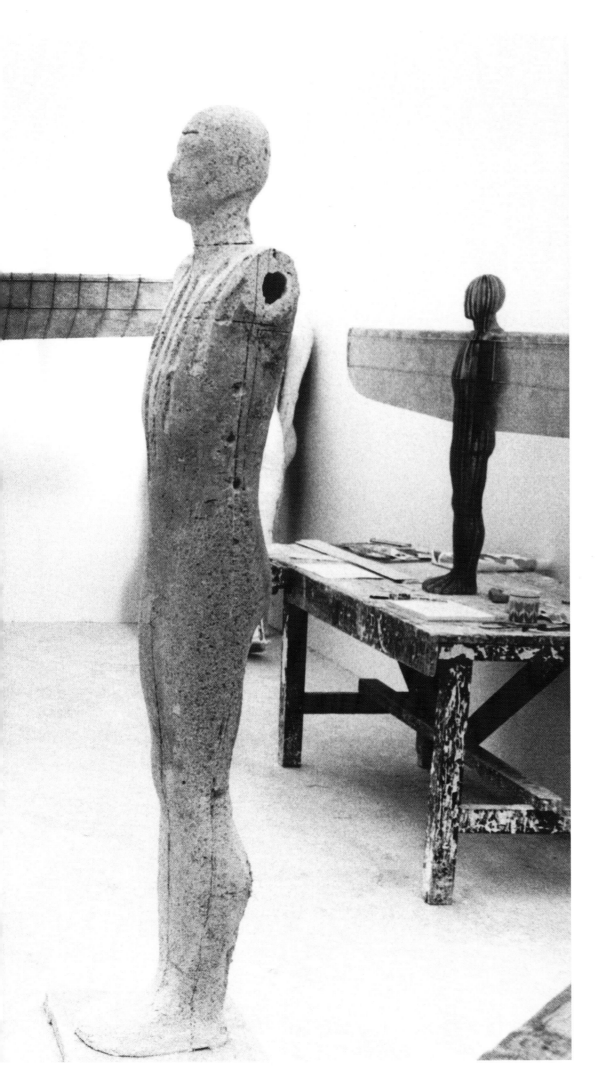

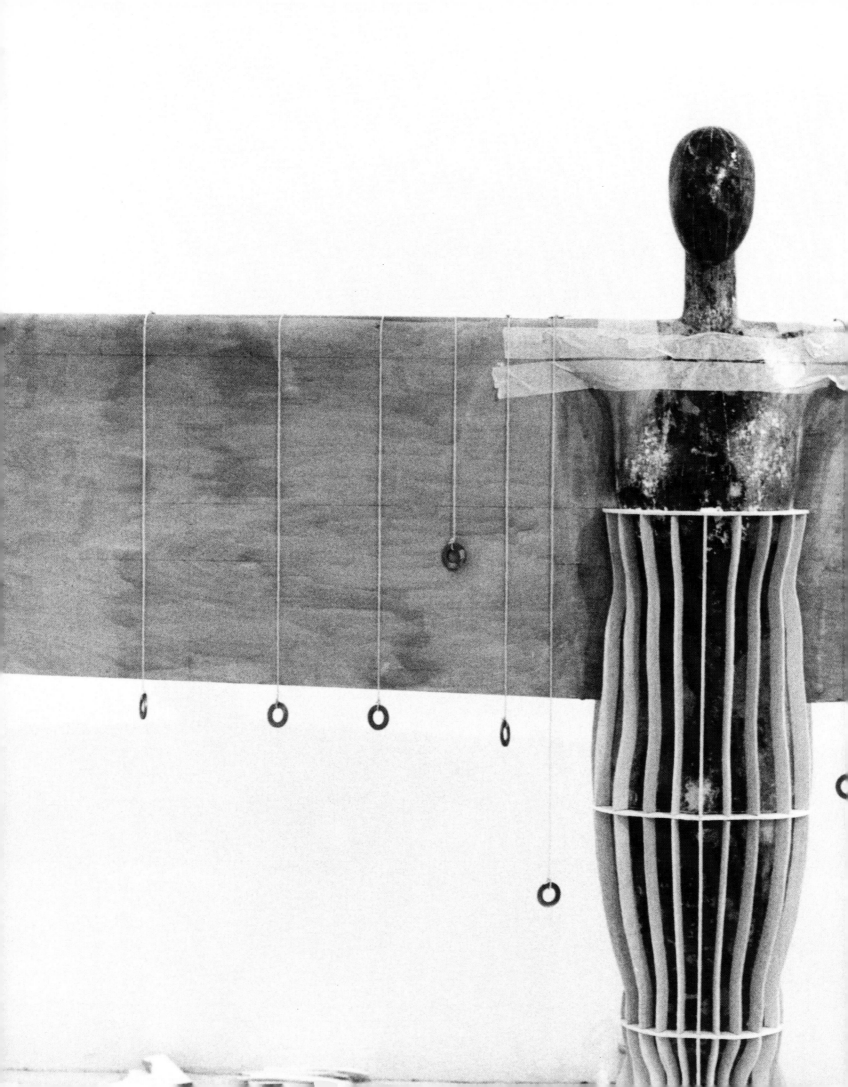

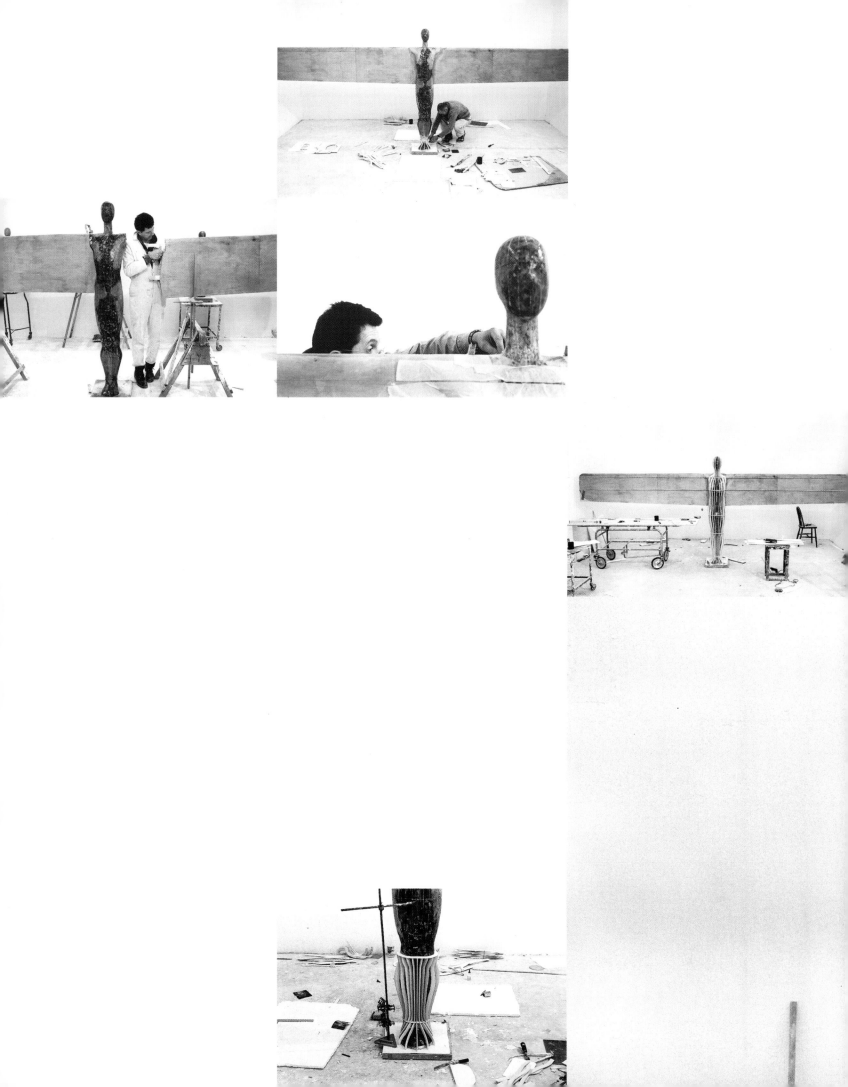

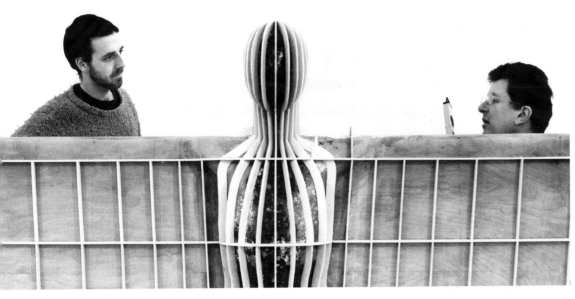

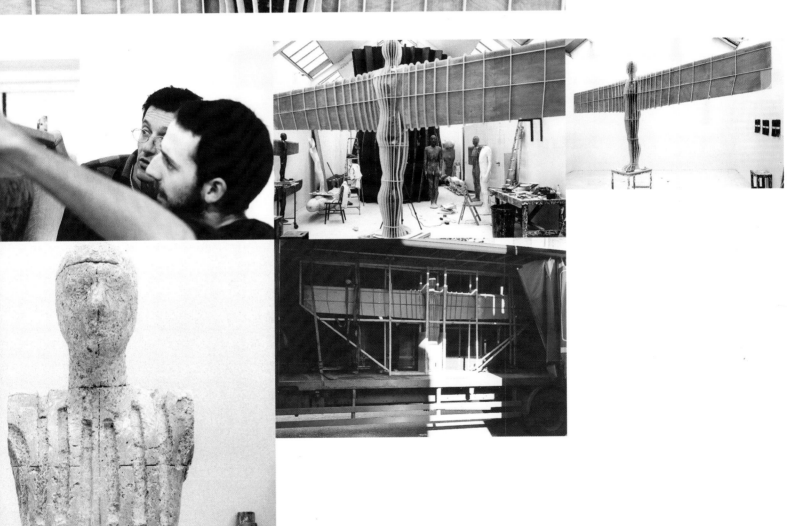

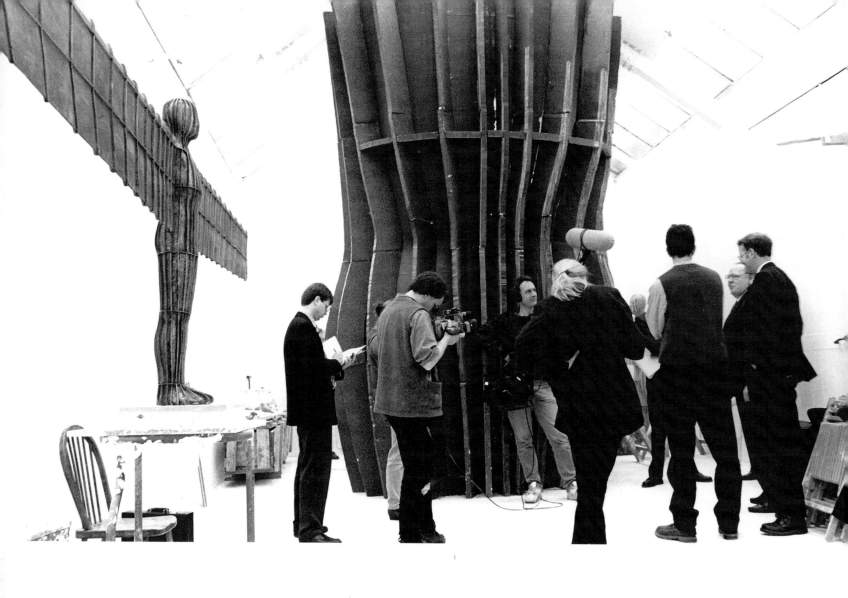

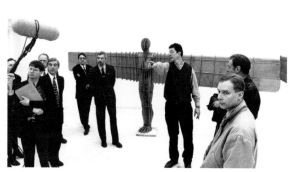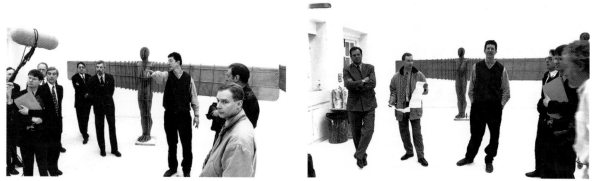

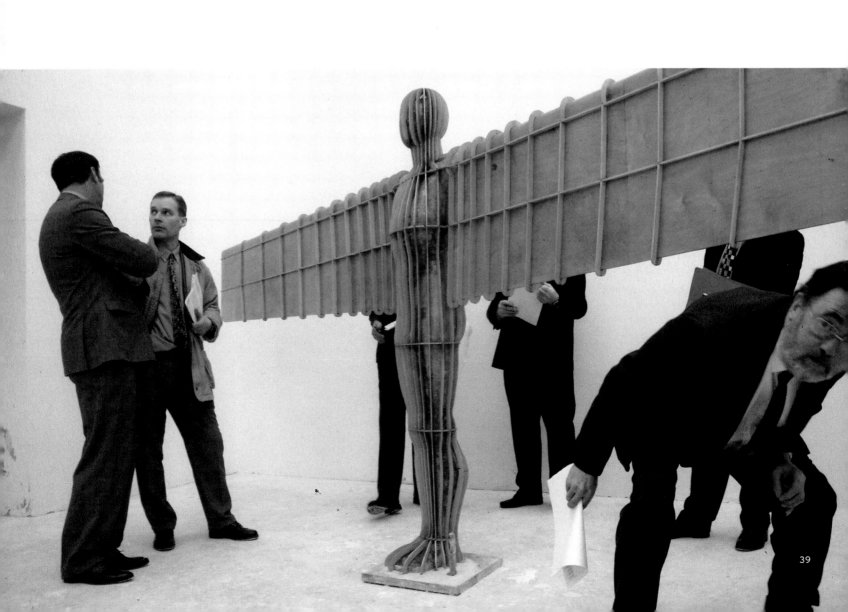

engineering the angel

ove arup & partners

The Engineering Problem

Imagine you are standing on the top of a hill. On a calm day you can stand upright with your feet together. In a stiff breeze you can still stand with your feet together, but you need to lean into the wind to avoid falling over, using your weight to balance the horizontal force of the wind. In a strong wind you need to lean further forward, but because the wind is gusty you also need to move your feet apart to keep your balance. In a howling gale you retreat from the top of the hill and take shelter. The **Angel of the North**, by contrast, can't lean into the wind, spread its feet, or shelter, and its wings offer enormous resistance to the wind.

So the fundamental problem in the structural design of the Angel was resisting the wind. As soon as the scale and form of the Angel became clear, Gateshead Council's Engineering Director Chris Jeffrey commissioned consulting engineers Ove Arup & Partners to advise. John Thornton, from Arup's London office, had worked closely with Antony Gormley on an earlier project, a large brick figure which was to have been built in Leeds, and he started to discuss the problems with Antony.

Developing the Solution

The ideal overall dimensions of the Angel as a whole and of its component parts had been chosen by Antony Gormley. Arup's first task was to establish whether a structure with these proportions could be made to work. Sculptures are often cast in bronze, but this could not be done at the scale of the Angel, and bronze would not have been strong enough to carry the loads. A special 'weathering' steel was chosen which does not need painting, but which, after initial minor rusting, is protected by a surface patina.

The critical section was at the ankles, where the forces to be resisted are large, but the cross-section is small. A wind blowing on the front of the Angel is resisted by tension in the shins, and compression in the heels. The distance between the heel and shin needs to be as large as possible to minimise these forces (this is why electricity pylons get wider at the base). An internal skeleton, as was used for the Statue of Liberty in New York, might have been possible, but Antony was keen to use the visible parts of the structure to carry the load, leaving the internal space empty; in any case there was not enough space inside the ankle skin, or inside the wings, to accommodate a skeleton. In discussions between Antony and John, a solution was developed where these forces were carried by visible vertical ribs which are a key feature of the sculpture. The skin of the body also helps to carry the load, and in particular resists twisting of the body when a gust of wind hits one wing only. Horizontal plates at intervals up the body stabilise the ribs and skin.

The same concept was used in the wings, but this time the ribs are horizontal. Another problem which had to be considered for the wings was the possibility that when the wind hit the wings at an oblique angle, the tips might flutter, leading to local damage or brittle failure under repeated cycles of loading, in the same way as a wire can be broken by bending it backwards and forwards. Arup's wind specialist, Andrew Allsop, was brought in at this early stage to consider this.

Estimating the Cost of the Angel

Once the concept had been finalised, John Thornton and his team did some initial calculations to establish the number and thickness of plates needed to carry the various loads. A budget price for the sculpture was estimated, but because of the unusual nature of the project it was decided that the fabricators who would eventually build the Angel should be asked to advise on the feasibility and likely costs. Both Antony and Gateshead were very keen that the Angel should be made locally, and about sixty firms in the North-East were contacted by Arup's Newcastle office. Four firms expressed an interest, and Arup took the 1:20 scale model which Antony had produced round to each of them in the back of a van so that they could see what the problems would be. Following these meetings the budget cost estimate for the steelwork was refined.

Another area which had to be investigated at this stage was what the Angel was to stand on. To stop it falling over, the feet had to be held down, and the foundations needed to be able to carry the weight of the Angel without moving. The soil on the site was not strong enough to do this, so the reinforced concrete foundations needed to go down to the rock, 20m below ground. The mound on which the Angel was to stand had to be removed temporarily to allow this foundation to be built. The Angel was to be erected on the site of an old colliery, and old mine workings had to be filled in. The cost of these foundations had to be estimated and added to the cost of the steelwork before Gateshead Council could set about getting funding for the project.

Completing the Engineering Design

Antony Gormley continued to develop the design, making a series of models at different scales to establish what refinements would be needed to the final form to give the desired effect. One change which affected the detailed

engineering design was to make the ribs stand out further from the skin, while keeping the overall size the same. This meant that the skin cross-section got smaller and so thicker plate was needed at the ankles to carry the twisting loads.

Making the skin for the body was a difficult process, because of its complicated shape. Cylinders or cones can be made easily by rolling flat plate, as you would roll a piece of paper, but on much of the body the surface is curved in two directions, like the surface of a ball. Thin plate can be hammered into this shape, but the thicker plate needed for the skin near the ankle is very difficult to form in this way. This problem could be avoided by using an internal core of cones and cylinders, but there was not felt to be enough room to connect all the ribs to this inner core, and, as already noted, Antony was keen to avoid an internal structure. An alternative solution was to cast the skin by pouring molten steel into a mould, and after consulting various foundries this solution was adopted for the lower sections of the body. Casting these complicated shapes is expensive, and the budget for the Angel was now fixed, so it was expected that only the lower body, where the skin needed to be thickest, would be cast.

Arup's Newcastle office developed the final design for the body and wings, refining the earlier calculations on plate thickness, and working out how the shape of the Angel should be defined for fabrication, with data on the body being scanned into a computer, while the wings were defined on drawings. The foundation design was also refined at this stage.

Selecting the Fabricator

To choose the fabrication company to make the Angel, a competitive tendering process was adopted. Arup produced drawings and a specification which defined the form of the Angel, the material from which it would be made, and the level of workmanship required, then the four companies which had expressed an interest in making the Angel were asked to quote a price for the work. To help them do this, a visit to Antony's studio to inspect the models and meet the sculptor was arranged. To demonstrate that the upper body sections could be made to a satisfactory standard, each tenderer was asked to produce a sample of curved plate.

The three lowest tenderers each had a different method of forming the lower body skin. One proposed a casting as specified, another proposed to form the skin by local heating and quenching, as used in shipbuilding. The third proposed to use an internal structural skin formed from conical and flat sections, and then to form the external skin from thin plate. This was the lowest price, and the only one which could be made within the overall budget.

After meetings with each of these tenderers, where the samples of bent plate were examined, and concerns about the various alternatives were answered, the contract for fabrication of the Angel was let to the lowest tenderer, Hartlepool Steel Fabrications in May 1997.

Steelwork Fabrication

To ensure that the shape of the body was an exact enlargement of Antony's model, a plaster cast of the body skin was scanned into a computer using stereophotography, a technique used in mapmaking. The University of Newcastle-upon-Tyne was commissioned by Hartlepool to carry out this work, and developed a 3D computer model of the body. Instructions from this computer model were passed directly to the cutting machine which produced the pieces of plate from which the Angel was made. This model was also used to determine the best combination of cones to form the inner core, and to define the geometry of these cones for bending.

These pieces of plate then had to be assembled into the final form. The plates were welded together, using an electric current to melt the steel locally. The wings were fabricated first, followed by the feet, starting with the inner core to which the vertical ribs were fitted. Fabrication of the body then continued upwards to the chest, while the head was made separately. More than 2,000 pieces of internal horizontal rib, which were not needed structurally, were welded between the vertical ribs to form the template over which the final skin was fitted. Skin panels were generally formed over these ribs using local heating and wedges.

Antony Gormley maintained a close interest in the fabrication process, encouraging the welders and platers to achieve an exceptionally high standard of finish.

Foundation Construction

The foundation contract was won by Thomas Armstrong Ltd. Holes were drilled 33m though soil and rock to inject a sand and cement mixture into the mine workings. Eight piles, each 0.75m in diameter, were formed by drilling holes 20m down to the rock and filling them with reinforced concrete. A 1.5m thick concrete slab was placed on top of these, then a column slightly larger than the Angel's feet, containing the 52 bolts, each embedded 3m into the concrete, needed to hold the Angel down in a gale.

Erecting the Angel

The Angel had to be delivered to Gateshead in three pieces, the body and two wings. Temporary bolted connections between these pieces had to be made up in the air on site, so that the cranes could be removed before the permanent welded connection was made. This temporary connection was designed by Arup to take the full weight of the wing, and a substantial wind loading.

The three pieces of the Angel travelled from Hartlepool to Gateshead, on low loaders with a police escort, over the night of Saturday 14th February. Luckily, Sunday was a calm day, and at first light the body was lifted off its trailer by two cranes, rotated into the vertical position and lowered over the 52 holding down bolts. It fitted perfectly. Once all the bolts had been tightened up, the first wing was lifted into position before lunchtime, and by dusk the second wing was fully bolted up. The wind got up overnight, delaying the scaffolding needed to allow completion of the permanent welded connection, but within a fortnight the permanent welded connection had been made and infill skin panels welded into place to complete the steelwork of the Angel. Landscaping to return the site to its original form was carried out in March.

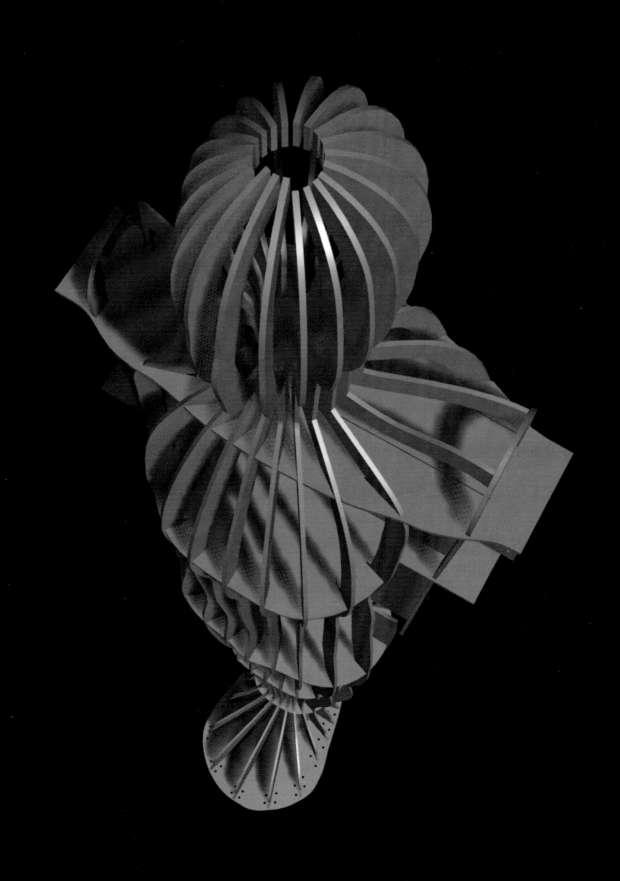

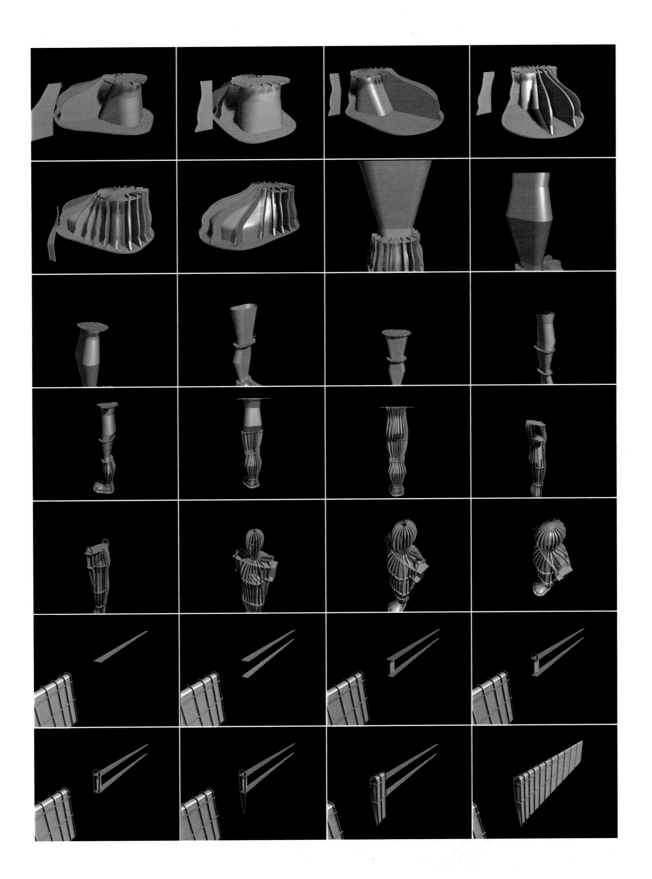

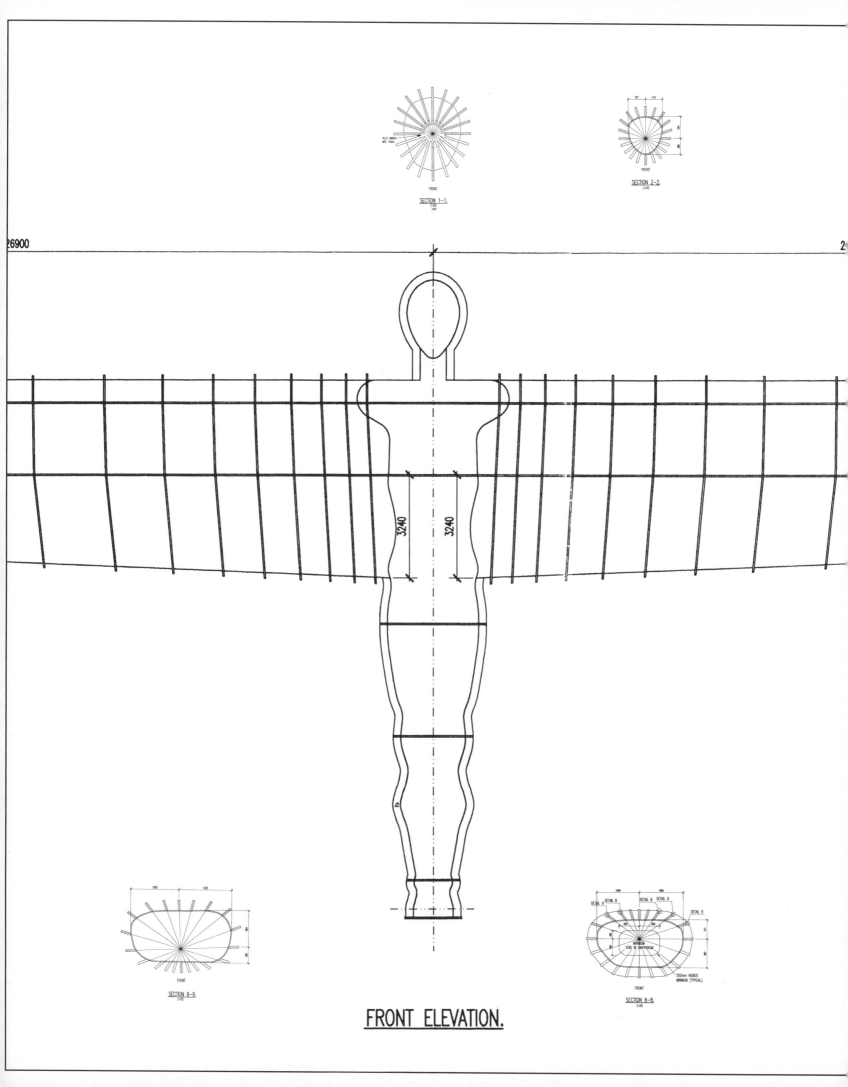

SECTION 1-1.

SECTION 2-2.

26900

3240 3240

SECTION 9-9.

SECTION 8-8.

FRONT ELEVATION.

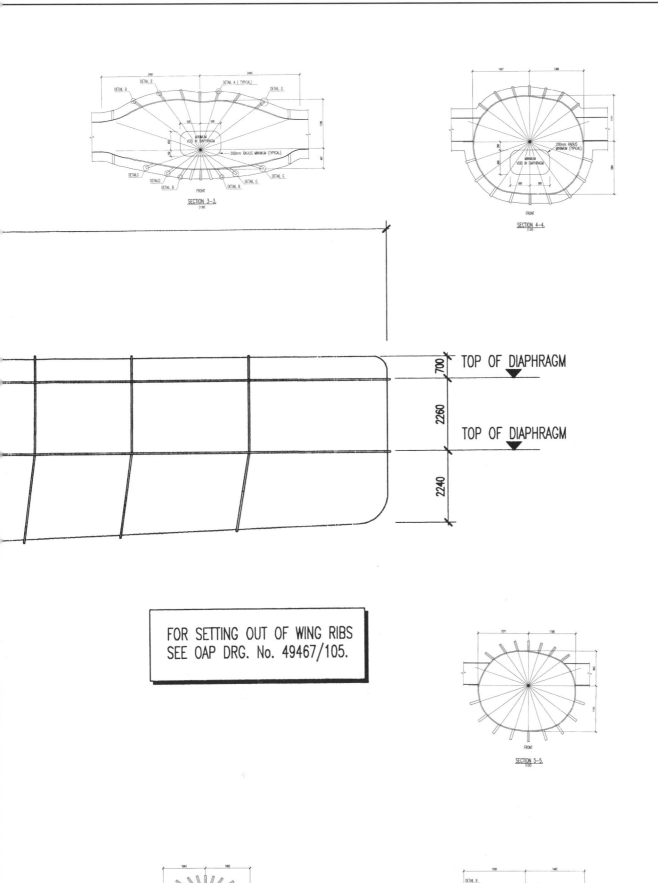

SECTION 3-3.
(1:20)

SECTION 4-4.
(1:20)

700

TOP OF DIAPHRAGM ▽

2260

TOP OF DIAPHRAGM ▽

2240

FOR SETTING OUT OF WING RIBS
SEE OAP DRG. No. 49467/105.

SECTION 5-5.
(1:20)

SECTION 7-7.
(1:20)

SECTION 6-6.
(1:20)

Rev.	Date	By	Description
C1	04/06/97	DCH	ISSUED FOR CONSTRUCTION

Drawing Status
CONSTRUCTION

GATESHEAD

METROPOLITAN
BOROUGH COUNCIL

CIVIC CENTRE,
REGENT STREET,
GATESHEAD NE8 1HH
TEL. 0191 - 4771011
FAX. 0191 - 4778422

Job Title
THE ANGEL OF THE NORTH

Drawing Title
STEELWORK GENERAL ARRANGEMENT

ARUP Ove Arup & Partners ©
Newcastle upon Tyne NE1 2EB
Tel: 0191-261 6080 Fax:0191-261 7879

Scales 1:100		Originator DCH
Checked	Approved	Date 04/06/97

Job No.	Drawing No.	Rev.
49467	101	C1

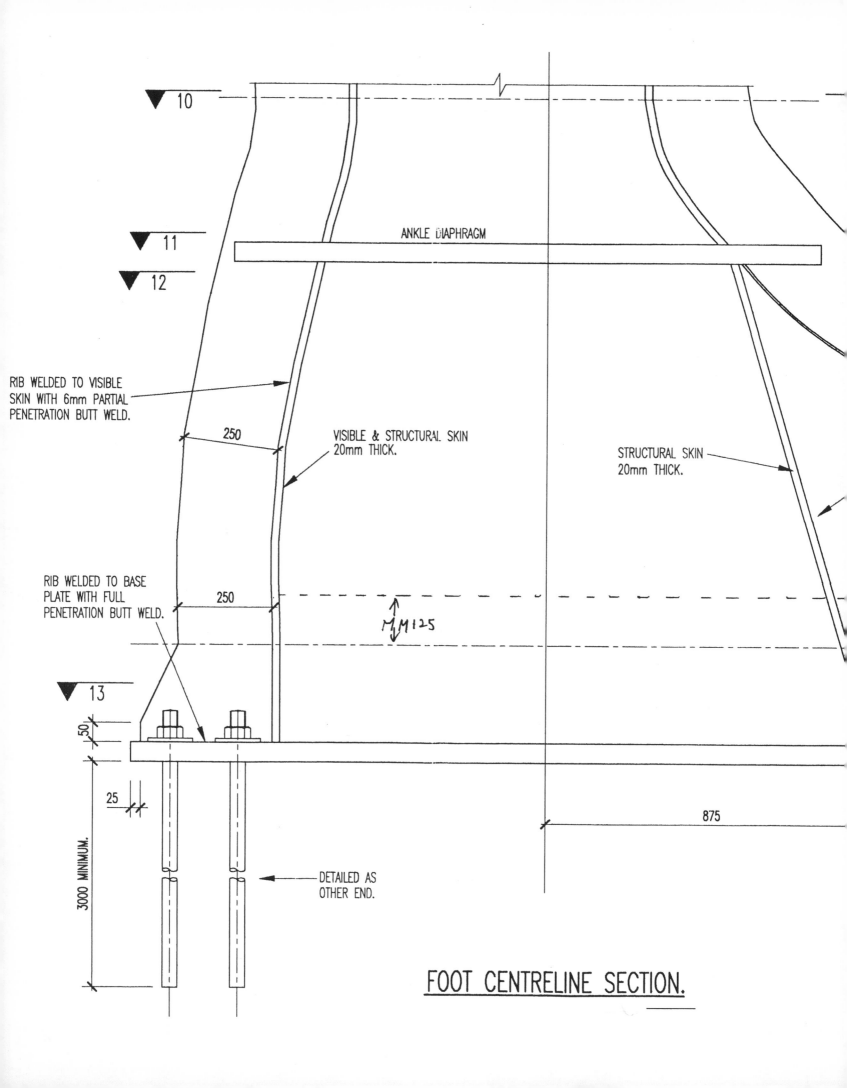

▼ 10

▼ 11

▼ 12

ANKLE DIAPHRAGM

RIB WELDED TO VISIBLE
SKIN WITH 6mm PARTIAL
PENETRATION BUTT WELD.

250

VISIBLE & STRUCTURAL SKIN
20mm THICK.

STRUCTURAL SKIN
20mm THICK.

RIB WELDED TO BASE
PLATE WITH FULL
PENETRATION BUTT WELD.

250

M₁M125

▼ 13

50

25

875

3000 MINIMUM.

DETAILED AS
OTHER END.

FOOT CENTRELINE SECTION.

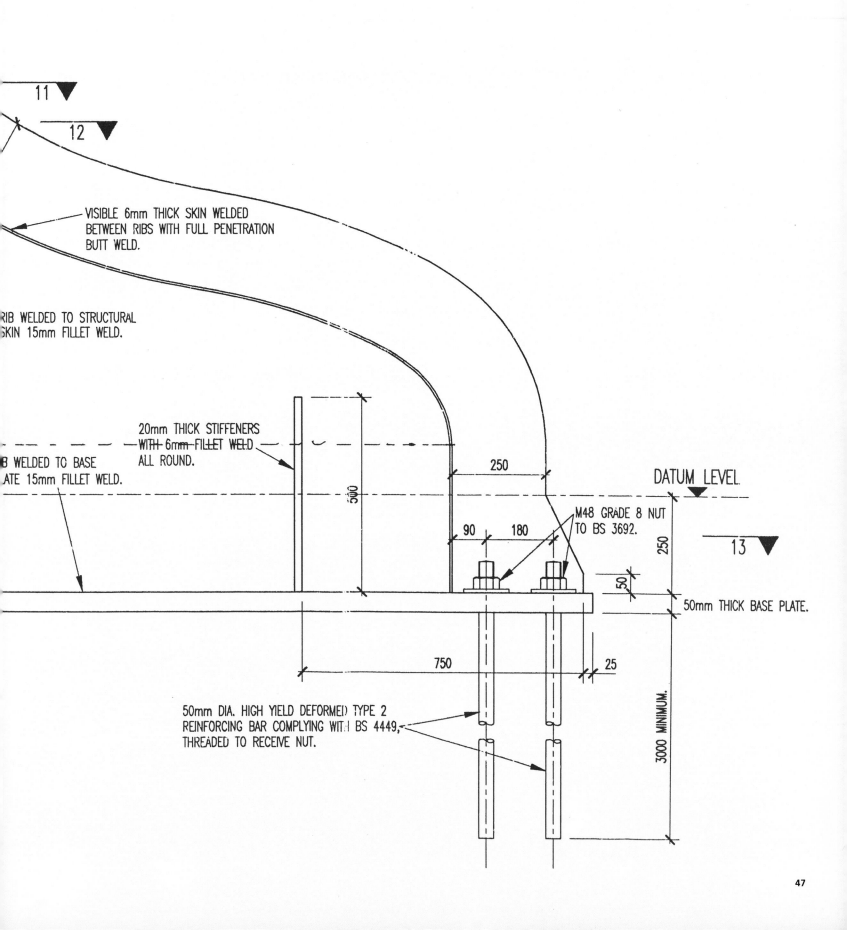

11 ▼

12 ▼

VISIBLE 6mm THICK SKIN WELDED
BETWEEN RIBS WITH FULL PENETRATION
BUTT WELD.

RIB WELDED TO STRUCTURAL
SKIN 15mm FILLET WELD.

20mm THICK STIFFENERS
WITH 6mm FILLET WELD
ALL ROUND.

B WELDED TO BASE
ATE 15mm FILLET WELD.

250

DATUM LEVEL.

M48 GRADE 8 NUT
TO BS 3692.

90 180

500

250

13 ▼

50

50mm THICK BASE PLATE.

750 25

50mm DIA. HIGH YIELD DEFORMED TYPE 2
REINFORCING BAR COMPLYING WITH BS 4449,
THREADED TO RECEIVE NUT.

3000 MINIMUM.

STEELWORK HEIGHT 20m
WINGSPAN 54m
WING HEIGHT AT BODY JUNCTION 6.2m
TOTAL WEIGHT 208 TONS
(EACH WING 50 TONS, BODY 108 TONS)
ANKLE CROSS-SECTION 780mm BY 1,400mm
(EQUIVALENT TO AN ORDINARY DOOR IN THE HOUSE)
3,153 PIECES OF STEEL ASSEMBLED
136 BOLTS NEEDED TO ATTACH WINGS TO BODY
(EACH 48mm DIAMETER)
22,000 MAN HOURS SPENT IN FABRICATION
(TWENTY MEN WORKING FULL-TIME FOR SIX MONTHS)
10km OF WELDING IN FABRICATION

DESIGN HORIZONTAL WIND FORCE ON WINGS 70 TONS
(EQUIVALENT TO THE ANGEL BOLTED TO A VERTICAL SURFACE
AND A 35-TON LORRY PARKED ON EACH WING)
450 TONS FORCE IN WING DIAPHRAGMS
1,200 TONS FORCE IN ANKLE RIBS
50 TONS FORCE IN EACH 50mm BOLT
(SO EACH BOLT COULD CARRY A LORRY AND A HALF)
2,500 MAN HOURS SPENT IN ENGINEERING DESIGN AND DRAWING
FOUNDATIONS 5000m³ OF SOIL EXCAVATED
AND LATER REPLACED TO REFORM MOUND
100 TONS OF GROUT PUMPED INTO MINE WORKINGS
UP TO 33m BELOW GROUND
700 TONS OF CONCRETE AND 32 TONS OF REINFORCING STEEL
USED IN FOUNDATION EXTENDING 20m BELOW GROUND
52 BOLTS NEEDED TO HOLD ANGEL UPRIGHT IN WIND
(EACH 50mm DIAMETER AND 3m LONG)

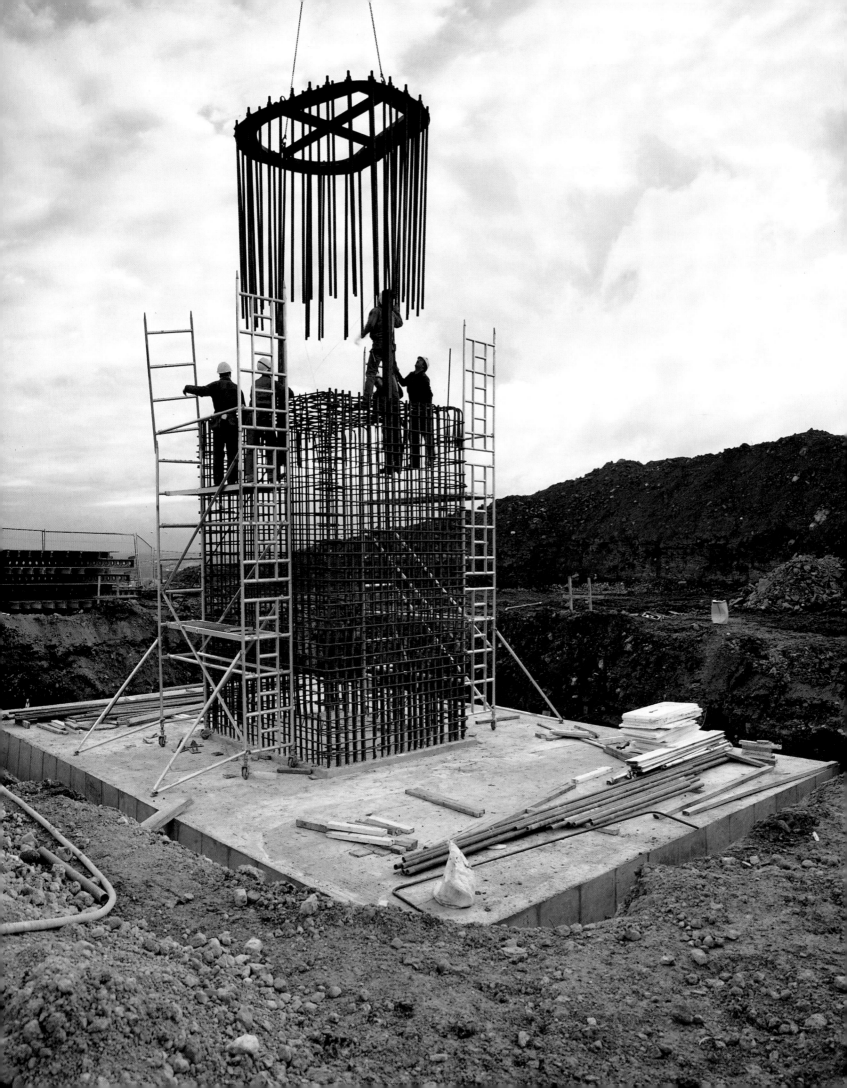

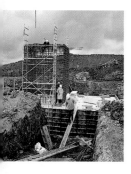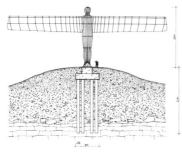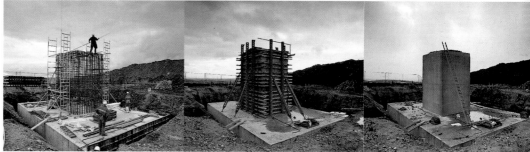

gateshead and the angel

beatrix campbell

When the **Angel of the North** was finally brought home to the lump of land where it will live for the next century, the people were asked to stay away, to let the installation of the twenty-metre steel being proceed unimpeded. But in a thousand acts of innocent defiance, people wandered up to the site while the engineers were working, they took dogs and grandchildren and flasks of tea and cameras, and they watched and wondered. The sound of the crowd was quiet, curious and contemplative; it was the sound of self-discovery, of a crowd asking itself questions and determined to see, close up, the birth of a new place.

Indeed the presence of the people during the installation took everyone by surprise: it suggested a new relationship to this scrap of land, now a landmark. It seemed that an empty space was becoming a place and the people wanted to be **in** the landscape, with the Angel.

Tyneside had not known what to think about the **Angel of the North**. Despite an extraordinary and robust, not to say brutal, public debate about the Angel, and despite elaborate efforts to bring the debate into the heart and soul of the community by the commissioners, Gateshead Council, the crowd seemed neither excited nor alienated, it was simply curious.

The Angel was slowly, carefully, planted in its home, a mound nestling between motorways flowing around the edges of Gateshead, the southern side of Tyneside. It is an iconic industrial landscape, worn and wasted, built and rebuilt, majestic and modest. The landscape of Tyneside belongs to labour, to the conflicts and solidarities of communities that homesteaded along the banks of the Tyne for 400 years, where people have dug coal, wrought iron, baked bread, blown glass, brewed beer, built ships, fed children, served dinners, and kicked footballs and each other.

Through all its metamorphoses, this landscape revealed a history of ruin and renewal, a history which also created the precarious bond between the two, and between spaces which historically have been polarised - places which are domestic or industrial, public or private, feminine or masculine. The great industrial territories of Britain have always dramatised the difference between public and private, between men's places and the space they share with women and children, home. This distinction is one of the modern age's gifts to human habitations. The borders between them marked their paradoxical proximity and incompatibility, and masked the searing struggles for mastery between genders and generations which have been buried in the sentimental rhetoric of community.

By the end of the twentieth century the majestic locales of manufacture, cathedrals in which (mainly) men made things, have been largely evacuated, emptied of productivity and profit, and men find themselves increasingly sharing the same time and place as women and children. But home has always been more than a house, a place to sleep, the place where men visit their families. Home has been a larger landscape, signified by locales which embrace - rather than exclude - the citizens who construct together their experience of community in their improvised sense of place.

In Tyneside the emblem of embrace has been the Tyne Bridge, the region's iconic arch spanning the Newcastle and Gateshead banks of the deep river. Although the visual access to the bridge has often been interrupted by crass buildings, it has remained the defining sign of a majestic cityscape, defined as much by the contours of the river as by human habitation. Its resonance has been rising with the decline of the river as a workplace and its renaissance as, simply, a place: a place to play and work and wander, a place that is alive by night and by day, that increasingly marks a historic commitment to congregation and the fabled wild, witty pleasures enjoyed amid the company of strangers, the defining culture of Tyneside.

The bridge, like the river, belongs to everyone and no one, it is in perpetual visual motion, a site of eternal activity, comings and goings, a place to cross, to see, rather than just a place to be. Its location in the collective imagination is secured in fleeting moments, passing glances. And yet it is secure, it signifies the city as a place of movement and congregation. Not least, the Tyne Bridge affirms the urban pleasure of seeing. It lives in the imagination not just as an emblem of engineering and industry, a triumph of the industries associated with the region's former grandeur - though it is all that, too. Its function in the events of everyday life creates its unifying connection with its communities. This is important: the engineering that is emblematic of Tyneside was also an exclusive activity. Its skills and its rewards were reserved for only one part of the population, the men. The industries associated with the region's economic ascendancy were, likewise, places that privileged men. The dominant pleasures, too - the football, the drinking.

However, the bridge affirmed the democracy of seeing. In its utility and its lowliness it became the unifying symbol of Tyneside. Its strong curves and its serenity contrasted with the region's other raging stereotypes: Andy Capp, the Toon Army and **Viz** magazine, the signifiers that infused Geordie identity with misogyny.

The presence and aura of the Angel, the history of its commission and construction, its location between busy roads on a reconstructed mound, and its significance in regional culture, are all suggestive elements of the debate about what it means to be a place, and the function of art in the processes of producing a sense of place.

Gateshead's Public Art Project has been a remarkable and redemptive intervention in the local landscape, bringing sculpture to sometimes devastated locales and investing them with new possibilities of visual pleasure. The project has done more than bring art to Gateshead, it has tried to inscribe art and artistry into popular culture by hosting the community's access to artists and to the making of art - its sculpture days, for example, are regularly attended by about 1,000 people. The project engaged thousands of children in the Angel exercise, and artists went into the schools, where the children contemplated their own angels and their own messages for the future.

But the commissioning of the Angel as a landmark, as a large, welcoming gesture to the people in their traffic to and from and around a mound on the edge of Gateshead, ignited a raw controversy about not only the prototype of the Angel but the very project of public art itself. The local press mounted a campaign against the Angel, arousing vitriolic opposition and mobilising a utilitarian view of renewal as merely industry and housing. It was a spartan discourse that seemed to scorn culture, art and pleasure, as if they did not deserve public

sponsorship, or worse, implying that Gateshead's reputation as an industrious community would somehow be ruined by alien adornment. But the fury of the debate was suggestive of something more than the philistinism that is blithely ascribed to the working class. The equation between proletarianism and philistinism is, in any case, confounded by the vigorous popular cultures which thrive in Tyneside, and more specifically by the response of Gateshead people to the Public Art Project.

When Gateshead installed Gormley's **Field for the British Isles** in a disused railway building, 25,000 people went to see it within the space of weeks. The Field attracted a passionate audience whose attention was arrested by the crowd of terracotta figures. Spectators would often crouch on the ground to get close to the thousands of figures, the spectators returning the gaze of their empty, searching eyes. It was a heartstopping communion that amazed both the audience and the organisers of the installation.

This response to the Field belied the notion that the community was simply anti-art. The debate seemed to suggest something deeper, something unsayable. It was as if the Angel disturbed sediments of loss, sadness and neglect, a grave experience of disappointment with the twentieth century, with its Faustian promises and fading optimism. Tyneside is one of the poorest places in Britain, where the grandeur of its industries has ebbed, for many of its people, into economic and emotional anxiety. Feelings that in the middle of the century would have been expressed in the language of politics were by the end of the century hardly expressible at all. It was as if that disappointment had hardened into a brittle but familiar idiom of thrifty respectability and nostalgia, too vulnerable to be challenged, too insecure to allow any alternative sense of itself, too defended to locate itself amidst diversity and the risk of self-discovery.

Scouring the books which comment on the Angel, the reader is assailed by a ferocity that implies fragility, a determined definition of Gateshead as a community that would be assaulted by the addition to its landscape of a work of sculpture: 'social housing is declining and NHS services are suffering ... it puts Gateshead to shame ... just like the other monstrosities in Gateshead ... the man who designed it wants to be locked up ... it is of no use whatsoever ... throw valuable funds away on crackpot schemes ... I am totally ashamed to admit I live in the town ... waste of public funds ... gives the rest of the country another chance to ridicule the North-East ... rubbish! ... the birds will have somewhere to shit ... give it to London because they're shite.'

It did not matter that the funds were not from the local authority, nor that they would never have been available for redistribution. What mattered in these comments was the tone – the rage. The economic complaint invoked a devastated spirit, a sense of the place fading away, dying. The cultural complaint, in contrast, implied an already established identity, a way of being, a confident community, and yet a community whose reputation and sense of self were at stake.

Against the abusiveness of its critics, the Angel's friends (judging from the comments book they represented at least an equal portion of the commentators) seemed both more and less confident, more at ease with the process of self-discovery and risk embedded in their engagement with the sculpture. 'I wasn't impressed at first, now I am totally fascinated ... it would be a nice structure if it had been painted and tidied up ... it is the making of history ... I think the wings are not very good but they match the industry of Gateshead ... Very magnificent ... it is magnificent and it's ours ...' A ten-year-old girl wrote: 'You can see it a mile away. My brother thinks the world of it. It makes me feel smiley.'

For some of the Angel's early critics, the desperation to find good grounds relied upon the notion that the land itself, the mound where the sculpture was to be installed, would be desecrated by the intrusion. 'It will spoil a nice bit of countryside,' it was said. But that bit of countryside was an island between streaming traffic, it was already land that had been worked and reworked, the site of a closed colliery – people had been working coal around there since the sixteenth century. For Gormley, the site was significant. The sculpture would rise up in the light from a site where people had toiled in the dark. 'The context was given, and that's what made me want to do it,' says Gormley, who was not only committed to the renewal of the site, but to bringing art to the eyes of travellers flashing by in cars, trucks and trains.

The early drawings had provoked some critics to damn the Angel with the style of Soviet or fascist monumentalism. These notions evaporated when the Angel emerged, not as a towering figure dominating the space, but as a sensual, serene one, settled in its place amid the urban clutter of lived-in space – roads, pylons, tower blocks and suburban semi-detached houses.

For Gormley, it seems that the debate continued the project's importance. 'I wanted to see if it was possible for art to live outside specialised conditions – ideological and institutional. Can we take art out and see if it survives, is it possible for art to be a resonator, an amplifier; is it possible that art is part of the built fabric of the world? Is it possible to make contact with unspoken, untouched feelings?'

The debate itself had revealed the fragility of identities and the pain buried in history. He wanted his work to resist any rhetoric of sentimental reassurance, while expressing the quality of endurance. He wanted the Angel to resonate with the experience of work and yet to recognise that 'the need for self-respect through work is what makes us vulnerable'.

The crowd wandering around the site during the day of installation, and the drama recorded by the local media, seemed to change the tone of the debate. It was not that an argument had been won or lost; the Angel itself changed the terms of the conversation. It was instantly surrounded by a 'field of emotions'. Gormley's terracotta Field and now the Angel 'both have a sense of identification with the dispossessed, but in

different ways,' says Gormley. The site, and its 'spatial peculiarity', dissolved the sacred atmosphere associated with the art gallery on the one hand, and untouched land, nature, on the other. 'People expect the sublime, something in the middle of nowhere, and they're shocked that the site is a social space, a working landscape of factories and football fields, tower blocks and terraces, marshalling yards and kiddies' playgrounds and communications masts.'

The presence or aura of the Angel itself expressed, for Gormley, his own priorities: 'What I am interested in is my human value, not my art value.' The Angel, like the Field, is 'a witness to life'. The Angel, by being 'a wayside stone, marks a limit, a point of observation, a point of reference, a witness to its time and the life that passes by, an invitation to a certain kind of dreaming. What it wants is to be totemic. Perhaps this thing is **them**, and they're frightened of it.' Perhaps, too, the Angel's composition as an object with familiar human contours, rather than an abstraction, ignited the most passionate feelings.

In a region known for its macho iconography, where art routinely evokes its history through the representation of miners or footballers, men cast as both masters and martyrs, the Angel is a sexual subversive. It is undoubtedly masculine. Gormley uses his own body as the form from which his work is figured. For him, then, his own body is both an object and subject. This, of course, challenges the history of the male artist's invisibility and the objectification of women in Western art. 'I use my own body because that's where I live. I challenge the traditional heroism of the male body in art, my interest is to work from the inside out.'

The Angel's masculinity is both there and not there, muted rather than proclaimed; it resides in the narrow shoulders, the swelling diaphragm, the modest mound around the genitals and the surprisingly voluptuous buttocks and legs. Its gender is, then, both an incidental and indispensable part of the Angel's identity. The soft sexuality of the Angel departs from the heroic tradition of transcendental muscularity embedded in the classical tradition, and reaching its apotheosis in the authoritarian monumentalism of the twentieth century. It offers to a region notorious for its incontinent, marauding masculinities another challenging model of masculinity: self-contained, serene, in a gesture of embrace rather than attack.

The ribs which structure the sculpture from top to toe broadcast the body's quiet sensuality. Here is a sexuality that is neither omnipotent nor objectified. The ribs gesture at this through the flaring silhouettes of feet, legs, buttocks and chest. There is something else in those ribs, which proclaims the Angel as the work of many hands and minds. Having decided at an early stage that the ribs should be external, Gormley consulted the engineers, who helped compute the Angel's technical imperatives, and produced an engineering solution which dramatically affected the design.

Instead of thick, sturdy ankles, a kind of trunk, to cope with the weight of the structure and the climate in which it was to live,

Ove Arup's engineers suggested an internal load-bearing structure. This freed the ankles, which emerged as an elegant, curving feature of the Angel's body map.

For Gormley this moment illuminates the collective labour invested in the Angel: 'That is what is so extraordinary, one of my ideas falling on to this land and growing.' The collaboration of the Ove Arup engineers, and computer specialists at Newcastle University's geomatics department, transformed an idea into a robust structure. The traces of their collaboration are inscribed in the body of the Angel: 'You can read the welds (and the welders can), they're not erased. I have a romantic idea that part of the Angel's boast is that it represents the collective body, that it comes from the energy of many lives and the touch of many hands. These multiple voices are not dissimilar to the built environment. I'm hoping that the Angel celebrates collective labour.'

It may also come to embody the collective imagination and the effort it takes to make a place. In Tyneside, one of the most isolated metropolitan conurbations in England, the commitment to place is palpable. People appropriate places and make them their own. Heavy metallers and goths on Saturdays appropriate the square surrounded by the bunkered shopping precinct built after T. Dan Smith bulldozed Newcastle's once glorious Eldon Square; it has come to be known as the Hippy Field. Mobile communities of young razzlers appropriate the Bigg Market and the Riverside at night. Christians, musicians and animal rights activists occupy the Monument, another collective meeting place, at weekends. The commitment to convivial congregation transforms these urban monuments into places.

Gateshead, across the water, is dominated by the Metro Centre, an eyeless fortress for easy shopping, and the patched-up car park that featured in **Get Carter**. If the landscape in that film – terraced back-to-backs and the cavernous car park – seemed faithful to an older image of Tyneside, the amazing array of accents revealed an older confusion about class and place: the characters in the film are hardly Geordies, their accents could come from anywhere. What mattered, presumably, was the suggestion of proletarian class origins, rather than the intense coupling of class and locale that produces language. In Tyneside dialect doesn't die. Just as London teenagers adopted the cool syntax of Afro-Caribbeans, so Tyneside teenagers endlessly modernise their own local patois. Their language is both a bequest from their ancestors and at the same time a cultural invention of their own, to specify their own mark on their place and their time.

And as the Tyne Bridge came to signify more than a road and rivets and engineering excellence, so the Angel seemed to stand for something more than itself, the embodiment of what Gateshead Council and Gormley had hoped for: as Gormley put it, 'part of the living experience of turning a site into a place'. With its empty, subdued face, its flaring ribs, its welcoming wings amid traffic and pylons, and its rusty, earthy hues, it is telling them that wherever they live, here is home.

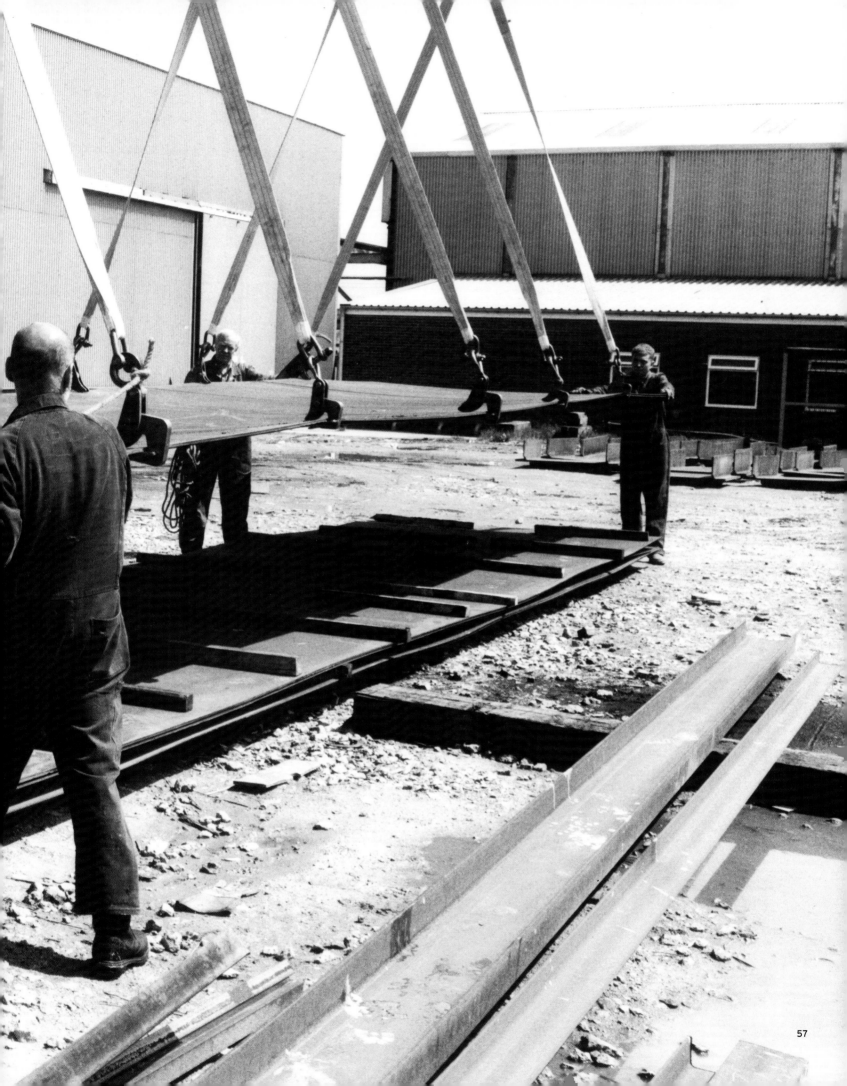

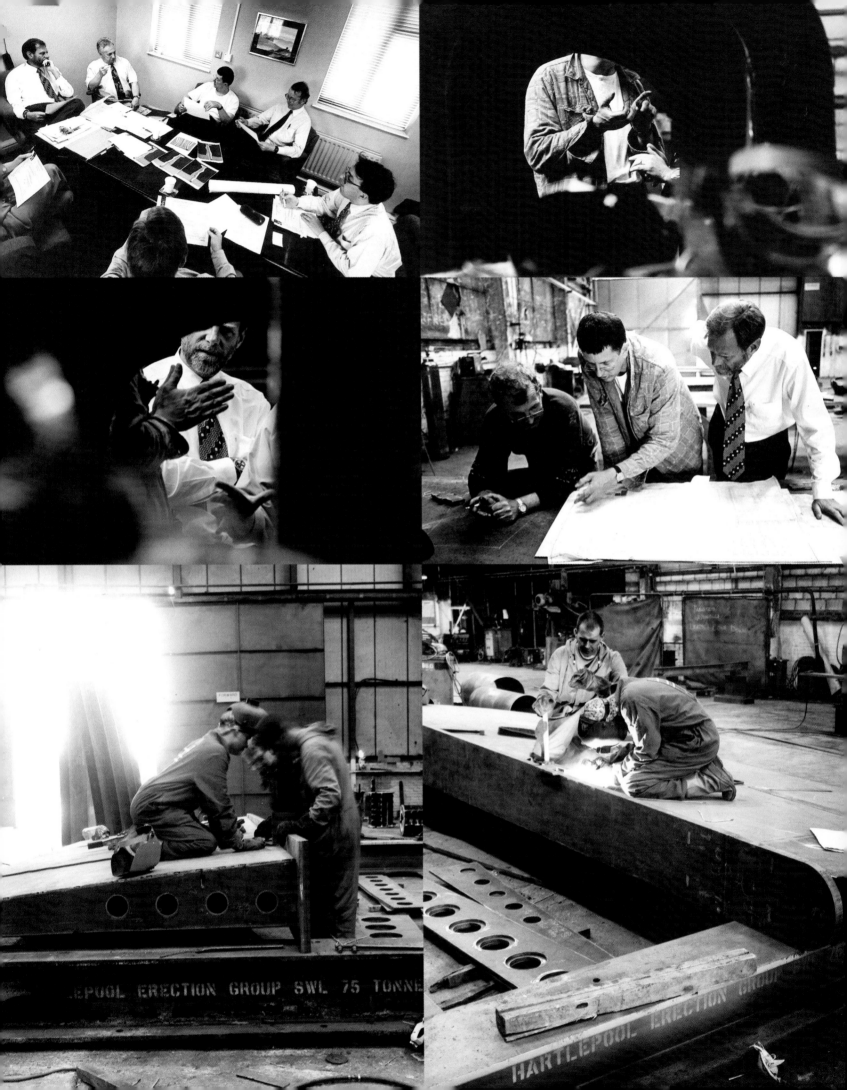

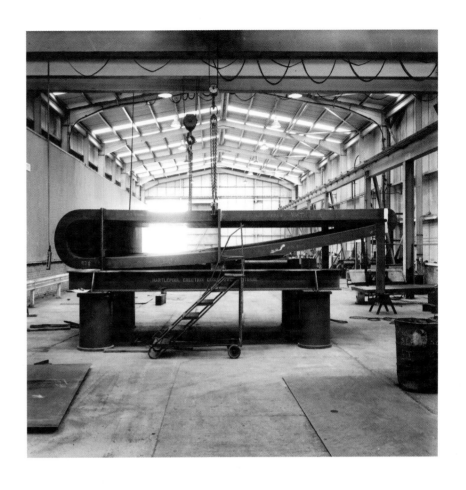

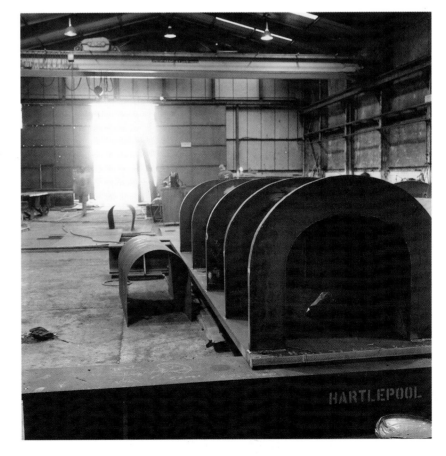

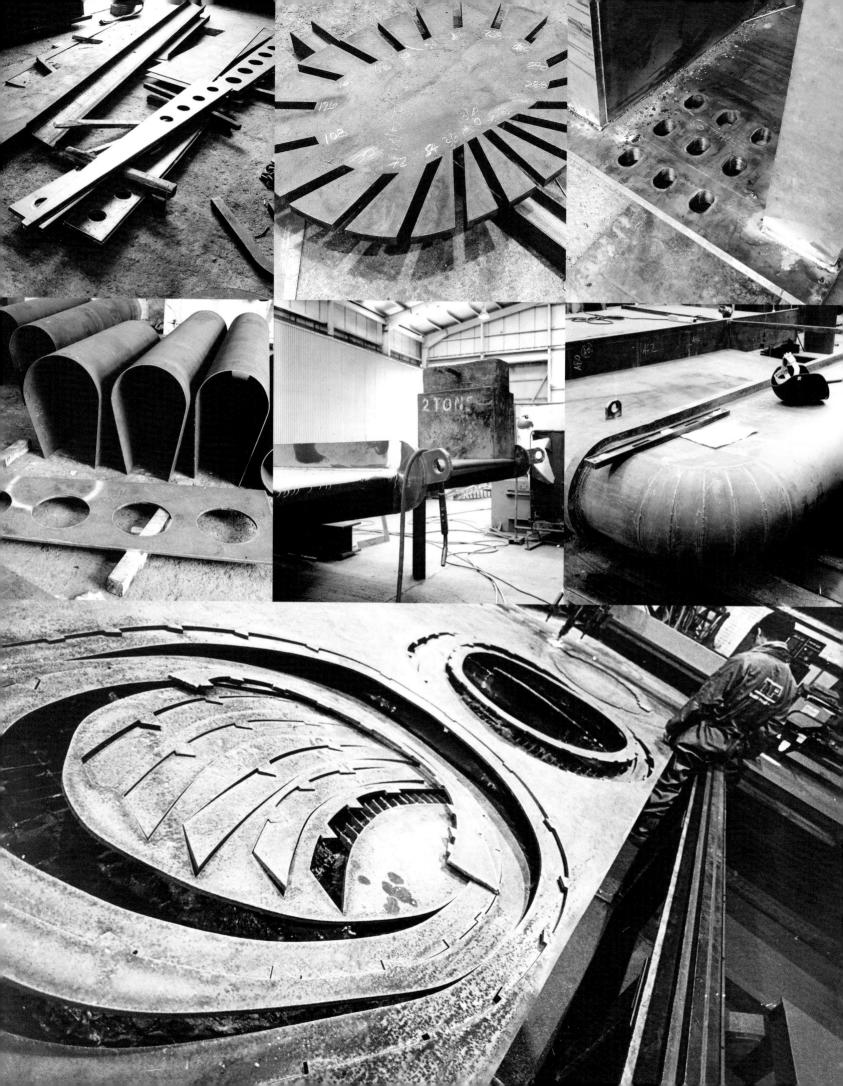

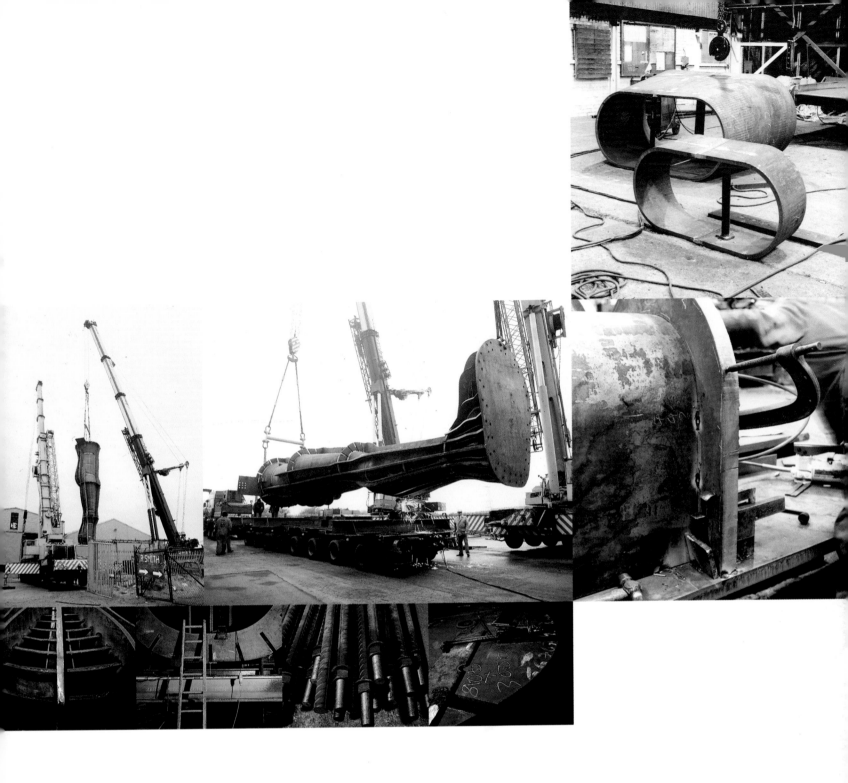
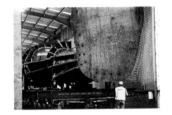

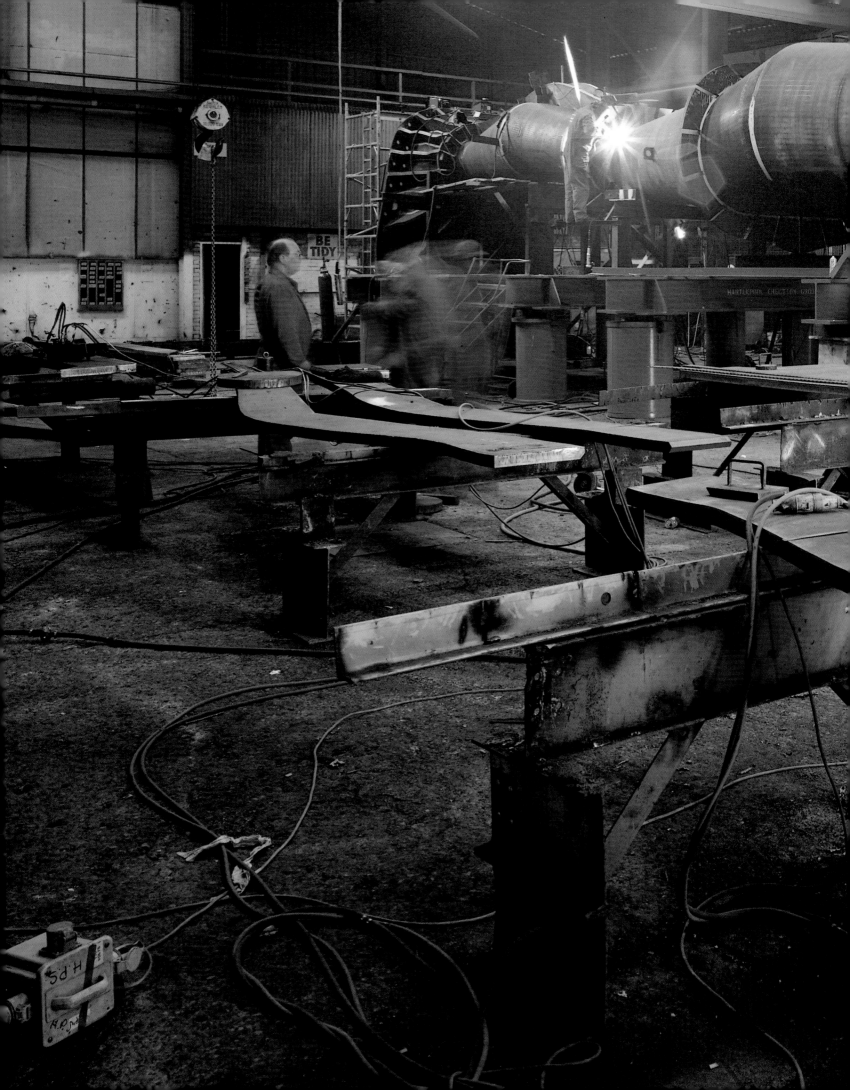

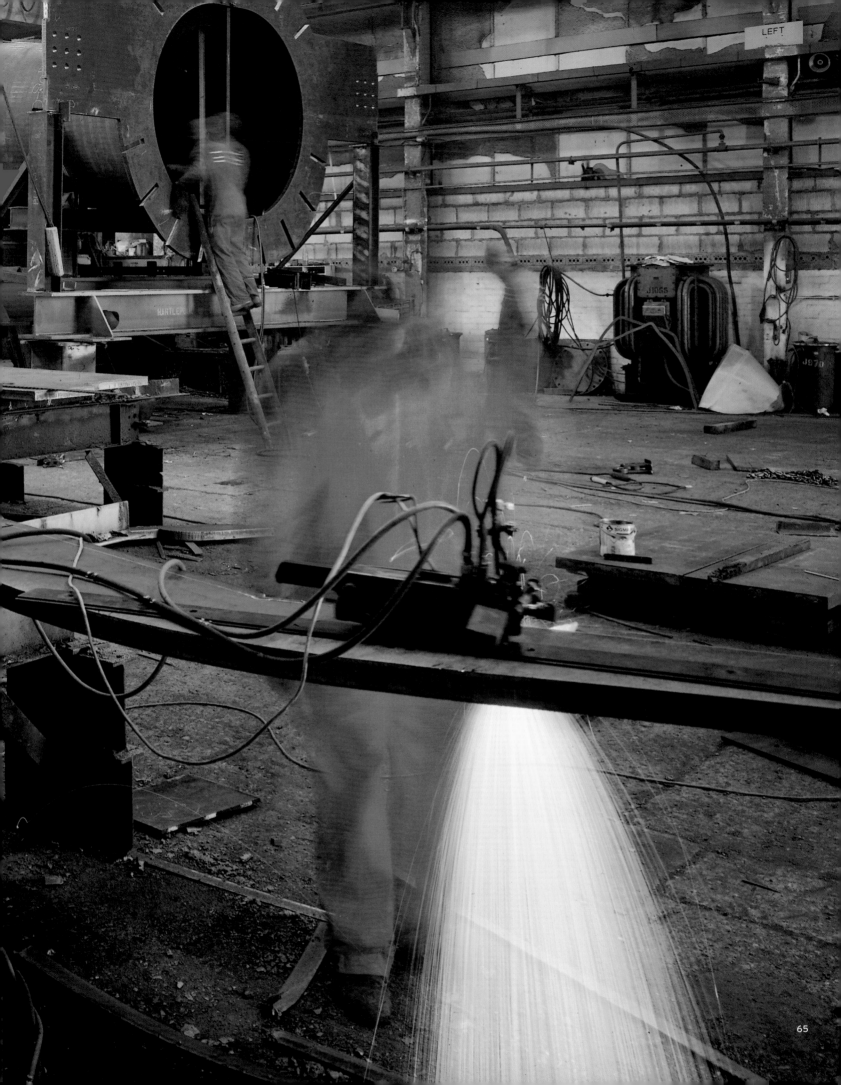

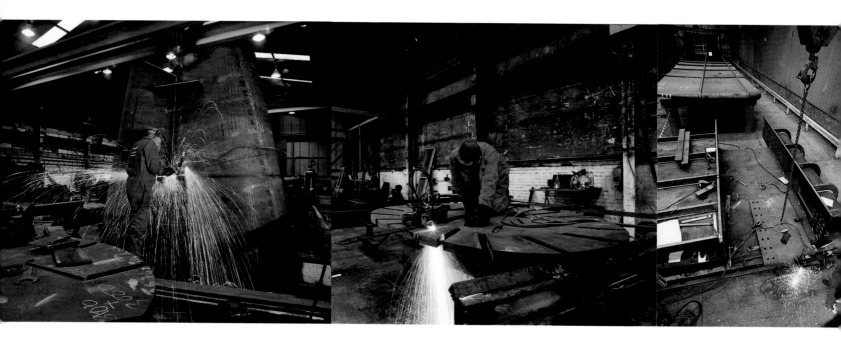

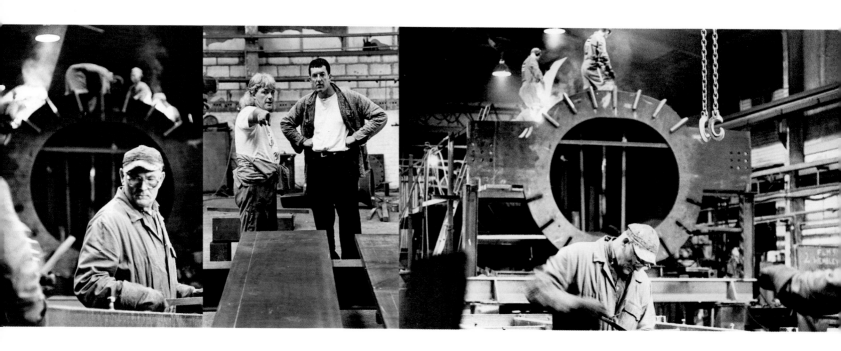

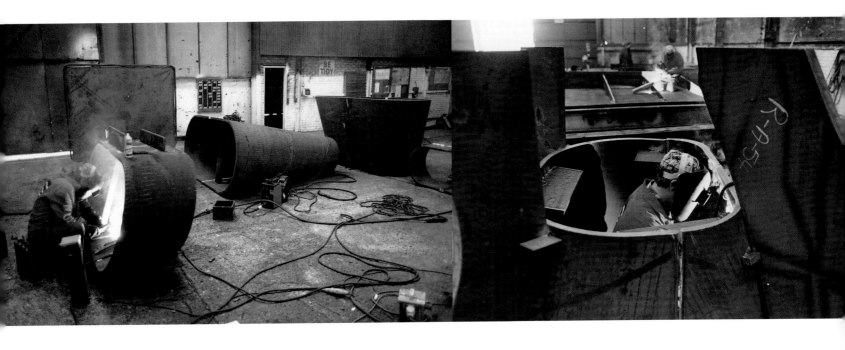

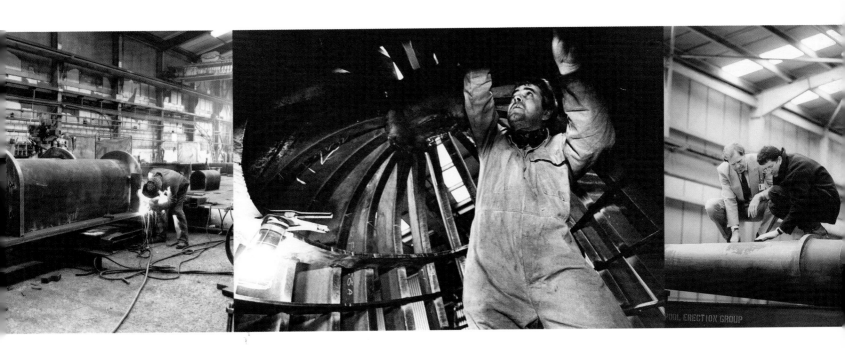

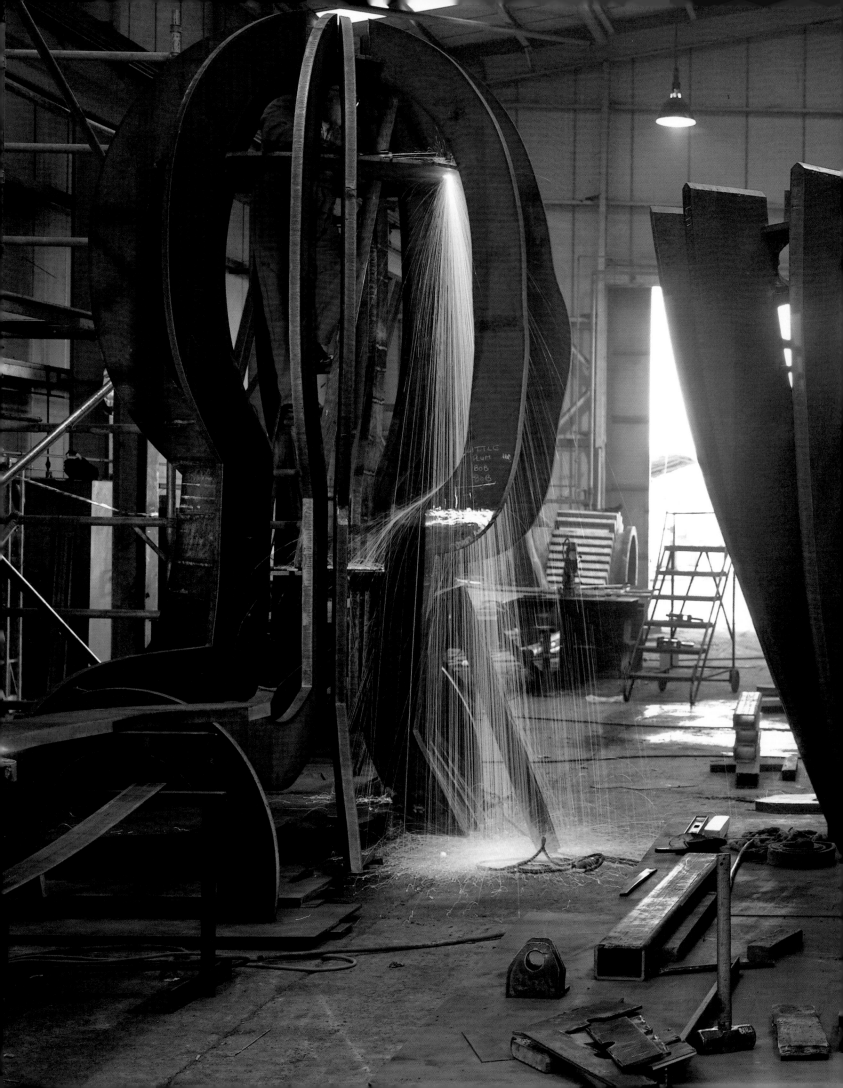

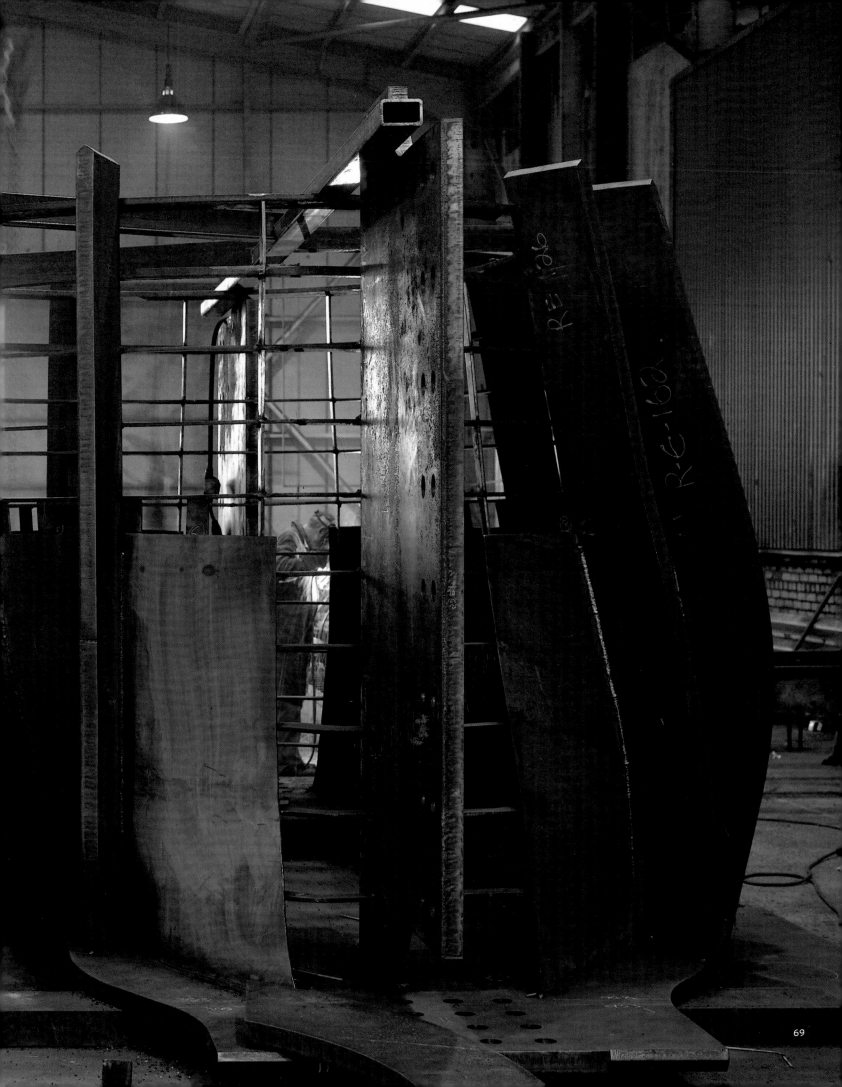

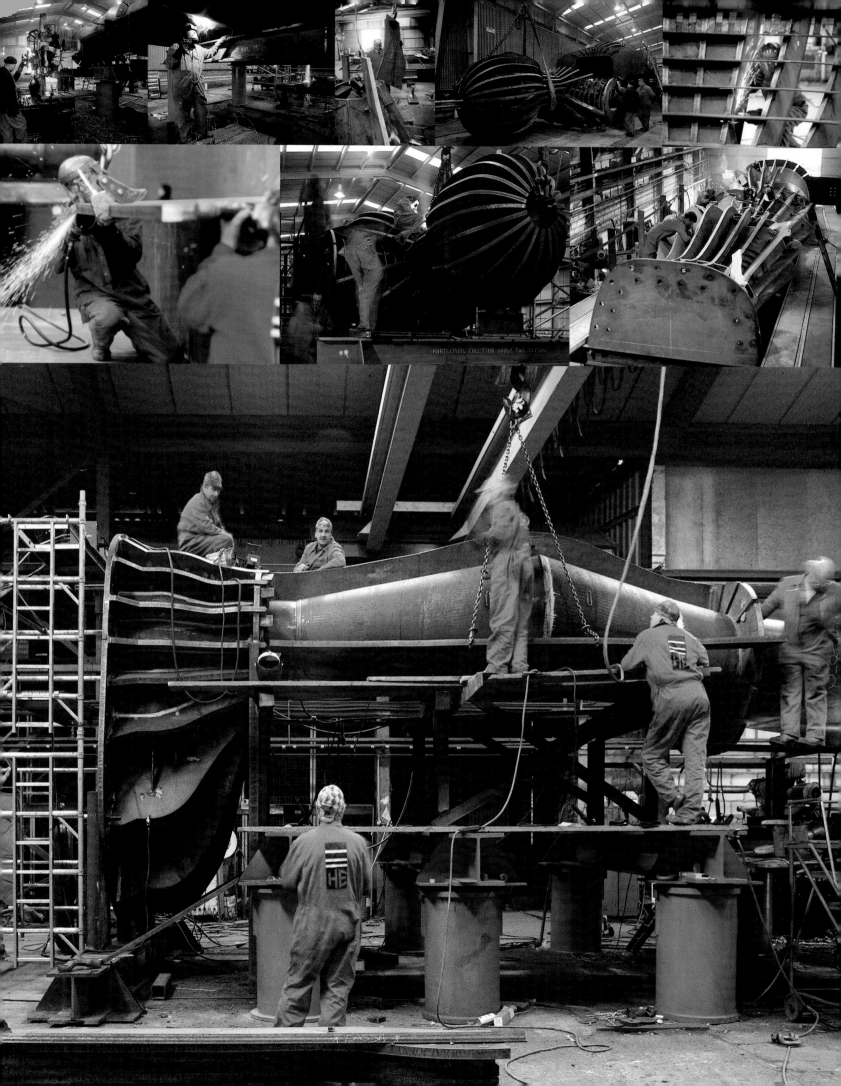

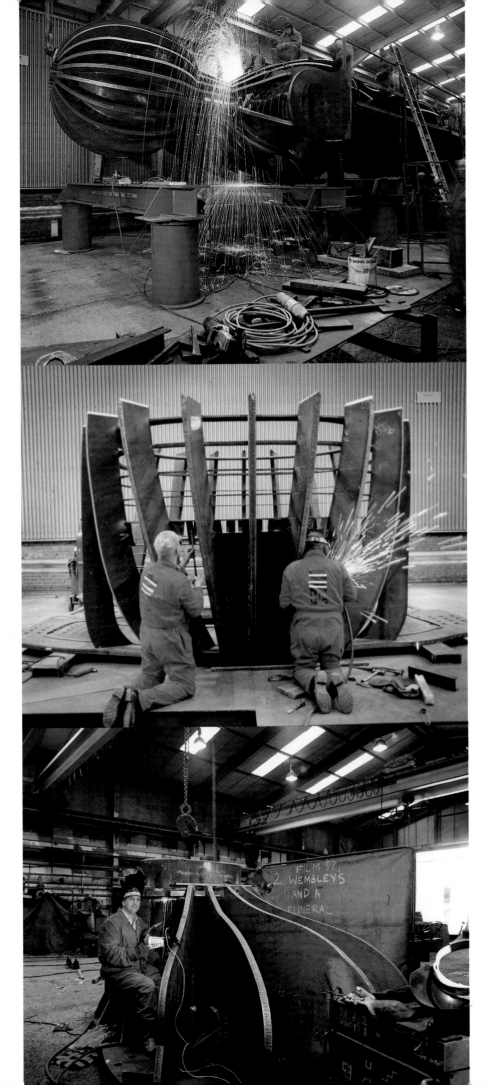

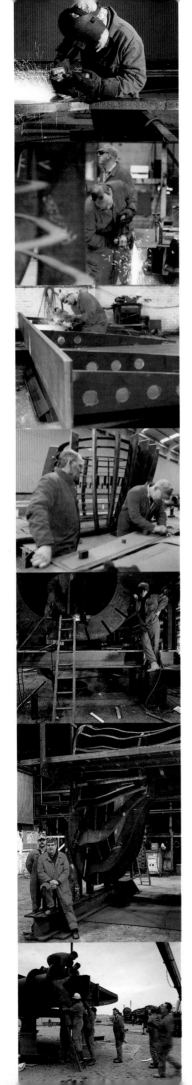

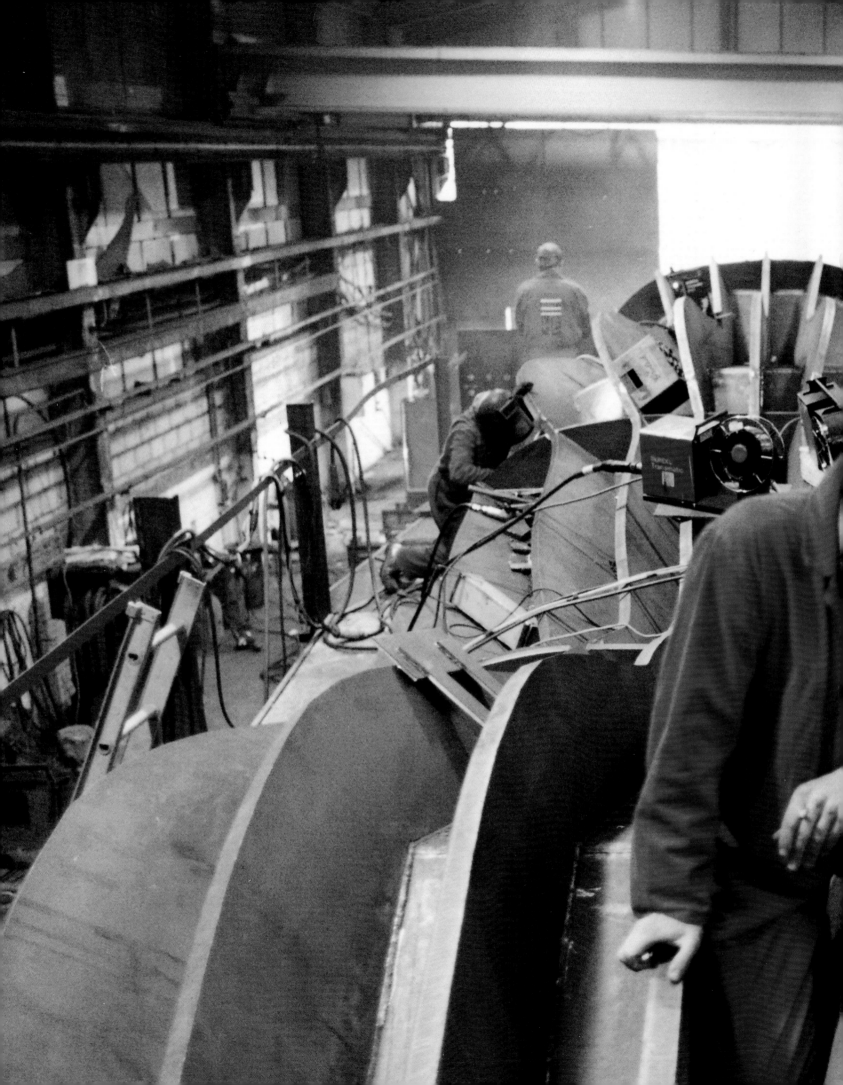

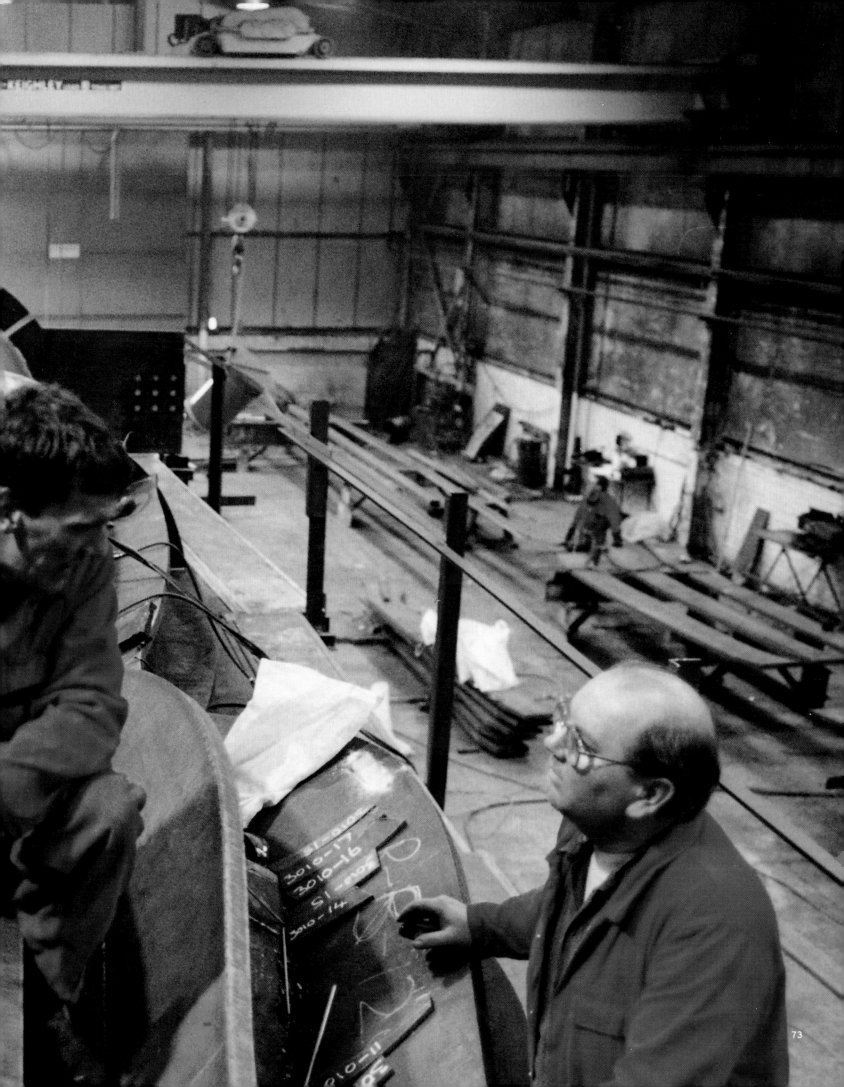

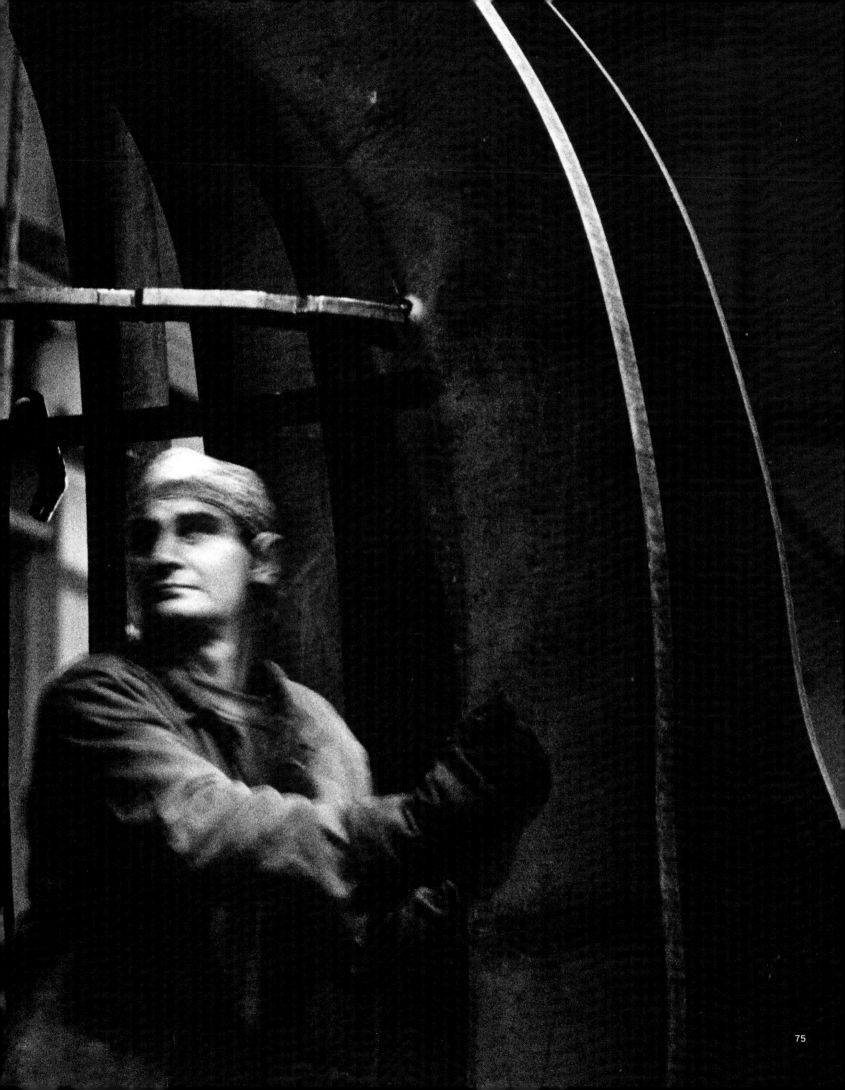

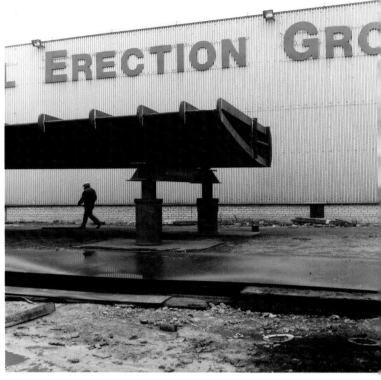

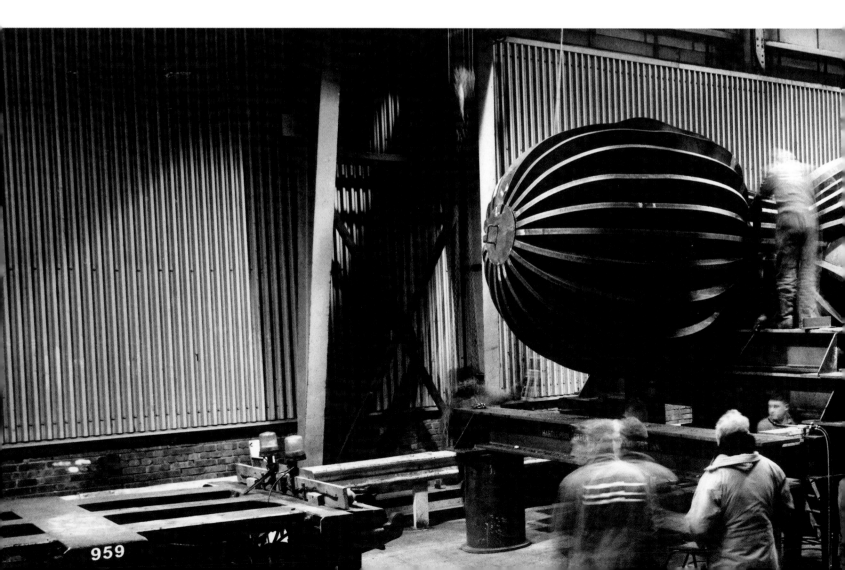

959

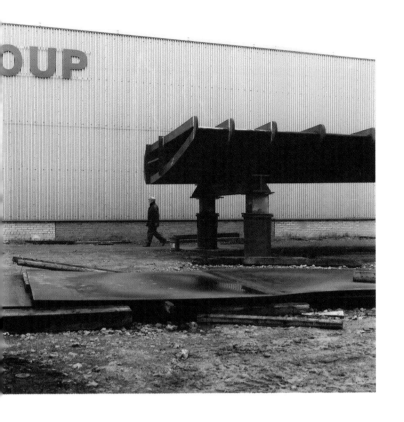
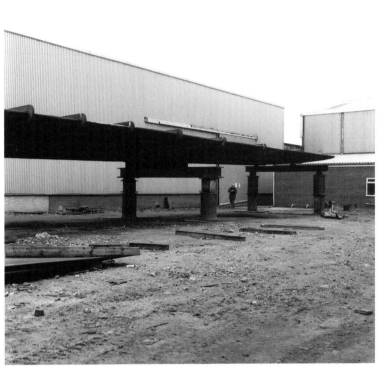
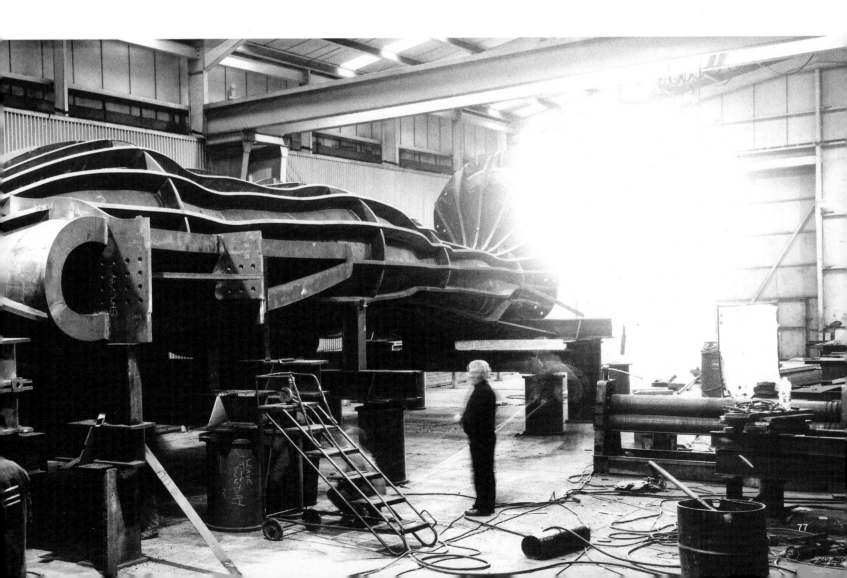

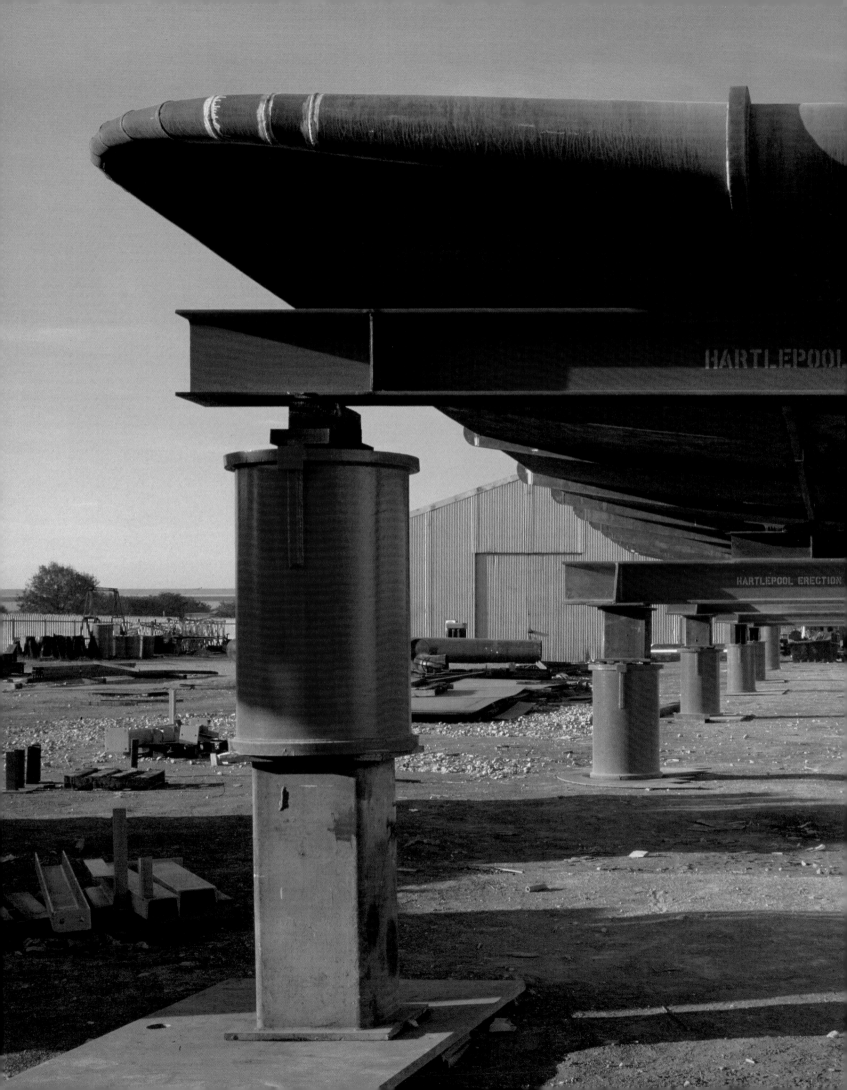

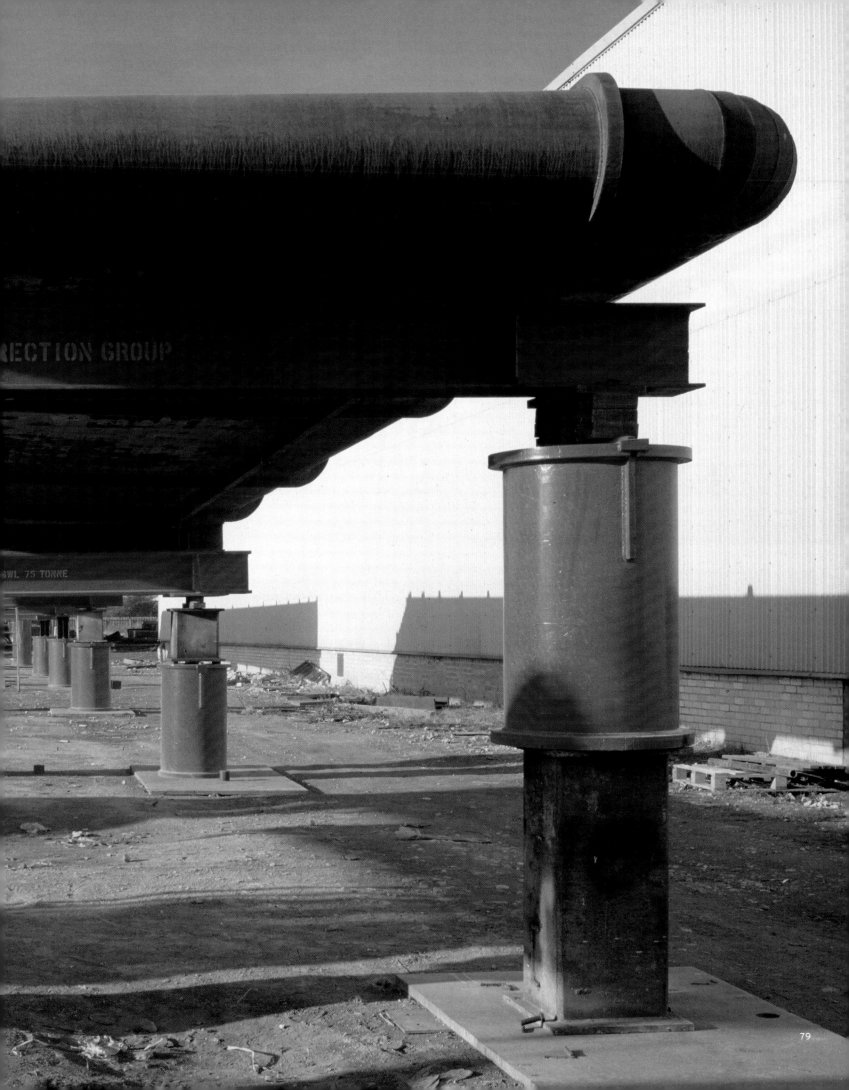

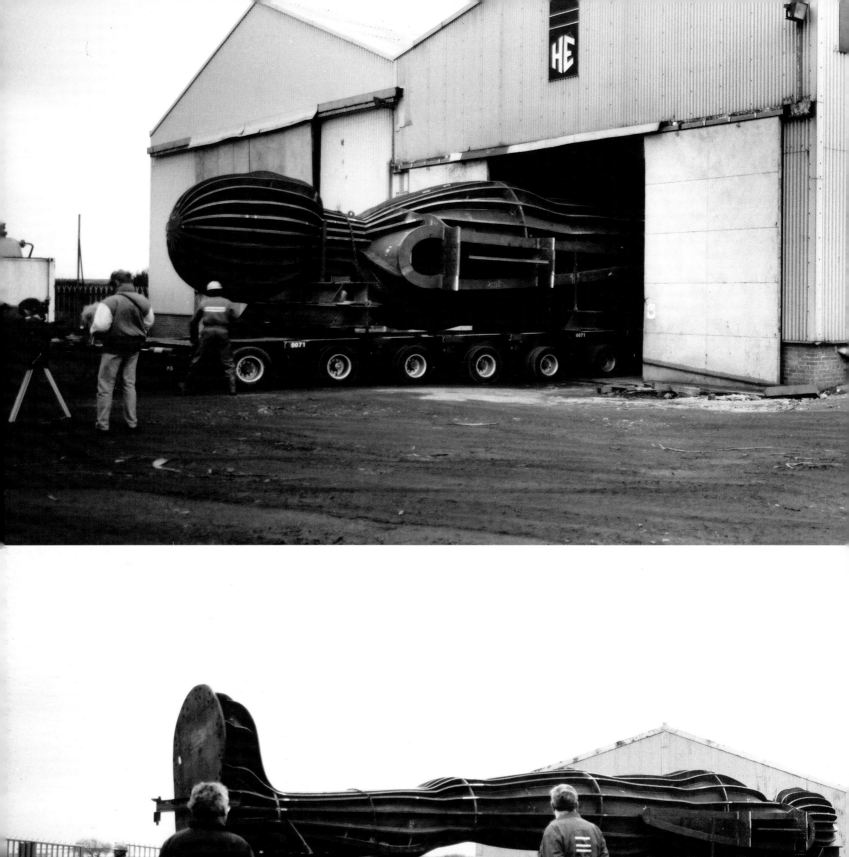
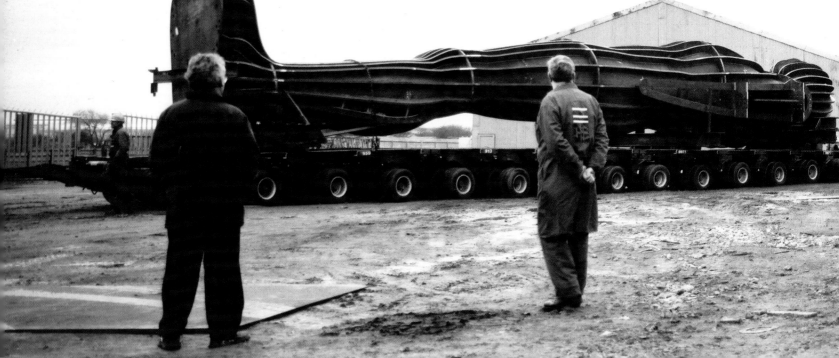

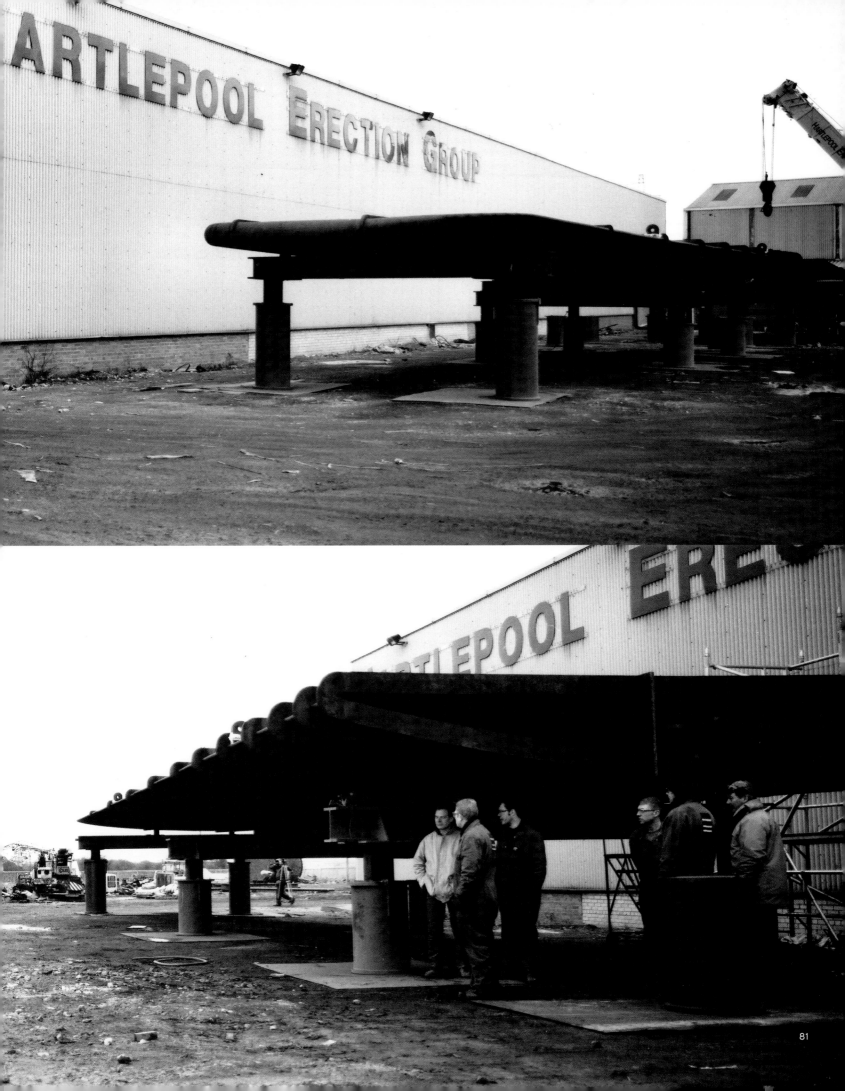

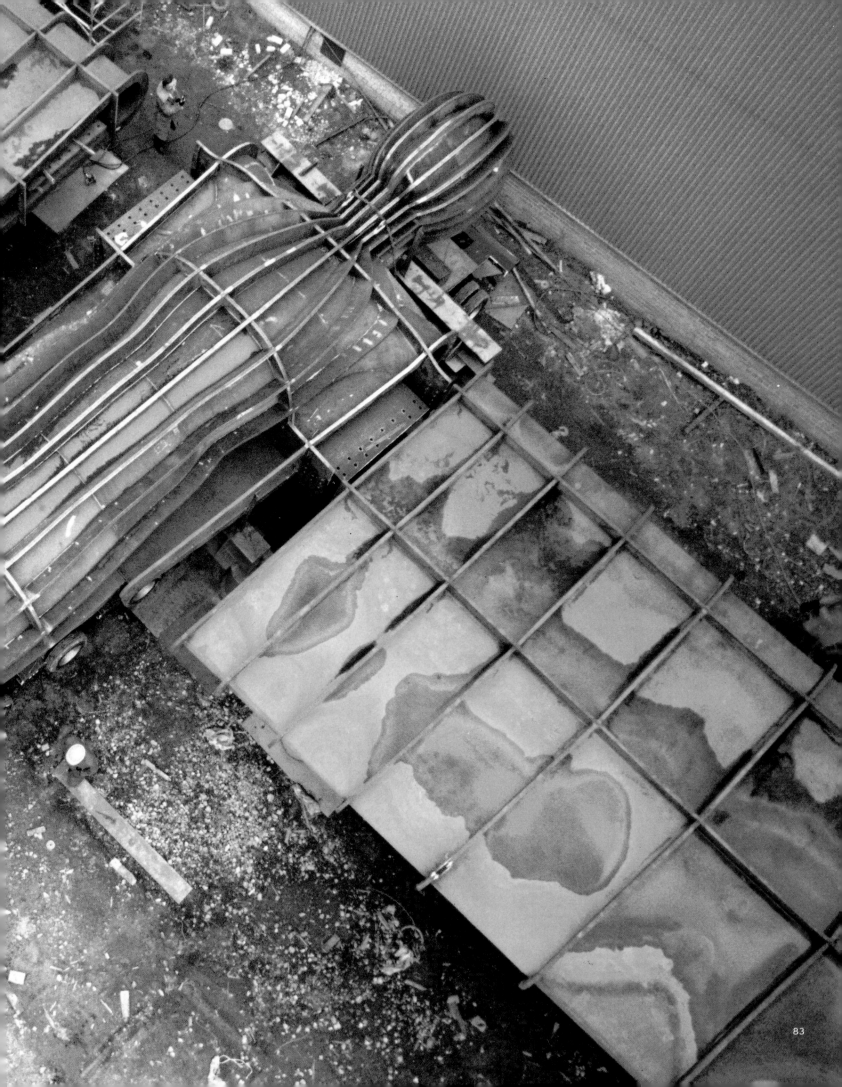

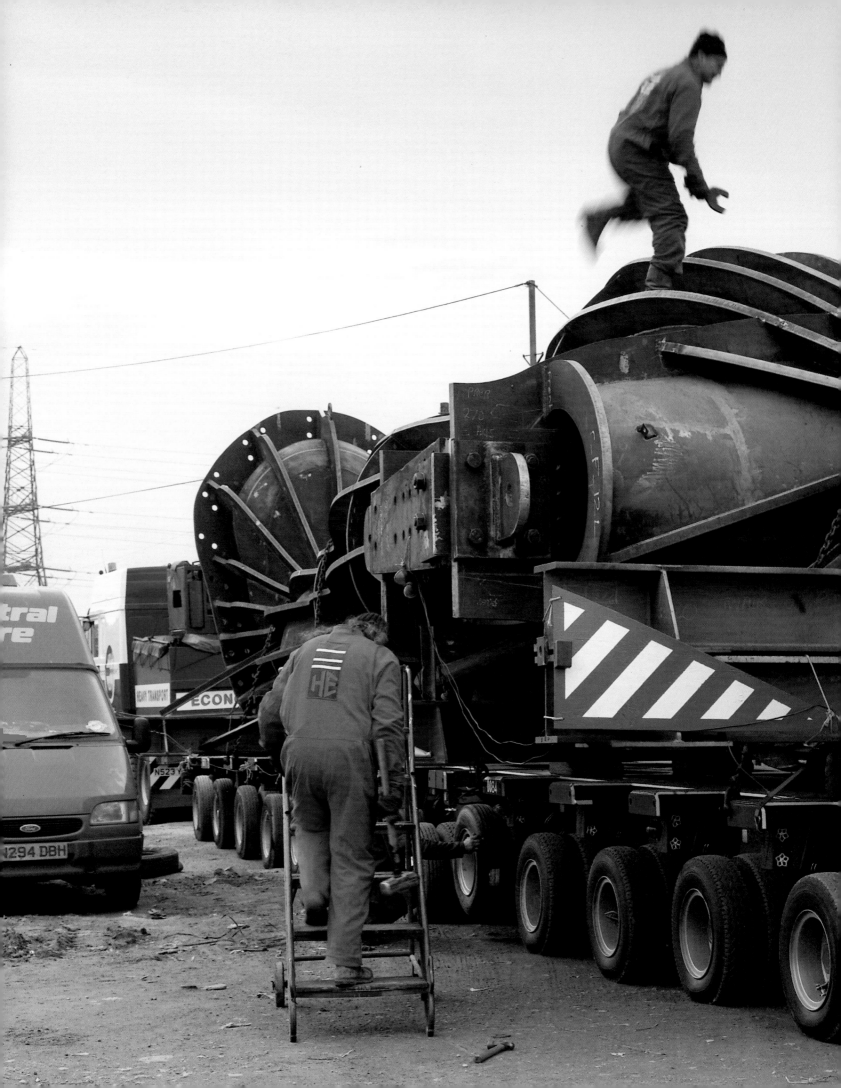

HARTLEPOOL ERECTION GROUP SWL 75 TONNE

LONG VEHICLE N523 YAJ

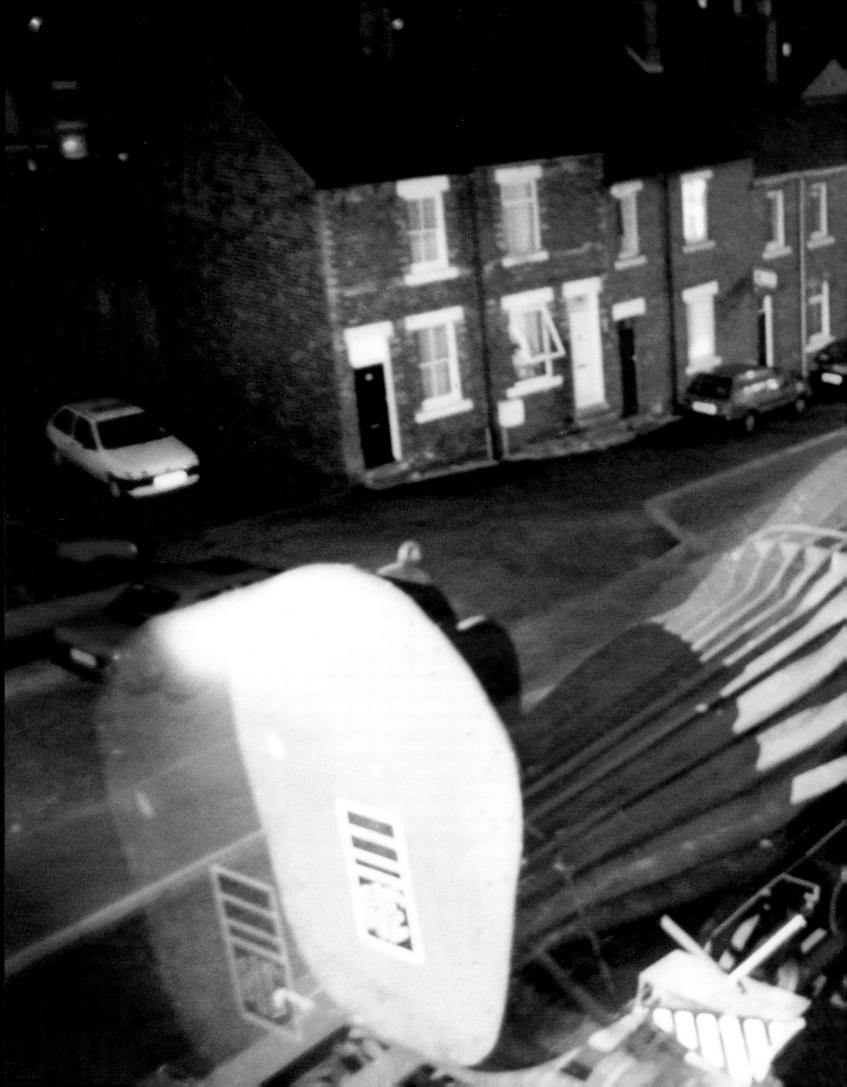

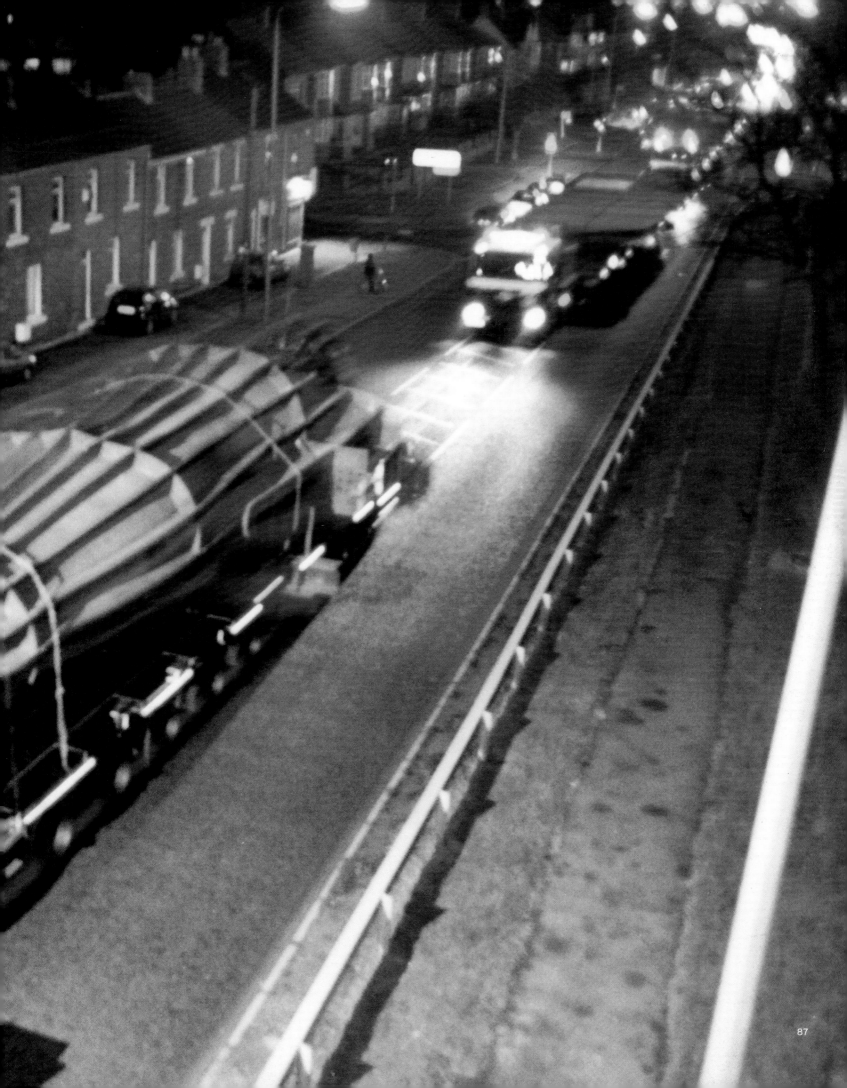

an enlightened icarus

dr stephanie brown

The biggest single sculpture in Britain, made in the closing years not only of the century but of the millennium, Antony Gormley's **Angel of the North** inevitably seems to assume the status of a bold defining moment, a confidently conclusive sculptural statement. On this level it is in a class of its own – though it also relates to a climate of fin de siècle giganticism, evident in the Millennium Dome. The Angel is certainly of its time and cannot escape such associations; but it is also a work that has evolved from an established artist's practice which, in turn, consolidates distinctive strands in late twentieth-century sculpture. Is it possible, then, to view the Angel not as a freakish case for special pleading but as an ambitious and innovative development of Gormley's existing preoccupations, and an instructive pivotal point between modernist and postmodernist sculptural idioms?

The difficulty of comparing this work with other sculptural entities is compounded by its dual identity as figurative sculpture and landmark. Large-scale landmark sculpture of a progressive type is firmly associated with non-figurative, temporary interventions such as Christo's wrapping of existing landmarks and geographical features. Because of its scale, the Angel initially invites comparisons with colossal landmark statuary such as the Rio de Janeiro Christ and the Statue of Liberty rather than with central developments in modern sculpture. The two categories are not mutually exclusive, however, and the former has been used to succinctly illuminate the latter. In 1970 the American sculptor Carl Andre formulated an account of major shifts in twentieth-century sculpture through analogy with changing perceptions of the Statue of Liberty[1] and this offers a convenient frame within which to discuss the Angel's wider context.

Unveiled in 1886, a present from France to America celebrating both their revolutions, the statue of **Liberty Enlightening the World** was a symbolic personification of an abstract idea. Andre observes that interest was originally focused on the form of this personification and on the way the sculptor Frédéric-Auguste Bartholdi modelled the copper sheets which constituted the outer skin of the statue. Attention then switched to Gustave Eiffel's cast-iron interior structure with its girders and cantilevers; and finally to the place, Bedloe's Island, where the statue was sited. Andre thus proposes the history of twentieth-century sculpture as successively concentrating on form, structure and place. Since 1970, a fourth category, 'socio-cultural space', as opposed to physical locus, has been suggested as completing this metaphorical progression.[2] All these strands are amalgamated in the Angel, and can be loosely applied in relating it to key aspects of sculpture in Britain in the second half of the twentieth century.

The form of the Angel is that of a winged figure, whose fusion of human anatomy with geometric elements links it to sculptures of the 1950s which embodied what Herbert Read

termed the 'geometry of fear', expressing art's post-war alienation from technological society. Agitated figure sculptures externalised inner states, mainly anxiety and despair, and sculptors such as Lynn Chadwick and Kenneth Armitage (ill. 1), produced hybrid forms fusing the human figure with unwieldy geometric elements – most commonly wing-like extensions. The significance of this was explicit in works entitled **Icarus** – a subject treated repeatedly by Michael Ayrton – but the Icarian reference was implicit in almost all these works.[3]

The myth of Icarus focused disillusionment with technological progress, which had promised freedom but promoted the terrible efficiencies of Nazi extermination camps and American A-bombs. Icarus was figured as modern man, irrevocably bonded to wings which betray aspiration and accentuate the vulnerability of flesh. Speaking of the Gateshead Angel's direct predecessor, **A Case for an Angel** (1990) (ill. 2), Gormley remarked: 'It isn't a kind of Icarus – you know, little bird feathers.'[4] Yet the wings of the fifties sculptures were not avian but constructed in form, and are formally and thematically closer to Gormley's angels than are the traditional bird-winged angels on funerary and war memorials.

The Gateshead Angel returns to 'the marriage of anatomy and technology', presenting it in optimistic rather than fearful terms.[5] It also echoes the awkwardness of the fifties sculptures, though in a radically different, non-expressive way, and Gormley has stated, 'My version of an angel is a rather uncomfortable mixture between aeronautics and anatomy.'[6] In this sense, the Angel, like all of Gormley's work, can be seen as an 'attempt to materialise uncertainty',[7] and he draws attention to this in mentioning the 'tension between the angel's slight vulnerability and the toughness of the metal structure that will keep it standing'.[8] Tension is also evident in the use of this particular type of structure both to describe a humanoid form **and** to ensure that it is rooted to the earth.

In the sixties, steel structures became the most important sculptural idiom – replacing the figure with abstract forms and dispensing with the plinth. Assemblages of steel plates and beams, pioneered by Anthony Caro and his followers from St Martins School of Art, demonstrated the possibility of an almost infinite extension of sculptural form. Caro was anxious to free sculpture of its totemic connotations and to introduce a greater emphasis on the horizontal. The Angel retains the former while stretching the latter to an unprecedented degree, not as a formalist demonstration of sculptural viability, but to maximise the meaning of the work. The result is a clear exposition of Gormley's central idea of a continuum between the body and spirit or consciousness, and between the earthly and heavenly realms. In this relationship the body, no matter how elevated, is finite: terminated by contact with the earth – that is, mortality. Although aspiration and infinity are traditionally represented by verticality, Gormley seems to invert this, using the horizontal

wings to indicate the expansive nature of inner space and the potential for unobstructed, infinite extension. This extreme horizontality, facilitated by a landscape setting, distinguishes the Angel from other contemporary large steel sculptures made for a particular site. There are, however, significant affinities with Richard Serra's (one of America's leading minimalist artists) geometric **Fulcrum** (1987) (ill. 3), a nineteen-metre-high unpainted work at Broadgate, London.

Although sixties sculpture exploited industrial materials and processes, it often had the industrial substance of Meccano - its parts bolted or welded into a whole which lacked a self-supporting internal structure. From the early seventies, Serra used steel not as a superficially industrial vehicle, but for properties recognised in engineering and construction, such as load-bearing capacity and strength-to-weight ratio. Serra looks to steel-frame buildings, bridges and towers as sources for his massive works on architectural sites. He uses steel mills and shipyards as his 'studio', and in 1990 he commented: 'I consider their most advanced processes and how I can interact with them. I try to extend their tool potential in relation to what I need to accomplish ... and extend both their work and my needs ... becoming an active producer within a given technology, not a manipulator or consumer of a found industrial product.'[9]

Gormley's involvement with the making of the Angel parallels these concerns, pushing them much further in respect of the complexity of the technologies and engineering involved, and the collaborative quest for solutions. Serra presents structure, materials and processes as self-evident, and this is also the case with the Angel, whose structure - an external skeleton - is integral to its appearance. What sets the Angel decisively apart from works like **Fulcrum** is the application of these concerns to a structure representing a human form.

Marginalised as a subject in the sixties and seventies, the human body was simultaneously resurrected as sculpture itself - largely as a reaction to Caroesque formalism. Gilbert and George became 'living sculptures'; performance art and shamanistic and ritual works involved the body in physically and psychologically extreme actions. The Angel appears distanced from such currents, but like all Gormley's sculpture it evolves from his own bodily presence. John Hutchinson has observed that 'There is a shamanic aspect to the ritual of self-entombment that is the first step in the making of Gormley's body cases.'[10] A sensation akin to rigor mortis must also accompany the hardening of the plaster on Gormley's body and limbs, but this intense ritual is not performed for an audience, but is fused to the sculpture itself.

A body cast made in this way was the starting point for the Angel, and though not physically incorporated in the work, it provided the data for technology to exactly reproduce its contours in the figure's ribbed structure. This confirms the

centrality of the body cast to Gormley's practice. It was his use of this form that brought him to prominence in the 1980s, when postmodernist pluralism in art saw a return to imagery in sculpture. Widely recognised as revitalising the tradition of figure sculpture, Gormley shared his anthropocentric preoccupations with other proponents of 'New British Sculpture',[11] notably Alison Wilding, Tony Cragg and Richard Deacon.

Deacon uses industrial materials and processes, corrugated iron, galvanised steel, studded with highly visible screws and rivets. This superficially recalls sixties sculpture, but Deacon applies this abstract formalist vocabulary to allusive biomorphic forms. These suggest internal and sensory organs held under tension - an impression increased by exaggerating their engineered finish. Situated on a bridge abutment at Gateshead, the proximity of Deacon's **Once Upon a Time** (1990) (ill. 4), to the Angel accentuates their similarities, particularly in the successive lines of planar projections which describe swelling biomorphic forms - the 'fins' on the Deacon piece and the Angel's ribs.

These ribs interrupt the Angel's spare, taut appearance with an insistent grid - an amplified variation on the prominent grids formed by soldered joints on Gormley's lead figures. In both cases these recall the latticed lines used by Henry Moore to stress volume and internal pressure in many of his figure drawings. Though the Angel also has clear affinities with Moore's simplified organic sculptures, its formal characteristics equally recall the earlier constructivist heads and figures by Pevsner and Gabo (ill. 5). The Angel's streamlined steel form, strictly organised by the regularity of the ribs, faceless, sexless, and equipped with vast rectilinear wings, develops what may be referred to as a 'mechanomorphic'[12] language suited to its site and scale.

Large publicly sited sculpture began proliferating in the 1980s in both non-representational and figurative forms. The latter suffer most from inappropriate exaggeration of scale, and those on a colossal scale would appear inimical to serious sculptors like Gormley. The seeming redundancy of this idiom is underlined by works from the 1980s by sculptors including Vincent Woropay and Igor Mitoraj, whose gigantic stone body fragments look as if they once belonged to statues of awesome proportions. These Ozymandian heads, hands and feet evoke the magnitude and certainty of a vanished past and the dismemberment of a monolithic whole, impossible to reassemble and unimaginable to reproduce.

Colossal fragments are literal expressions of the loss of a sense of wholeness rooted in the past,[13] but this concern - in a radically different, non-anthropocentric variant - has also prompted a highly significant development in late twentieth-century sculpture. Since the 1970s, increasing numbers of

artists have worked in the landscape, reviving values, processes and forms from the prehistoric past, and developing a language in which sculpture is synonymous with place. Frequent reference is made to megalithic monuments which are located at sacred sites, related to geographical features and astronomical movements, positioned in a living cosmology. Contemporary allusions to prehistoric forms and rituals are reminders of the symbiotic relationship between man and nature – the holistic basis of neolithic and Bronze Age life. From discreet interventions made by artists such as Andy Goldsworthy and Richard Long to the largest earthworks, this approach uses materials found on site to make sculpture integrated with nature and landscape rather than imposed upon it.

The environmental and spiritual concerns implicit in these works promote ideas of the earth as a sacred source of spiritual renewal rather than an exploitable source of profitable raw materials. Unsurprisingly, the 'healing' connotations of this approach have recommended it to projects reclaiming derelict industrial land. Works influenced by burial mounds, standing stones and other prehistoric forms are well suited to the scale and location of such sites. Gormley's Angel, on the site of a former colliery, belongs to this type of project but departs from the self-effacing, integrating approach epitomised by works such as Richard Cole's nearby **Windy Nook** (1986) in East Gateshead. This transformed a colliery slagheap into something resembling a neolithic walled earthwork, so well integrated with the landscape that it is often assumed to be of genuinely ancient origin.

In contrast, the Angel's imposing anthropomorphic structure rises above the landscape in what may seem a regressive echo of man's mastery of nature.[14] However, Gormley also puts restoration of wholeness at the centre of his philosophy: 'Nature is within us. We are sick when we do not feel it. The sickness of feeling separate from the world is what is killing it.'[15] Rather than opposing ideas of wholeness and connection, the Angel develops these values in a form that combines idealism with a realistic response to place and socio-cultural considerations. Gormley has observed that 'For me there are two kinds of culture, one that is an expression of the connection of man with the physical world that surrounds him, and the other is familiar to us all as Western rationalisation that separates us from the physical world ... one leads to materialism and the other to magic and freedom. My job in a broken but self-conscious world is to reaffirm connection.'[16]

Like so many contemporary sculptors, Gormley contrasts the holistic culture of ancient non-Western and prehistoric peoples with the spiritually and environmentally toxic culture of the materialist West. But however many works evoking cairns or standing stones we now make, we cannot make **ourselves**

prehistoric, and as part of his project to 'reaffirm connection', Gormley's Angel recognises the need to establish a point of contact between apparently irreconcilable cultural values.

There is an acknowledgement of prehistoric prototypes in the Angel's hilltop site, which Gormley has pronounced important for its 'feeling of being a megalithic mound.'[17] Such mounds were sacred burial sites, and Gormley introduces an appropriate allusion to mortality – shunned in materialist culture but an essential point of reference in a conscious and connected existence. Beneath the mound, the Angel's foundations are sunk deep into the subterranean realm of mining – which underpinned the region's industrial past – while its highly visible structure proclaims the continuation of the region's other great traditional industries, iron, steel and engineering. One industry dies, the other reinvents itself.

Before its industrial renown, the North-East was already celebrated as 'the cradle of English Christianity'. The Angel is the most prominent structure between Durham Cathedral and the Tyne Bridge. It relates to both, and is central to a historical continuum embracing the spiritual and the material. But its relationship to socio-cultural space also extends to the prehistoric past, and not just through the allusion to megalithic mounds. The North-East has some of Britain's most notable neolithic rock art, carved into the landscape itself – 'the earliest site-specific art in a region notable for promoting such initiatives'.[18] The Angel is the most recent and the most ambitious of these initiatives, and though it was made 4,000 years after the rock art, its message is remarkably similar in expressing ideas of infinity, death and rebirth, regeneration, the survival of the spirit.

Many landmarks of the North-East's recent past – the colliery headgear and slagheaps – have been levelled; but the landmarks of a prehistoric culture, made thousands of years ago, still endure, though they are now threatened by atmospheric pollution. If the Angel survives its projected century, its relationship with this prehistoric art may well have been lost. The suggested cluster of connections with modernist and postmodernist impulses and idioms, advanced to relate the work to a wider sculptural context, will doubtless prove strictly provisional. Above all, the Angel's meaning will alter as its surroundings continue to be transformed.

Ten kilometres south of the Angel, on a ridge above Hetton-le-Hole (ill. 6), a row of recently erected wind turbines fifty metres high are one-and-a-half times taller. Their two blades, rather than the more familiar three, emphasise their affinities with the Angel. The turbines harvest wind energy, and their elegance derives from the integration of the effects of natural forces into their design. This sets them apart from the electricity pylons which are their close neighbours, and from the vanished pits which depended on exploitation of non-sustainable energy.

Despite their scale, the wind turbines introduce a technology which sits more lightly on the land and visibly interacts with nature, rather than attempting to subdue and exploit it.

Arrogance made Icarus underestimate the power of the sun which melted his wings and caused his downfall. Gormley's Angel can be seen as a metaphor for man as an enlightened Icarus. Its glider-like wings relate to a lightweight technology which ensures high performance with low energy expenditure - the synergy possible in combining the human body with constructed materials. The hubris of technological man tragically defaced the twentieth century but on the brink of the next, the Angel stands as an eloquent reminder of the potential for an equilibrium between the material and the spiritual concerns in a post-industrial age.

6 1

2

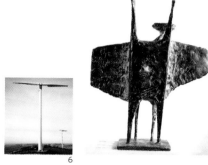

3

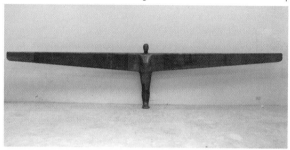

4

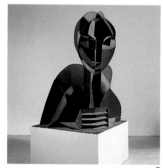

5

1 Phyllis Tuchman, 'An interview with Carl Andre', Artforum, vol. 8, no. 6, June 1970, p. 55.

2 Lynne Cooke, 'Re-Definition: The "New British Sculpture" of the Eighties', Starlit Waters: British Sculpture, An International Art 1968-1988, Tate Gallery Liverpool, 1988, p. 48.

3 The theme was equally widespread in Europe, including Icarus sculptures by Wander Bertoni (1953, Italy) and Jaap Mooy (c. 1958, Netherlands), and the French sculptor César's Homme de Draguignan (1957) and Homme de Saint-Denis (1958) where figures are dwarfed by massive rectangular wings, divided into geometric sections.

4 John Hutchinson et al., Antony Gormley, Phaidon, 1995, p. 137.

5 Ibid. Gormley's words, used in connection with A Case for an Angel, although the technological dimension here is far less explicit than in the Angel of the North.

6 Ibid., p. 25.

7 Ibid., p. 61.

8 Statement by Gormley, Gateshead Metropolitan Borough Council leaflet, February 1995.

9 Extract from lecture given by Serra at Yale University, January 1990, in Charles Harrison and Paul Wood (eds), Art In Theory 1900-1990: An Anthology of Changing Ideas, 1992, pp. 1124-1125.

10 Hutchinson et al., op. cit., p. 56.

11 Term applied to work by a loosely connected group of sculptors who first made an impact in the early 1980s in exhibitions such as 'Objects and Sculpture' (ICA/Arnolfini, 1981) and 'Objects and Figures: Recent Developments in British Sculpture' (Fruitmarket Gallery, Edinburgh, 1962). Other associated figures include Anish Kapoor and Shirazeh Houshiary.

12 'Mechanomorph' is the term used by Lawrence Alloway to describe American artist Ernest Trova's sculpture made in the 1960s: highly polished metal figures, which, like Gormley's Angel, are tautly curved, sexless and featureless. Lacking arms, Trova's standardised figures are differentiated mainly by technological apparatus fused to their bodies. In contrast, technology and machinery were intrinsic to the abstracted formal language of the Russian Constructivists Naum Gabo and Antoine Pevsner. The rhythmic disposition of planar projections in the Angel's ribs and their introduction of spatial depth across the surface of the figure echo Gabo's Constructed Head no. 2 (metal, 1916) and Pevsner's Torso (Construction) (copper and plastic, 1924-6). There are even more striking formal affinities between the Angel and the work of a later Russian sculptor, Joannis Avramidis, whose Large Figure (polished bronze, 1958) reduces the figure to a baluster-like form whose curving outline is accentuated by regular horizontal and vertical grooves. This precise grid appears in relief form and is even more pronounced on Avramidis's Head Structure (resin on aluminium, 1959).

13 For Linda Nochlin, body fragments of any scale, as they appear in art from the end of the eighteenth century, carry this meaning and can be read as 'metaphors of modernity' (L. Nochlin, The Body In Pieces: The Fragment as a metaphor of modernity, 1994). Gormley's Angel, in restoring and magnifying a sense of wholeness, throws off the despair, pessimism and nostalgia associated with the fragment.

14 No such structures appear to have existed in prehistoric Britain, apart from the discreditable, and possibly apocryphal, colossal wicker figures used by the Druids to enclose and burn mass live sacrifices (memorably explored in the film The Wicker Man, 1973). If these existed they were temporary, and surviving gigantic figures at Cerne Abbas and Wilmington were cut into the surface of the land, not raised above it.

15 Hutchinson et al., op. cit., p. 124.

16 Ibid., p. 120.

17 GMBC leaflet, February 1995.

18 Stephanie Brown, Northern Rock Art: Prehistoric Carvings and Contemporary Artists, Durham Art Gallery, 1996, p. 1.

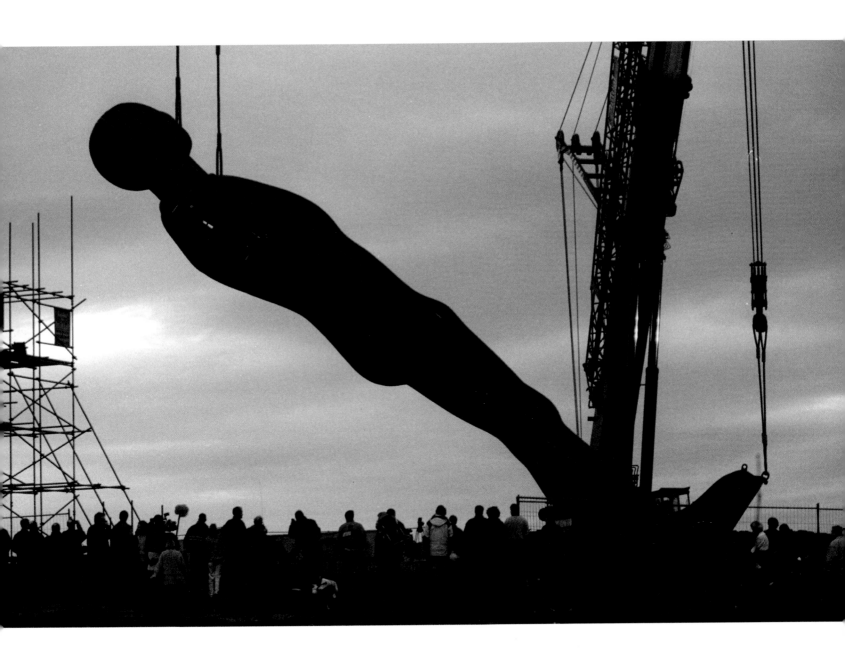

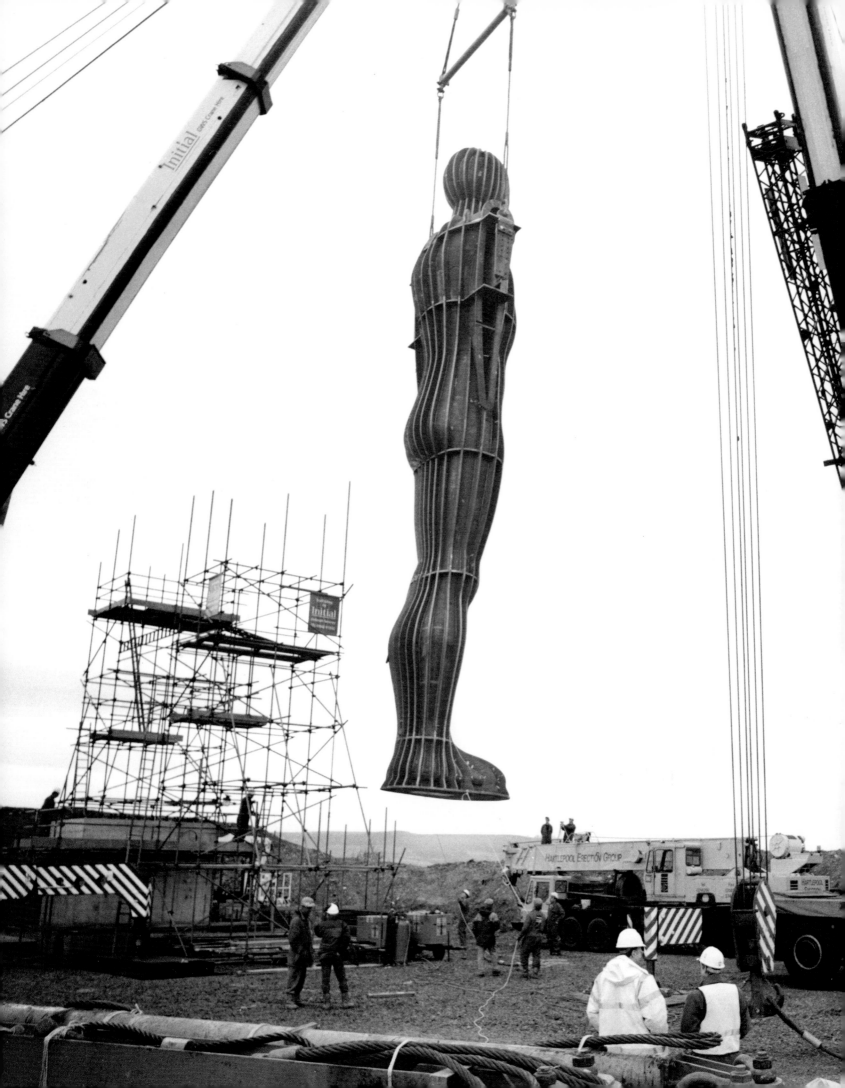

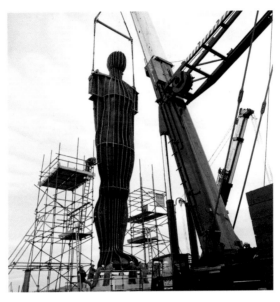

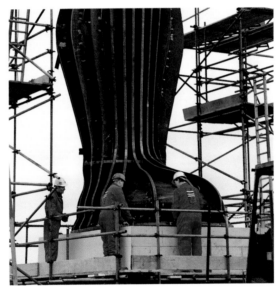

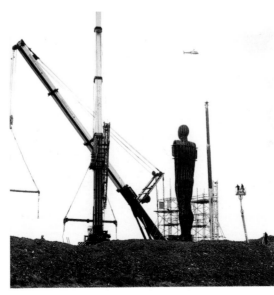

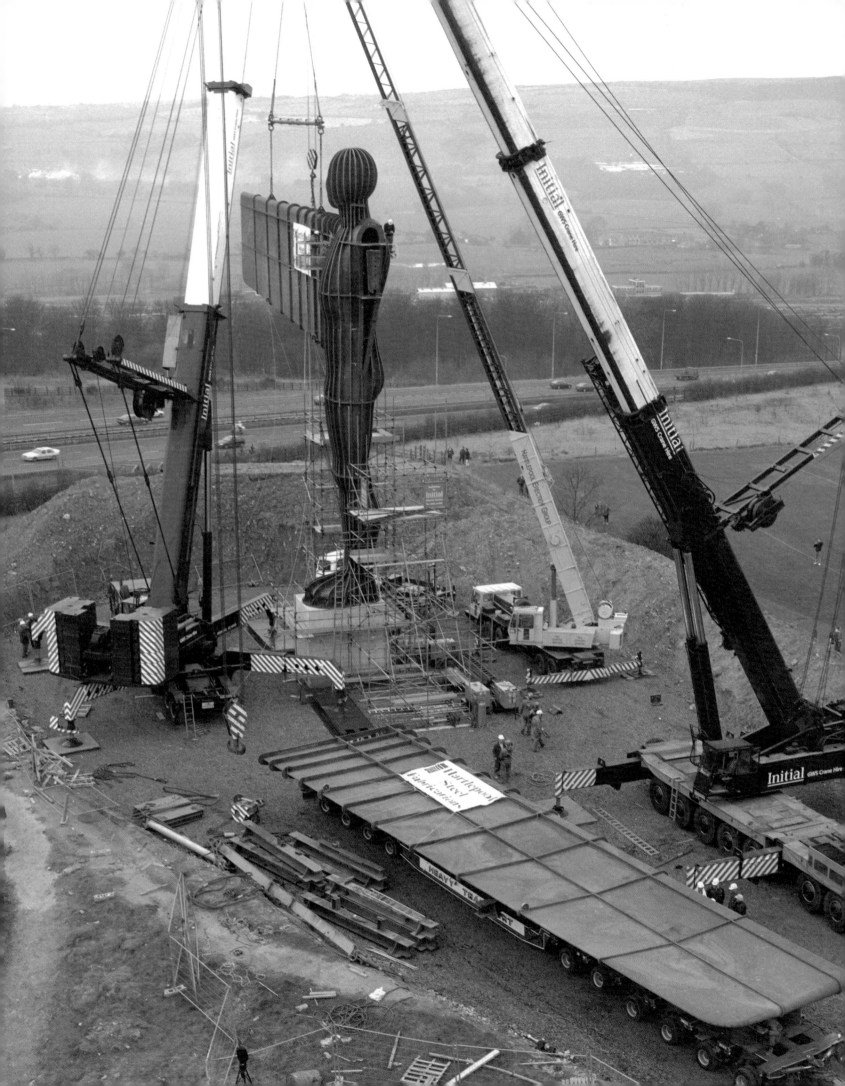

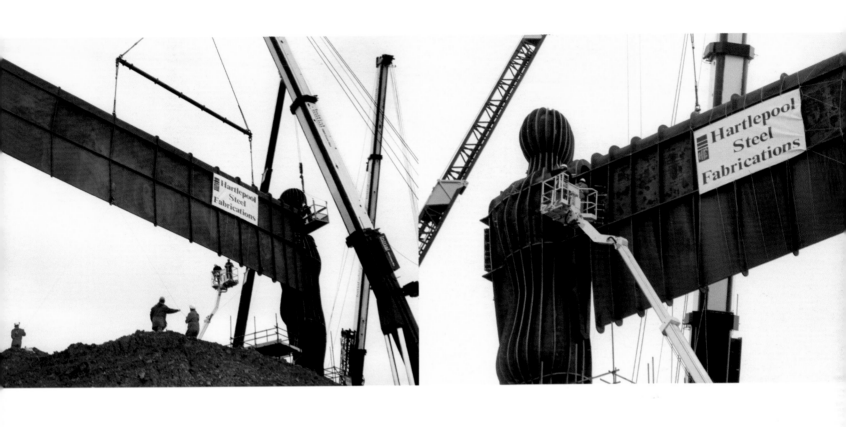

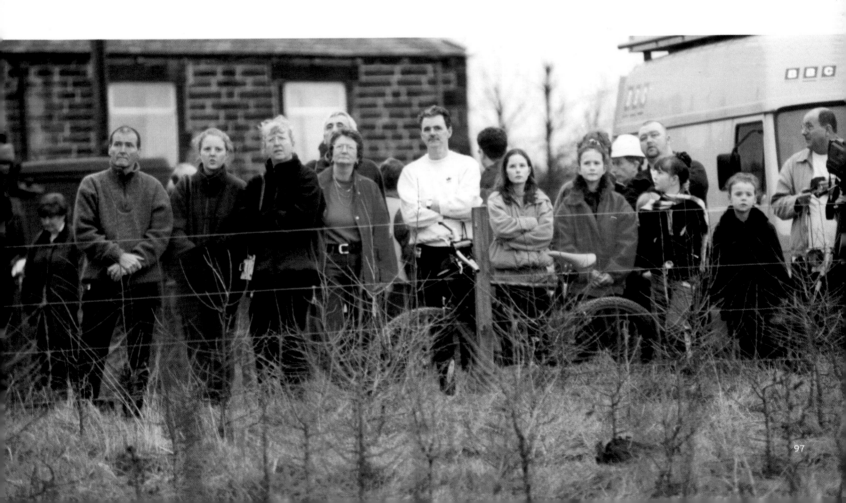

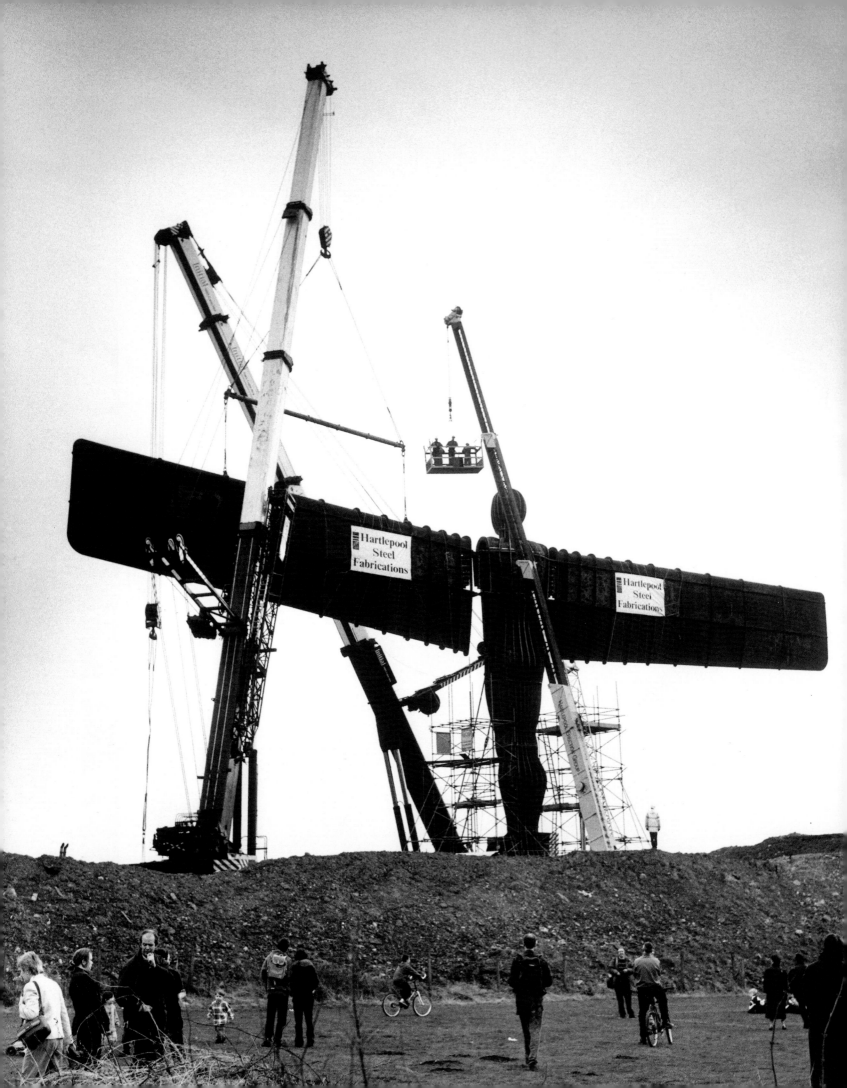

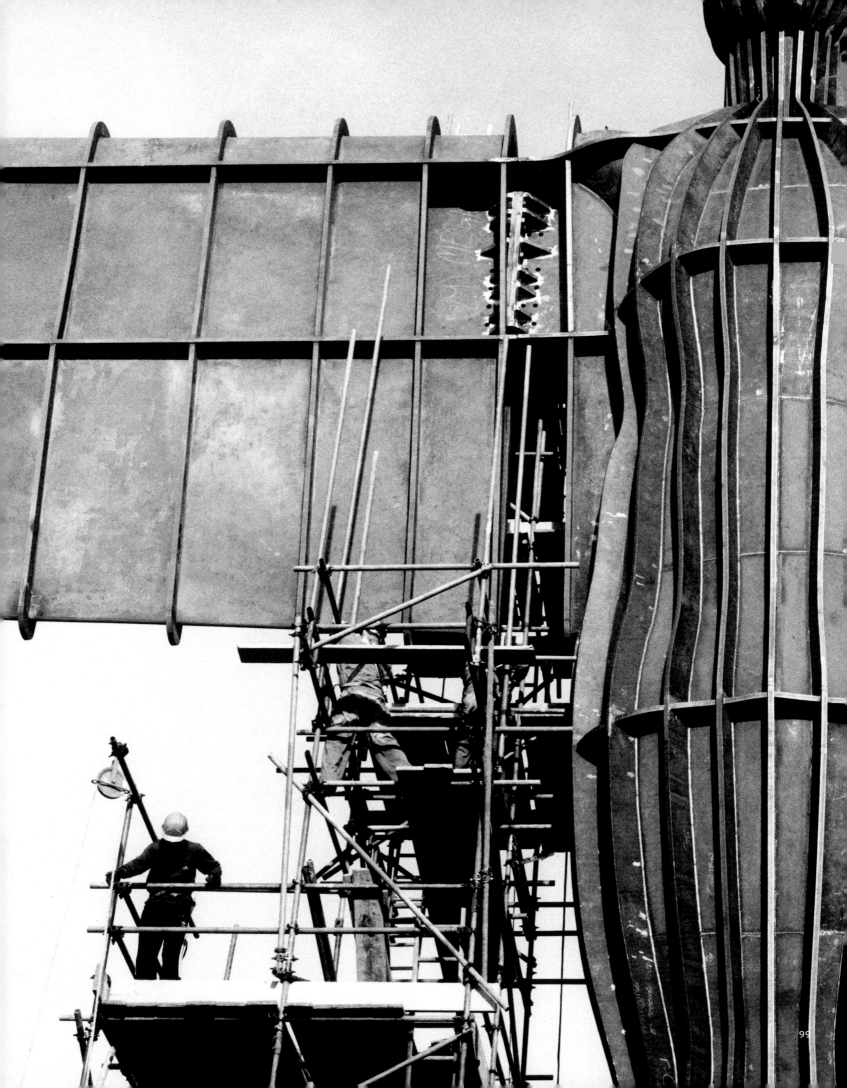

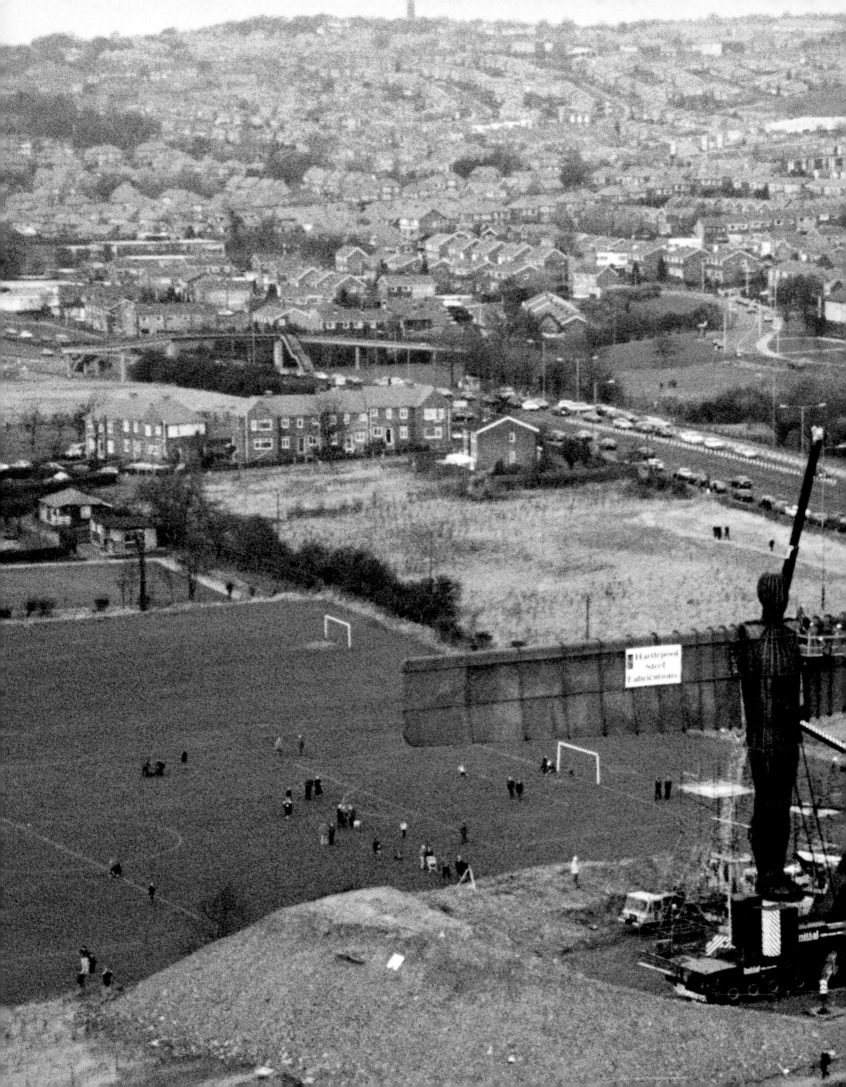

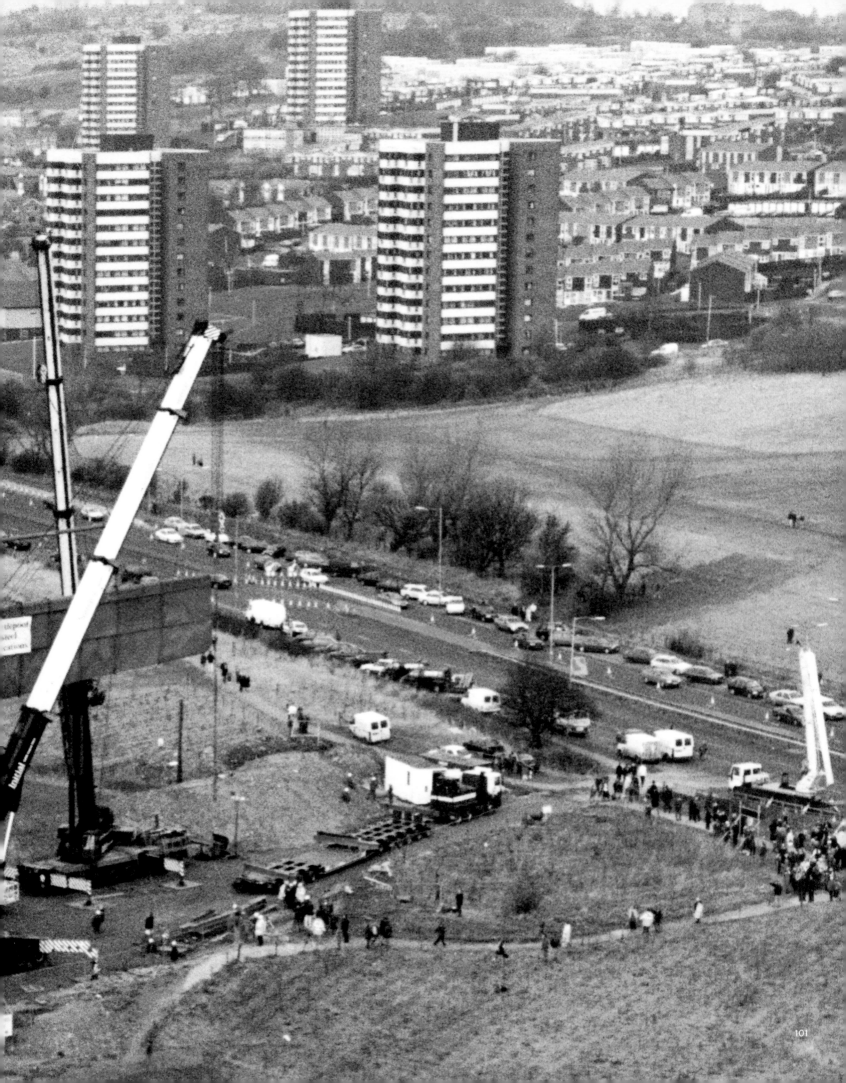

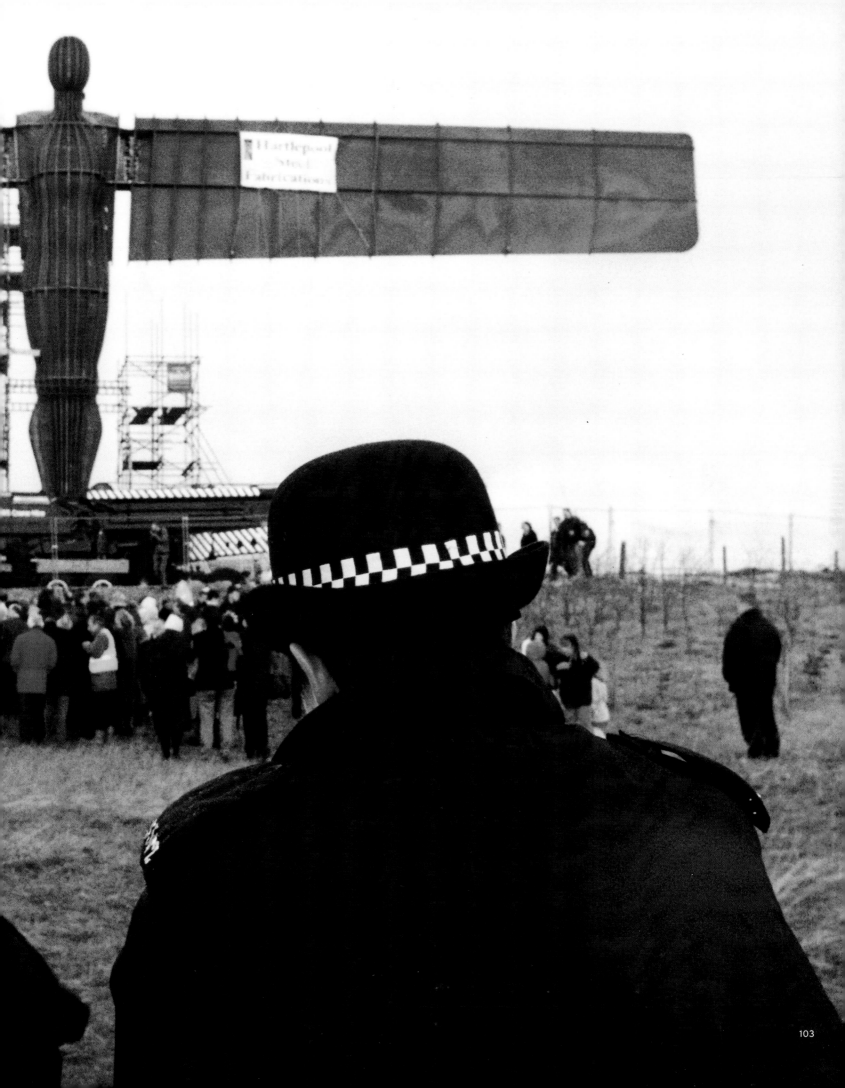

angels

gail-nina anderson

Antony Gormley's **Angel of the North** in Gateshead undoubtedly appears to belong to well established traditions of large monumental sculpture; yet it is paradoxically easier to describe in terms of the expected generic criteria that it does not fulfil, rather than those that it does. It is not a memorial work, dedicated to the memory of any individual or event. Though infused with a complex possibility of references and readings that will no doubt generate their own mythology of responses and meanings, it is not a symbolic work in the same way as, for example, the Statue of Liberty, with a single intended meaning backed up by literary reference. It is not associated with any architectural unit or complex, nor a work of art intended solely for the gallery, nor a public portrait. Just as the Angel deliberately lacks the specificity of such work, it would seem similarly to avoid being tied down to the celebration of any one occasion.

Yet of course it is celebratory, and anyone who watched the coverage of its erection on 15 February 1998 will realise that the figure is already creating its own mythology. It may avoid identity with any one historical event or meaning, but its status as a large work intended to be as prominently visible as possible in a particular location and community will generate a history. The fact that the work is figurative will add an unavoidable resonance of meaning to that history. This article is part of that, along with the whole campaign to publicise the commission and the public response to it. Estimates that predict a life span of a hundred years for the figure, speculations as to how the metal will age and change colour, even popular newspaper coverage of the ways in which wild birds will colonise it and alter its appearance, all constitute an awareness of the Angel as an object with a temporal existence that is more than just a commemorative gesture frozen in time.

The Angel clearly embodies some of the qualities one might associate with monumental sculpture. It is already, even against a chorus of dissenting voices, a focus for civic pride, an instantly recognisable landmark and a notable feat of engineering. An emphasis on engineering will relate it comfortably to the proud local tradition of the shipyards, and so will deflect any anxieties that as a civic landmark it might be a

bit 'arty' for the hard-headed North-East. Local publicity has understandably stressed the engineering aspect but, unlike the Tyne Bridge, the Angel has no practical or mechanical function. It also has a subject, and a name, filled with inescapable cultural resonances – another traditional aspect. It is an angel, a title or theme that Gormley has used for other work, and however abstracted in form, it remains a piece of figurative sculpture. It is also a work about human presence in its scale, proportions and context. Like much of the sculptor's work, it was initially based on a life-cast of Gormley's body, thus literally incorporating the measure of a man into its conception.

On its pithead vantage point, the Angel is in some ways reminiscent of the earliest British monuments, those great prehistoric standing stones. Like them, it seems to guard the landscape and to confer a special quality on the territory it surveys, turning a defunct industrial feature into a sacred site redolent with meaning. But far from being a rough-hewn monolith, this is actually a sophisticated piece of engineering and metal casting. And although it does not relate to a narrative or have a point-for-point symbolic meaning, it does belong to a long established iconographic tradition.

Large winged figures which seem to hover vertiginously high above the city or landscape, their more-than-human silhouettes clearly outlined against the sky, are commoner than one might think. The useful little guidebook to public sculpture in Tyne and Wear can list six such apparitions without venturing outside the county.

At one level their meaning is clear: they usually commemorate the dead, celebrate the victorious or embody a wish for peace. Often these meanings blur and overlap. Just as often, the circumstances that inspired them become forgotten or confused. The things they commemorate become vague, while the very familiarity of their presence renders them effectively invisible. If we could pretend they were new and strange, they might be fraught with mystery, but giving form to the immanence of the other-worldly, transcending the ponderous burden of their marble or metal forms to fuel fantasies of soaring, rustling, air-cleaving flight.

A walk around the **Haymarket Angel** in central Newcastle concentrates a whole history of cultural conceptions. Prominently sited outside a busy Metro station, what in popular parlance is called 'the Angel' is actually a complex memorial. A tall ashlar column has one figure at its apex and another

reaching up from its base, the distance between making them earth and air, human and divine. The work is full of such ambiguities, its comforting familiarity capable of dissolving into the mysterious and the weird. The angel is a hybrid, not just of human form and great, swan-like wings, but also of Christian and classical, with most of its features doing service for both. Its vaguely Greek robes had long previously become regulation sculptural wear for any figure not historically specific. Its sword is equally applicable to the martial archangel Michael, to the allegorical figure of Justice, and to any personification of military achievement. Its wings belong to angel and Victory alike, and for inescapable historical reasons its nature is as much a composite one as its form. Is it a classical Victory celebrating military heroism, or a Christian angel whose wreath implies victory over death and the glorious martyrdom of those who fought the good fight?

Such a familiar local precedent inevitably contextualises Gormley's Angel within a historical pattern, provoking comment as to whether an angel remains iconographically appropriate for a contemporary public sculpture. The perceived brutality of a great metal figure with wings more machine-like than biomorphic could be viewed as painfully at odds with the protective spirituality usually attributed to the delicate, decorative Christian angels of the popular imagination.

The truth is that representations of winged figures have a more complex history than the sweet-faced angels who flutter round every Christmas-card Nativity might suggest. They also predate the Judaeo-Christian-Islamic tradition with which we most readily associate them. The relief sculpture of ancient Assyria and Babylon, the carved seals and cylinders that commemorate in fragmentary form a complex set of rituals and beliefs, depict many deities sporting wings. These attributes of supernatural power are associated particularly with a protective function, and the figures who most commonly bear them also carry lustral vases from which they sprinkle purifying water. In Ancient Egypt it might be a falcon, a scarab, the disc of the sun or a benevolent goddess whose wings spread embracingly across a mummy case, symbolically protecting the inhabitant in transition to an eternal afterlife. The classical gods of Greece and Rome may have manifested themselves artistically in highly naturalistic human form, but they were still capable of sprouting wings where appropriate. Wind gods bear them as part of their aerial nature: Hebe, the youthful Olympian who serves the gods with nectar, is shown winged; Eros or Cupid, son of Aphrodite, the goddess of love, causes emotional chaos

as he flits around; Nike, the allegorical deity who personifies Victory, does so in the form of a proudly winged woman.

Because of the Jewish prohibition of figurative art, the angels of the Bible were initially creatures of verbal rather than visual description, and their appearances fall into two loose categories. In the more visionary books, such as Isaiah, Ezekiel, Daniel and (moving into the New Testament) Revelation, the Biblical writers convey an awesome, almost incoherent splendour. Eyes, wings, flames, precious stones and shining metals contribute to a notion of strange, dazzling, awe-inspiring and alarming beings. Elsewhere, though, it is plain that the heavenly messengers simply appear as men. The being who wrestles with Jacob, the strangers who come to Abraham, Lot's visitors whose beauty attracts the lust of Sodom - there is no indication that any of these have wings, and certainly not that they resemble the mystical creatures described elsewhere. The angels who are seen at the empty tomb of Christ are distinguished only by their shining garments. The Greek term **angelos**, used to translate the Hebrew **malakh**, means simply a bringer of tidings, and does not imply any particular appearance.

The imagery of Christian art, however, initially taking tentative form in the late Roman Empire before developing through the ritualised imagery of the Byzantine Church, made the angel's wings virtually canonical. So many pagan precedents had used wings to signal the divine nature of an otherwise human-seeming figure that the significance of the motif was established and its usefulness self-evident. Nothing monstrous or overly strange was needed to indicate that the being represented belonged to a celestial rather than an earthly plane of existence - nothing more than a graceful hybridisation of anatomy that caused wings to sprout from shoulder blades, with the tempting implication that the human frame might be as capable of flight as the human imagination.

The passionate development of Christian iconography and the move towards naturalism in medieval European art engendered whole flocks of angels, and they were no longer just the holy messengers of the Annunciation or the Resurrection. As well as playing their appropriate role in representations of Biblical narratives, they seem to become an all-purpose decorative motif in Gothic churches and cathedrals. They cluster round capitals and spandrels, a heavenly choir articulating earthly architecture. When they appear as repeated horizontal beams along the length of an 'angel roof' they become architectural

elements themselves. But they still continue to carry a meaning, to indicate the presence of the other-worldly by their sexless adolescent beauty as they swing censers, play instruments or brandish the books and scrolls which gave them their origin.

The classical heritage diversifies, multiplies, and even confuses our modes of angelic representation. The Renaissance re-embracing of all things Roman gave them rounded limbs and tactile swathes of drapery, introduced energy and muscularity, and engendered appealing broods of chubby infant **putti** who might as well be pagan **amorini** as baby cherubim. The Renaissance also adapted the grand rhetoric of Roman sculpture to its own funereal uses, and angels became part of tombs which might include not only overtly religious details, but sarcophagi, portraits of the deceased, and triumphal arches, which in this context signalled the triumph of the Christian soul over death. The angel, always an intermediary between two worlds, was also a guide of souls, and its presence implied their successful passage into Eternity. In a classicising mode it might be perceived as winged Victory translated into Christian guardian.

Since the classical style and the funereal function remained central to European sculpture right through to the end of the nineteenth century, and arguably beyond, this was where the angels came to roost. When the great age of cathedral building was over, they still found their way onto tombs and monuments, riding out a neo-classical distaste for any lingering traces of the Gothic by emphasising their new role as Virtue or Victory. The angularities of clerical garb gave way entirely to the billows and folds of the chiton, they became more Greek than Roman, more decorative than theological, and often more feminine than genderless. The Victorians, enthusiastically rediscovering all things medieval, then thickened the mixture by reintroducing a romanticised neo-gothic element without abandoning the lessons of the classical. On innumerable public monuments, winged figures proffer laurel wreaths and blow trumpets to indicate triumphs moral and martial, human and divine. The angel and the Victory have fused and, somewhere in the process, the winged being whose very existence was once fraught with the mysterious and the mystical has become so commonplace as to pass unnoticed in our visual landscape.

Antony Gormley's Angel sidesteps the familiarities of this tradition by a process of reinvention and paring down. It is clearly an evolved angel, whose wings are its natural upper limbs rather than merely an extra set borne in addition to its arms. Their massive size suggests a frightening capacity to cleave the sky, more like a plane than a bird, yet they also weigh the figure down, gravity and gravitas combining to hold it in dignified stillness on its terrestrial foundation. Its dual nature, with air and earth as its elemental homes, is indicated not by fluttering draperies or ethereal grace but by a sculptural tension between surface and space, inside and out. The body of the Angel is a membrane, corseted by an external armature of massive ribs. Inside it is space, by implication that once occupied by the body of the sculptor, but now subjectively claimed by the observer. An invisible pressure from within balances the atmospheric pressure from without, and the Angel becomes confrontational in its stillness. The fused simplicity of its body-shape is a mummiform case with which we can fill our own corporeal awareness.

It is also an angel for the 1990s, a high-tech tribute to modern engineering in a period busy amusing itself with fairies and angels, spirit-guides and reincarnations. The desire for spiritual enlightenment, solace or even just fantasy sits awkwardly alongside technological rationalism, and strange hybrids are created by this cultural clash. Gormley's Angel successfully occupies contested territory by inviting complex, and often contradictory, interpretations. In relation to the industrial legacy of the landscape it scans, it is a Blakean angel of Dark, Satanic Mills, yet it has also been claimed as a defiantly positive symbol of local regeneration. The mechanical look of the heavy, ribbed wings ceases to perturb if we read the figure less as a poetic fusion of human and avian than as a symbiosis of plane and pilot. The Angel is superhuman, weird, transcendental, and refuses to deny its spiritual ancestry. Instead of springing at right angles from its torso, the shutter-like surfaces of the wings incline at a gentle angle that might imply the beginnings of a protective embrace. The benevolent function of the ancient deities can still be discerned, and the concept of the guardian angel is far too potent to be displaced by the purely mundane or mechanical. The flight of angels retains its significance precisely because it is a flight of fancy.

Though it commemorates no external event, the Angel will still be termed a monument and viewed in relation to the whole chronicle of angelic representation. Its massive scale makes it a local landmark, but its iconography has a universal resonance far beyond this particular commission. The most contested area is always the borderland, and messengers still have a role to play.

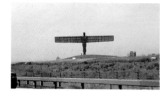
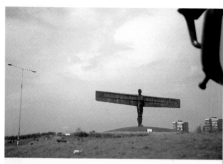

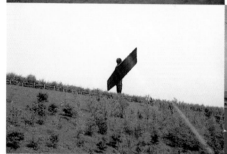
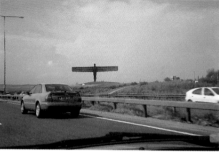
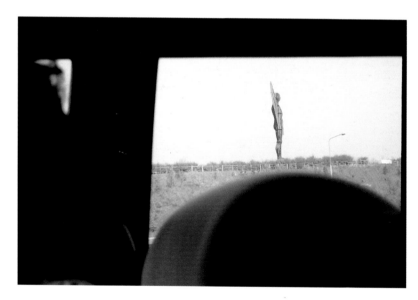
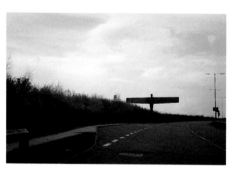
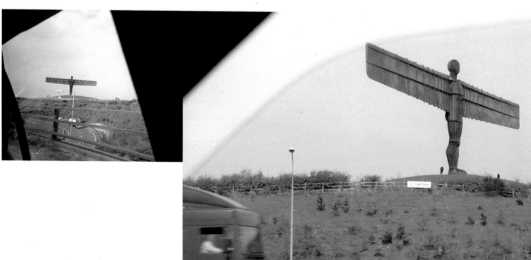

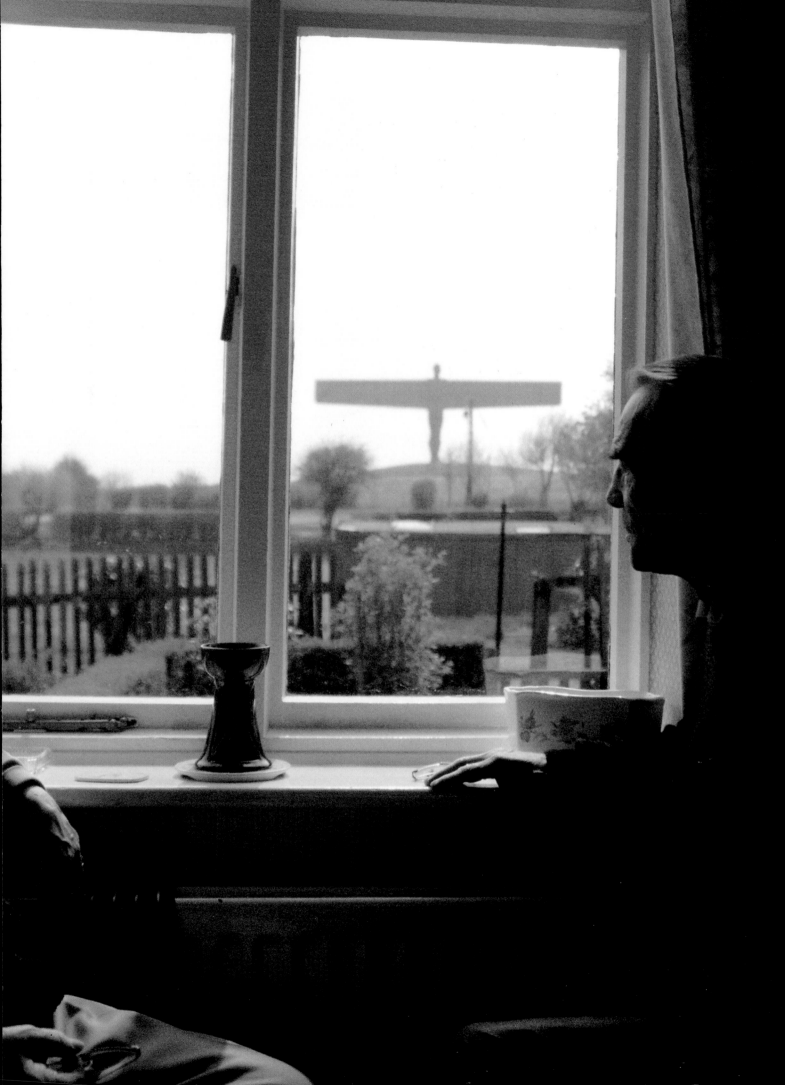

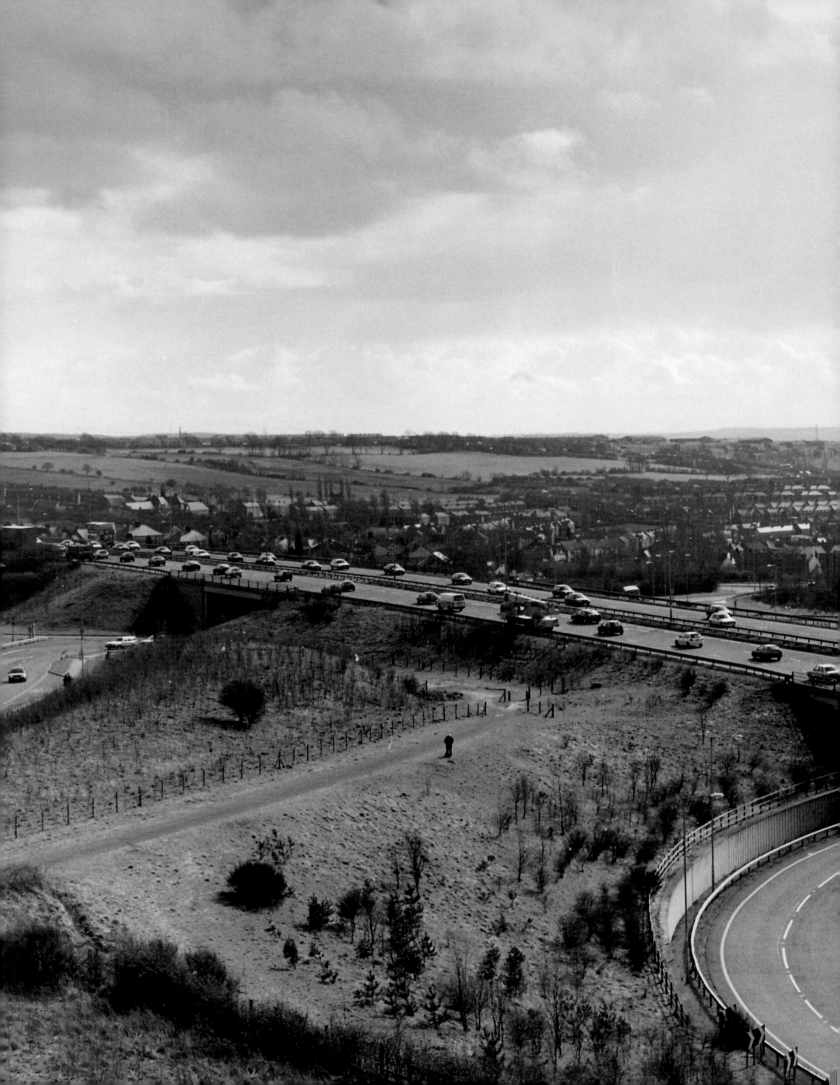

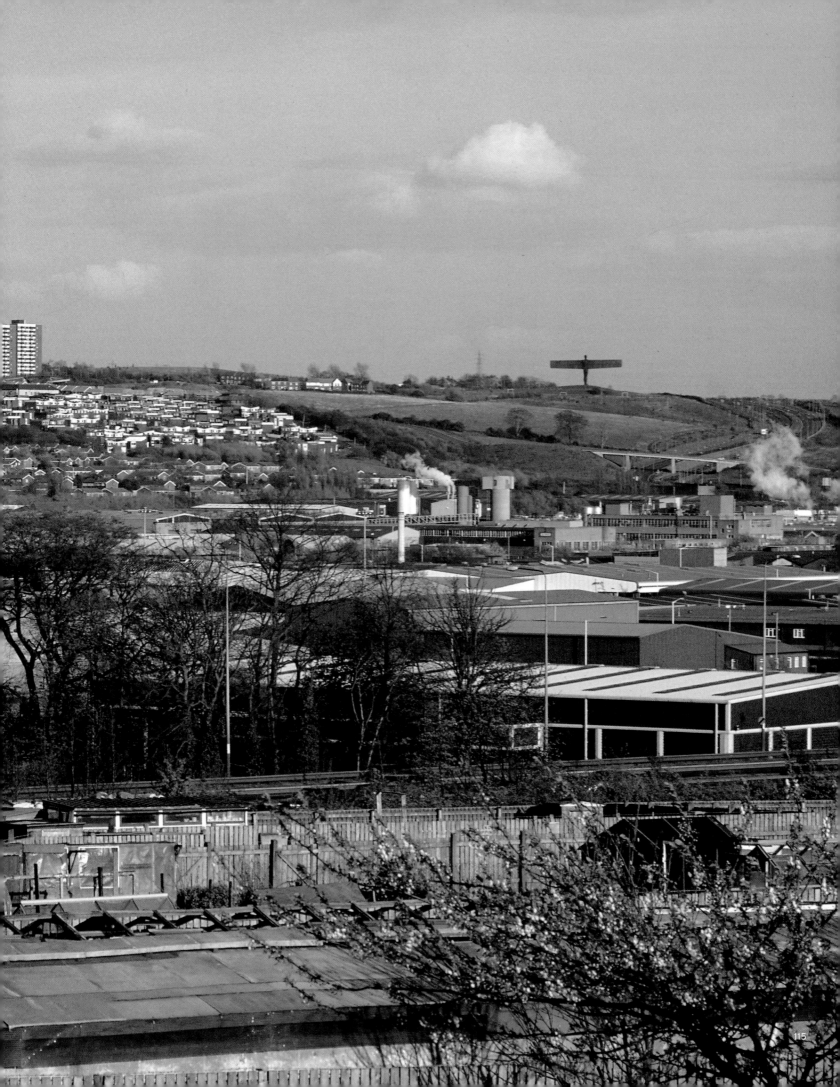

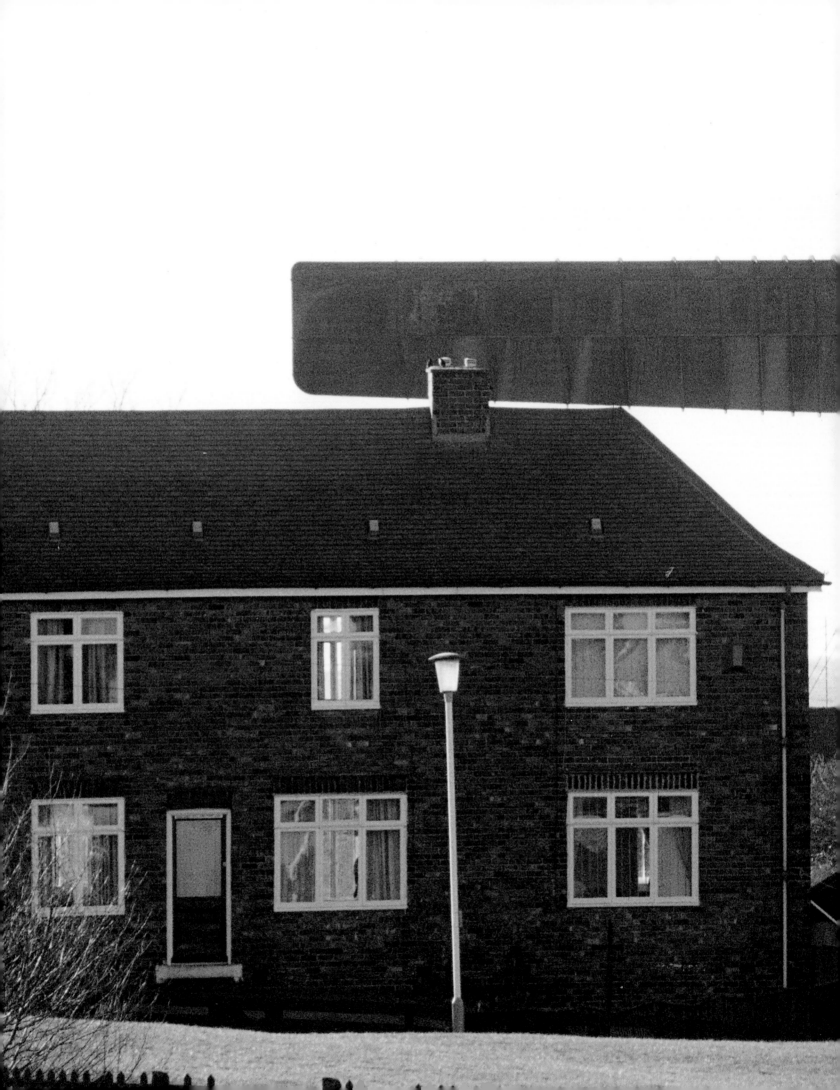

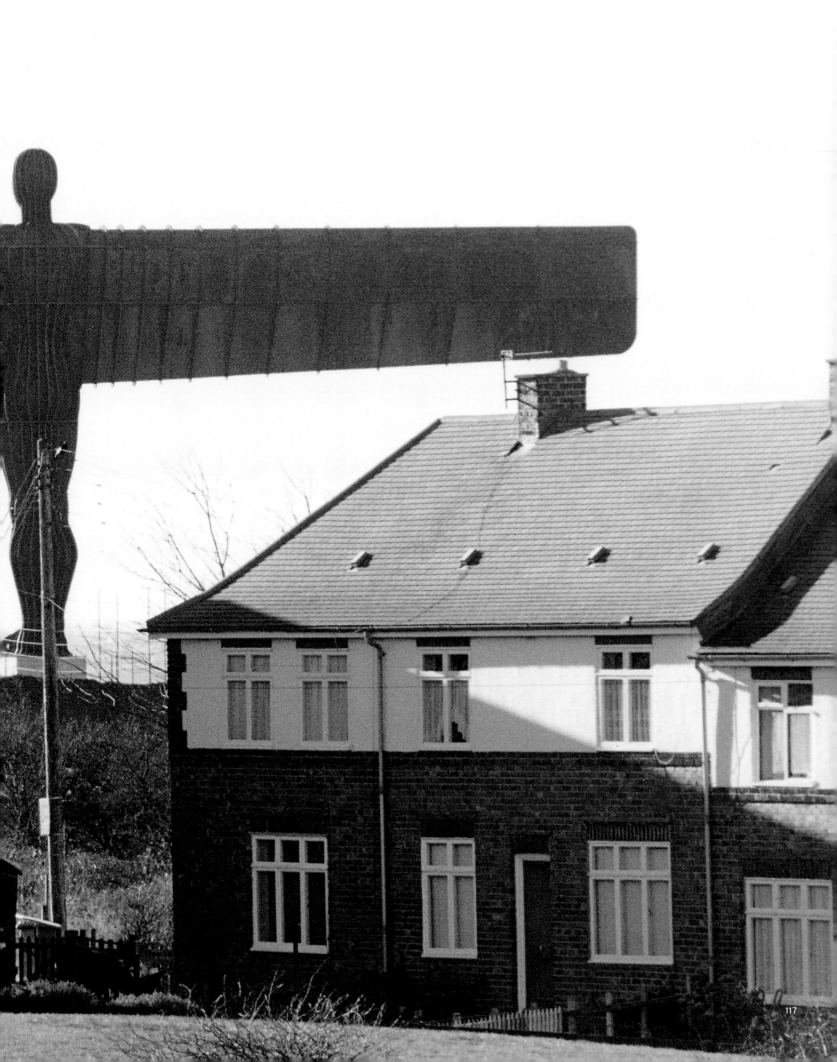

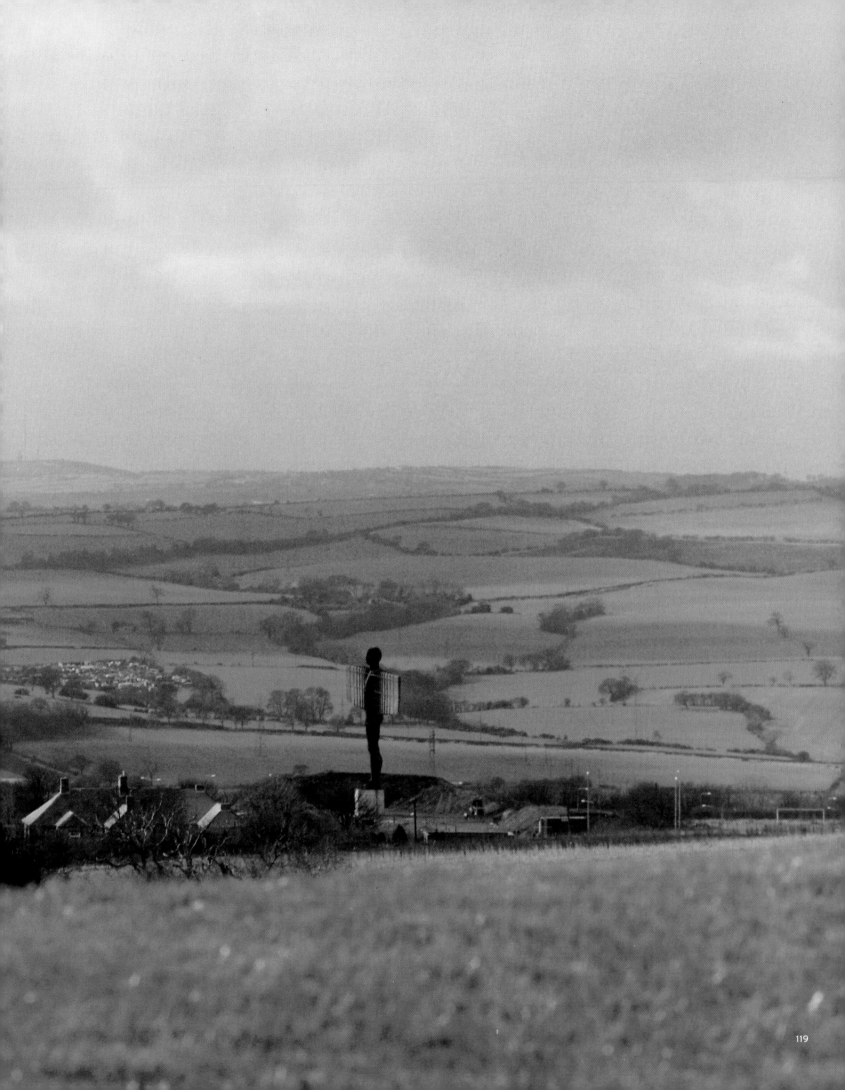

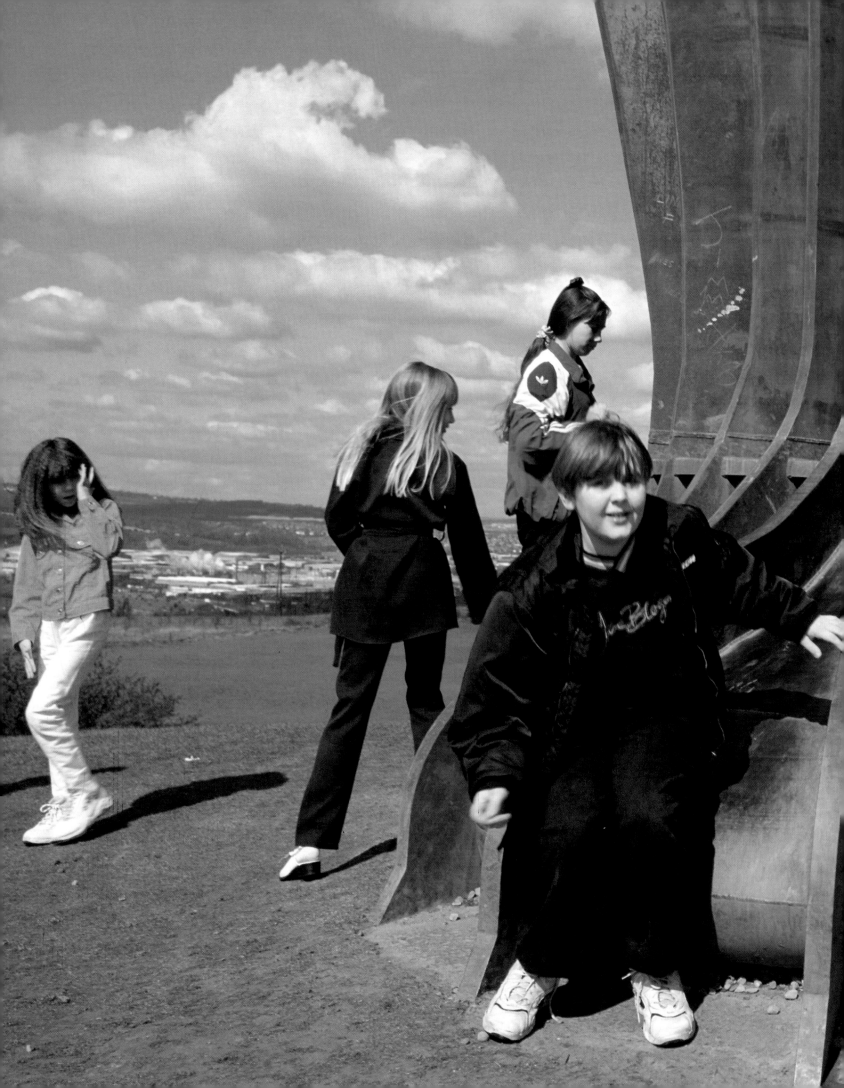

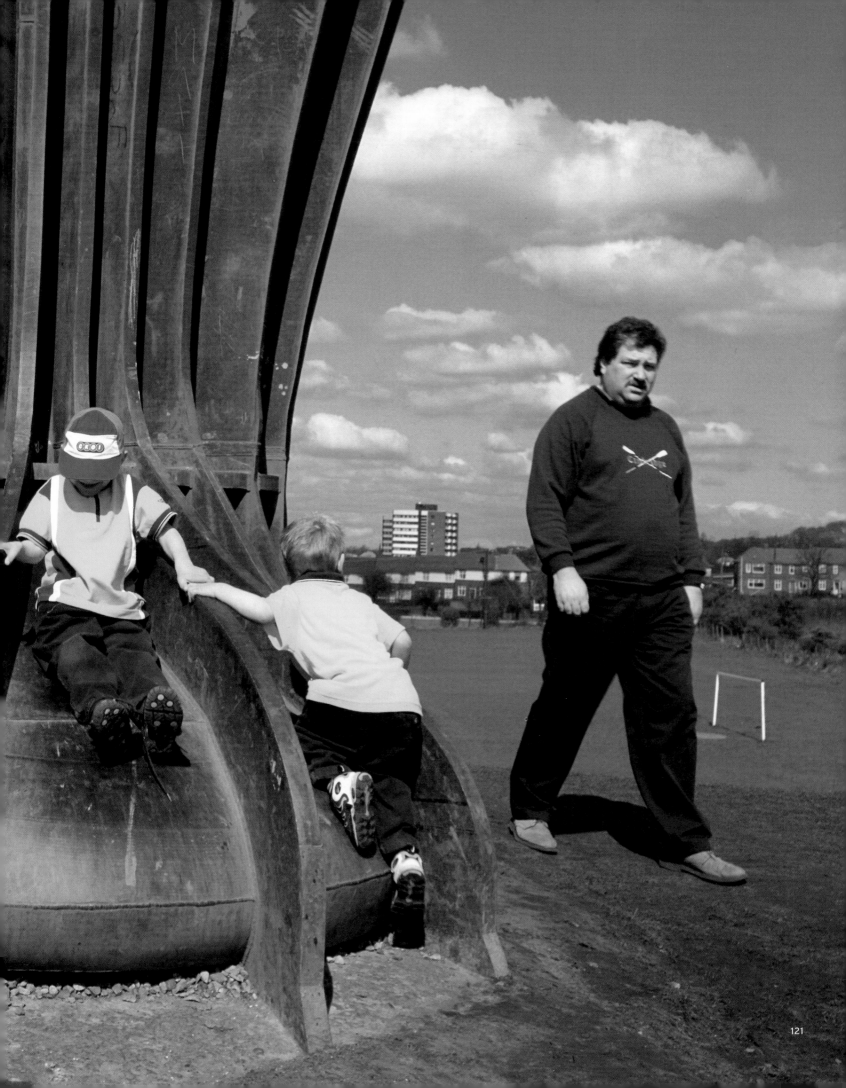

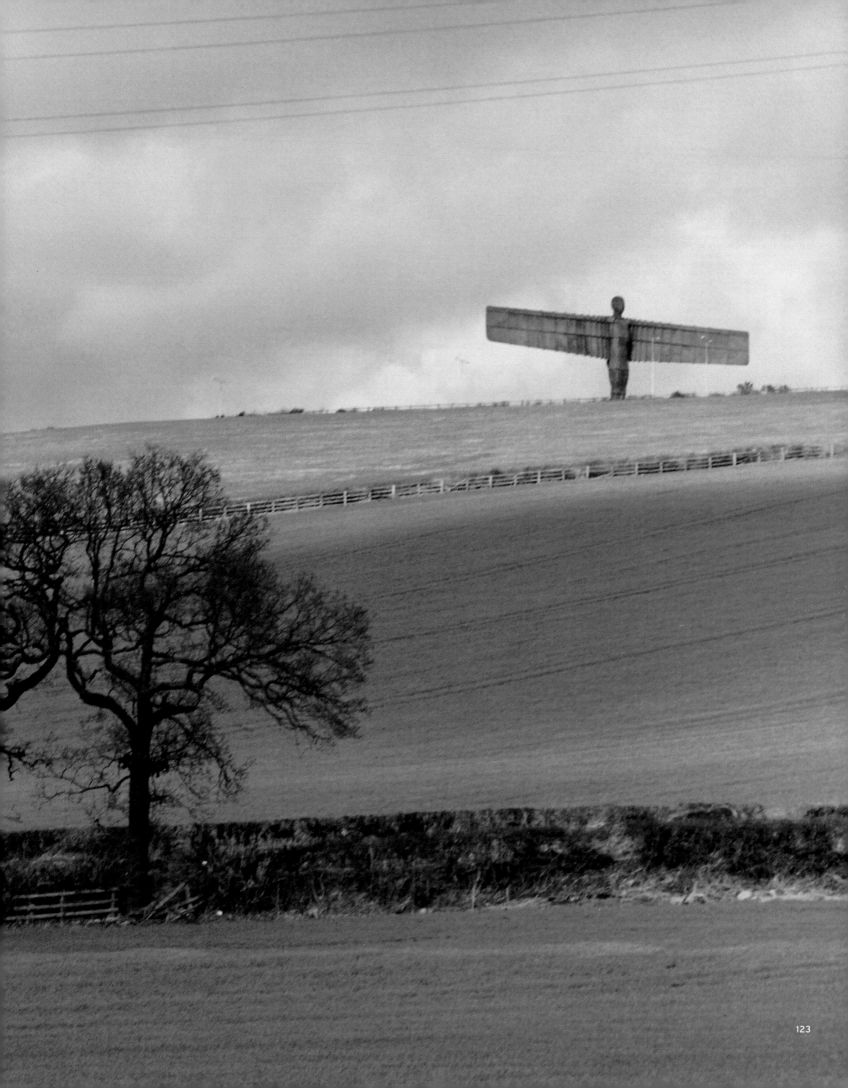

Unholy protest to stop 'angel'

Flap over the Angel

Opposition councillors who said no to the Gateshead Angel have accused the ruling Labour group of a cover-up

THE ANGEL WITH A DIRTY FACE

THE GATESHEAD yesterday was launched yesterday to try to stop a 60ft high

YOU HAVE YOUR SAY

Just a publicity stunt

I'M sick

HELL'S ANGEL?

NAZI ... BUT NICE?

Giant Angel off to a flying start

By PETER TAYLOR

THE final go-ahead has been given for the controversial Angel costing the best part of a million pounds to be built at Gateshead.

A haven for bungee fans

AFTER the many letters published on this proposal for the 60-foot Angel maybe some good may come of it after all.

A Time to clip angel's wings

GATESHEAD Council has had the clearest possible message about its plan to erect an enormous angel close to the A1.

Angel still has devil of a fight

CHRONICLE COMMENT

GERMANY 1935: The Angel commissioned by Hitler is saluted by the Luftwaffe.

GATESHEAD 1995: The Angel planned as a symbol of welcome to Gateshead.

Sky high price

PLANE

Angel's plan to fly over last hurdle

By JON FLINN

ONE of the claims of Gateshead in support of its plans for a "angel"

ANGEL ON LOTTERY?

THE NATIONAL LOTTERY

National Lottery to build this Angel is nothing more than criminal.

Angel will put us on the map

BY LINDA

THE Chronicle's anti-angel campaign has accentuated the negative side. I would like

HEAVEN HELP US

Winging in for summer

THIS WEEK'S £5 STAR LETTER ★

Carving new image for town

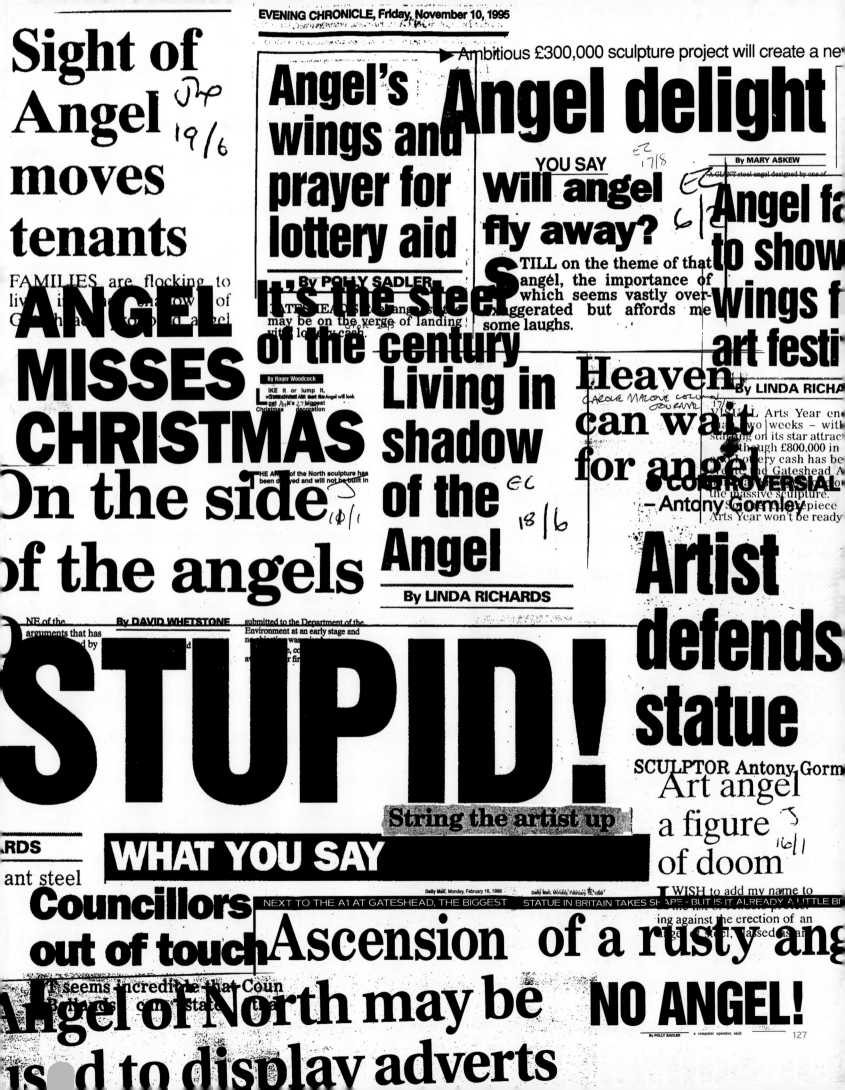

Evening Chronicle

ESTABLISHED 1885 Monday, February 16, 1998 26p **GATESHEAD EDITION** BT NORTH EAST NEWSPAPER OF THE YEAR

BONUS TOKENS INSIDE TODAY
FLORIDA TOKEN

Dawn breaks over the £800,000 sculpture which has transformed the Tyneside skyline

Picture: ANDY LAMB

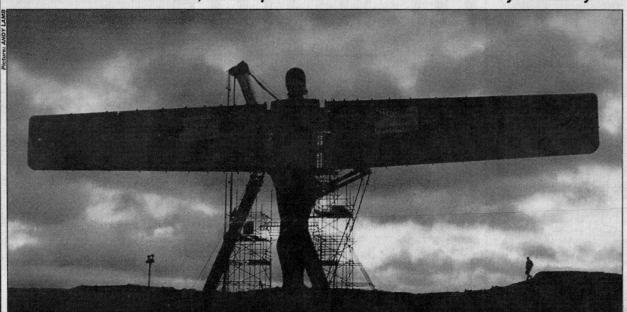

THE ANGEL HAS LANDED

DAWN broke over the Angel of the North today as holiday bosses predicted it would spark a tourist boom.

More than 150,000 people a year are expected to stop to admire the massive sculpture which will be seen by 33 million drivers a year on the A1.

And as work continued on the 65ft landmark it was revealed that Gateshead Council's computer experts are working on an initiative to woo coach parties to the site.

By LINDA RICHARDS

They will be taking coach operators on a virtual reality tour of the Angel at next month's British Travel Trade Fair in Birmingham.

A Gateshead Council spokesman said: "This will give them a chance to see what the Angel looks like without having to visit it. We are confident they will see what a tourist attraction it is and will organise coach parties to come to see the Angel and take in other North East attractions."

The Angel, seen as a symbol of regeneration, is expected to have spin-off benefits for hotels, businesses, shops and the leisure industry.

There were fears that it would lead to traffic chaos on the A1 but police and road watchdogs reported no problems today.

Police said that traffic was flowing normally and there were no difficulties among the thousands of motorists driving past.

But an AA spokesman said they feared it would distract motorists and warned they would monitor the situation.

▶▶▶ **HAVE YOUR SAY ON THE ANGEL OF THE NORTH – Pages 2 & 3**

arts

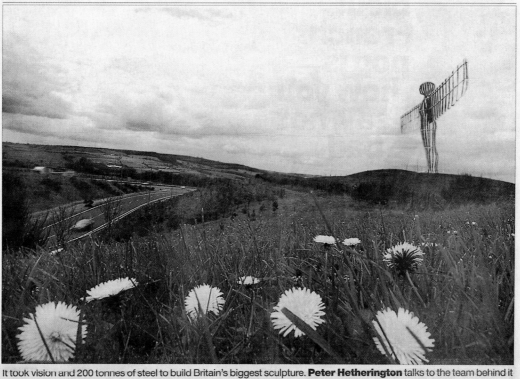

It took vision and 200 tonnes of steel to build Britain's biggest sculpture. **Peter Hetherington** talks to the team behind it

On the side of the Angel

The Making Of
The Angel Of
The North

Even before it is erected, Antony Gormley's 200-tonne Angel Of The North has become Britain's best-known piece of public art. But is the object that will go up next month a sculpture or an amazing feat of engineering? Five storeys high and with a wingspan as big as a jumbo jet's (52 metres or 169 feet), it will stand on a mound by the site of a colliery beside the A1 on the southern approaches to Gateshead. It will be seen by over 90,000 drivers a day, as well as passengers on the main east coast railway line.

The project has provoked both ringing praise and withering criticism. Gormley has been stung by remarks about "fascist" art, arguing that the whole idea of the monument has been tarnished by totalitarian regimes. As a result, at one stage he says he suffered a slight crisis of confidence.

But the Angel has now captured the imagination of the north-east. Gateshead Borough Council, which has nurtured the project since the early nineties and put together the £800,000 of Lottery, European and private money that paid for it, claims it will be the most dramatic piece of engineering in the north since the building of the Tyne Bridge in the twenties.

Antony Gormley: I was first contacted at the end of 1994 by Gateshead Council. They talked about a competition for a landmark sculpture, but I did not pay any attention to it. I was rather busy at the time, and when someone from Gateshead rang me up and said, "Look, we would like you to take this seriously," my reply was, "I don't do roundabout art."

Sid Henderson: We have only one gallery in Gateshead, and it's very small, so the idea was, why not go to the public with art? The problem is, if you go down any high street, from Arundel to Alnwick, public art is all the same. There's no individuality. There's got to be some sort of statement, or opportunity for individuality to express itself. There used to be a colliery on the site, and we said that would be an ideal place for a sculpture, a landmark. Everybody agreed.

We spent hours looking at contemporary artists and their work. We saw this image of the angel that had been exhibited by Antony — at Malmo, I think — and we decided to go for him. He came to the site, a mound, and said, "This is very inspiring." He could envisage the feet going into the roots of the earth and the Angel reaching to the sky with aspirations for the future. What could be better? The size was ... well, difficult to comprehend.

Antony Gormley: They were very persuasive. They sent me some material and I was immediately intrigued. What is marvellous about the site is that it is very much a working landscape, with the motorway and everything. There's a mound on the site of an old colliery, and this was already saying that something went on underground. Men worked under there for 200 years, and out of that came the coal that gave rise to the history of the north-east, and that should not be lost. Sid really does have a vision. He believes that human diversity is as much in danger as biological diversity, that McDonald's culture is providing more and more of less and less. He sees the Angel as being a resistance to that.

Bill Stalley: A chap from Gateshead came to us with a model of the Angel in a big wooden crate in a box van. They just took the front panel off the crate outside and we all trooped into the back of the van and had a look. What did I think? You want an honest answer? I didn't have an opinion apart from the fact that this was a contract — work.

Neil Carstairs: Antony Gormley had a clear idea of what he wanted above the ground, but it soon became clear that the foundations had to be larger than any of us envisaged if the wings were to take substantial wind forces. The idea was to take Antony Gormley's model and enlarge it without changing the dimensions in any way — and that could have meant it being fatter at the bottom — and we found it was just possible to keep to his plan.

One hundred and fifty tonnes of concrete have been poured into piles, which will root the structure into solid rock 20 metres below the surface and enable it to withstand winds of more than 100mph. A concrete slab 1.5 metres thick has been laid on top, topped by a 5.3-metre plinth on which the angel will stand, secured by 52 three-metre bolts. I think it will look very impressive.

Bill Stalley: We have dealt with Neil Carstairs's firm (Ove Arup) successfully in the past, and a company of their standing wasn't going to get involved in a white elephant. Instead of the Angel being completely manufactured in steel, they were looking to cast the body up to

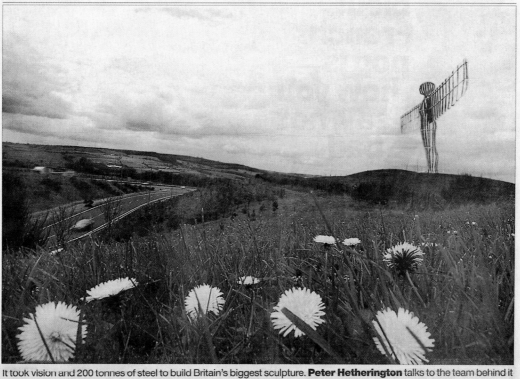

How the Angel measures up

Colossus of Rhodes
Greece
100ft high

Christ the Redeemer
Rio de Janeiro
98ft high

Angel Of The North
Gateshead
65ft high
169ft 'wingspan'

Mandelson Man
Millennium Dome
(no genitals, based on an idea first used by the Nazis)
45ft high

Cast of characters

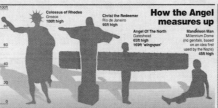

Antony Gormley (left, with a section of wing): 1994 Turner Prize-winner. Has exhibited around the world, with major public works in the US, Japan, Australia and Norway. In Britain, his work stretches from the crypt at Winchester Cathedral to Birmingham city centre.

Sid Henderson (below): Labour chairman of the arts and libraries committee on Gateshead Metropolitan Borough Council.

Neil Carstairs: senior employee at engineer Ove Arup. Tested the feasibility of Gormley's original design.

Bill Stalley (below): MD of Hartlepool Steel Fabrications, a family engineering firm 30 miles from Gateshead, which won the contract to build the Angel.

James Bustard: visual-arts supremo at Northern Arts.

Eddie Smith: Joint owner of the Angel Inn, opposite the site of the Angel, which recently changed its name from the Old Barn.

Maureen Adamson: sister of Eddie Smith.

about chest level. The wings, the top, and the head were still to be fabricated.

We were well aware of the £800,000 budget the council had. We looked around for one or two firms that could make castings, but they were just so far off the budget that we thought it would never go ahead. A few days before the tenders were due in, we sat down and came up with the idea that we could fabricate the central core, to which we could then attach the ribs and an outer skin. We did a quick estimate and got it down to somewhere near the budget.

Sid Henderson: We saw it as an opportunity for engineering, using traditional skills, and were determined to keep the work in the area to provide jobs. It's provided work for 30 men in Hartlepool. One of them said to me: "It's nice — we're going to be able to show our children what we actually do." It's a one-off, a huge feat of engineering.

Bill Stalley: The raw material, the plate, is weathering-grade steel with a small amount of copper content, which forms a protective coating. Antony had various models based on a cast of his own body, which was used as the final shape, and we sent it to the geometrics department at Newcastle University. They did a scan for the shape, and that information was fed into computerised machines, which cut the shapes we needed. The ribs were then attached to the outer core and then we started to form the skin.

The wings were simple and straightforward. We finished them in October. Once the body is completed in the workshop, we will bring it outside and line it up to the wings. Then the whole thing will be transported to Gateshead in three sections — two wings and a body. It could take a week or 10 days to erect. The biggest problem is wind. We've got to get the body lined up, then lift up the wings and put them into place by bolting and welding.

Antony Gormley: It is important to me that the Angel is rooted in the ground — the complete antithesis of what an angel is, floating about in the ether. It has an air of mystery. You make things because they cannot be said.

I hope it is never a symbol in the way a trophy is. It is about asking questions about this transformation between the industrial and the information age, about whether art can be a focus for people's hopes and fears. We now have what used to be an angelic faculty — the Wright brothers' flight in 1904 in some way set the tone for the century — and the Angel is reminding us that we have enormous potential, but it comes with enormous danger. So it

Welcome to another world . . . above, how the Angel Of The North will look next month
PHOTOMONTAGE: NORTH NEWS AND PICTURES

celebrates and acts as a warning at the same time. It generates as much fear as excitement.

Bill Stalley: It will look absolutely perfect. For our company, there's a lot of pride in this. As the job developed, people started to say, "Oh, this is going to be the biggest sculpture in the UK," and you start to think, "Hey, we're on to something here. What we've made will be in the public eye for generations, and we're the people who've made it." Really it is not a sculpture: we've reproduced what was on a drawing. I'd never heard of Antony Gormley, although I don't class myself as a follower of art. But he's a good bloke, one of the guys, and likes a good chinwag with the men.

Antony Gormley: I think the project has got to Bill a bit. You can tell by his body language. I am only a very small part of this, and it should be very much seen as a collective effort. Even if you don't like it, the engineering is extraordinary — like building the Forth Bridge without the banks on either side. Art in the 20th century has been characterised by the individual's pursuit of his own freedom. The point about this work is that it has been built by a lot of people for a lot of people.

James Bustard: It is a very powerful image. People talk about images when they talk about paintings, but not when they talk about sculptures — and this has become the best-known sculpture in the country before it has even been erected. I do not see it as provocative, but here is a sculpture that has provoked reaction — it has stuck in the imagination. Gateshead Council has stood by this through thick and thin. They recognise that art can be used as a means to reposition a town.

Eddie Smith: I think it's great. It will do for Gateshead what the Tyne Bridge did for Newcastle. It's got people talking. People say, "Did you buy the pub because of the Angel?" but to be honestly didn't.

Maureen Adamson: It's awful. I'm more traditional. I prefer ordinary things. But I could be in the minority. I'll never like it, but it is something we have to accept.

Eddie Smith: Oh, Maureen. You've got to move with the times.

Antony Gormley: I'm not looking for uncritical adulation. I do not think Mount Rushmore is any good or that the Statue of Liberty is a particularly good piece of sculpture. This might not be any good, but I am optimistic. It is an experiment . . .

This one's got wings

The Angel of the North is a supreme artistic achievement. WALDEMAR JANUSZCZAK finds his spirits soaring

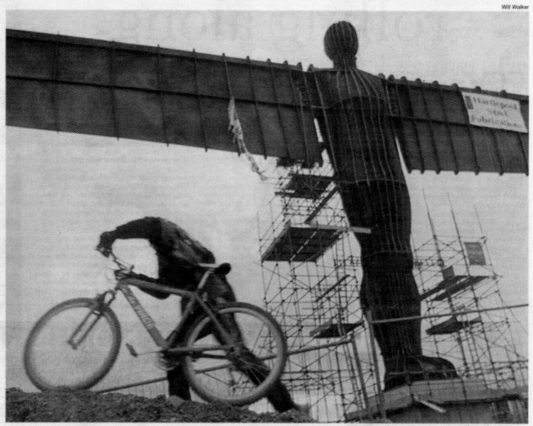

Will Walker

Guiding principle: Antony Gormley's monumental Angel towers over the grim post-industrial surroundings of Gateshead

Size is, as we know, important in various avenues of life, but what role does it play in sculpture? Is it a help or a hindrance? These are the sort of questions we should be asking ourselves in this truly momentous sculptural week that not only saw the unveiling of Britain's largest public sculpture but also heard the first rumours of something even bigger. A giant mother and child sculpture is, it seems, being planned for the Millennium Dome. Nobody knows yet what it will look like. But many seem to have made up their minds already that they do not like it. Why?

Because, as Yeats once observed despairingly of these islands and as events this week have sought to remind us, there is safety in derision. Because the Millennium Dome, and anything that is rumoured to be planned for it, has been bringing out a mean-spirited, cowardly, depressing, dumb negativism in record quantities in those typically grim British observers who would rather sit there moaning, pointing and mocking than roll up their sleeves and make something work. Because many will spend the build-up to the millennium wishing failure on Mandelson and his celebrations just so that they can turn round at the end and say: I told you so. How pathetic. How wasteful.

I'm thinking all this because I have just been to see the Angel of the North, the aforementioned largest public sculpture in Britain, and found it to be a moving and thrilling sight. For years, however, enormous quantities of animosity were directed at the project, locally and nationally, by the same cast of moaners and can't-do-ists. If the nay-sayers of Gateshead and beyond had had their way, the Angel wouldn't be here now either. And instead of a world-famous landmark that brings some genuine visual excitement to a messy urban sprawl on the outskirts of Newcastle, there would have been — nothing.

There are many critical, life-enhancing reasons for the importance of art. But among the most significant is art's divine ability to turn nothing into something: a minus into a plus. Arriving by road at this previously unremarkable corner of Britain, this is what you pass: a huge and entirely ghastly selection of boxy industrial units called the Team Valley industrial estate, the architect of which ought to be

arrested for crimes against aesthetics; the A1 crammed with lorries and cars — 90,000 of them a day — belching fumes; row after row of identical pseudo-suburban semi-detached housing; a dual carriageway; a roundabout; some notably ugly concrete tower blocks; a forest of electricity pylons supporting mile after mile of sagging, beer-bellied cable; and an outrageous new mobile-phone mast that is at least twice as tall as the Angel of the North, but which seems to have gone up recently without a fraction of the fuss.

I mean no disrespect to this ordinary corner of post-industrial Britain — its only sin being that it is absolutely typical — when I ask what, pray, could possibly have been spoiled here by the arrival of the Angel of the North? What were the preservationists trying so desperately to preserve? The erection of Antony Gormley's hugely effective public sculpture cannot disguise or eradicate the civic mess that surrounds it. But it can and does act as an antidote to it.

As you drive towards the half-man, half-glider (it never strikes

you as a proper angel) and it grows in your windscreen, crucified against the sky, your attention is directed upwards — hallelujah! — away from the Team Valley industrial estate, away from the outsized mobile-phone mast, away from the roundabout and the dual carriageway, towards bigger thoughts. In particular, Gormley's sculpture makes you savour afresh Gateshead's finest natural attraction: its huge skies. This is what fine public sculpture can do. It can repunctuate a familiar vista.

That said, I was expecting something much bulkier. The statistics being bandied about have tended to concentrate on the Angel of the North's size. It is the heaviest sculpture in Britain. It weighs 200 tonnes. It's wingspan is almost that of a jumbo jet. It can withstand winds of up to 100 miles per hour. And the one I like the best: "It is believed to be the largest angel sculpture in the world . . ." How many challengers are there to that particular title?

None of these sums and comparisons hints helpfully at the impact of

the thing itself, which is unexpectedly delicate. This is particularly noticeable in the profile view: what sensitively drawn buttocks; what a pleasing pelvic bulge. Most monumental sculpture is forced by its own bulk to appear ponderous. Gormley has avoided this by employing a sculptural strategy popularised by the Coca-Cola bottle: he has traced a curvy outline with a series of undulating head-to-toe ribs that draw the shape but do not fill it in. The Angel is both solid and not solid.

The figure itself is supposed to be — as always with Gormley's work — a cast of the artist's own body, but in the flesh he is a notably tall and lanky man, while this is a fuller, shorter, more muscular presence: more Spider-man than a basketball player. Thus, instead of swaying dangerously in the hill-top wind, or appearing to — as any figure closely modelled on the real Gormley would certainly do — the Angel stands firm and solid on his low hillside, a genuine engineering feat, anchored against the gales.

The gracefulness of the torso turns into something altogether

weirder at the wings. Their inspiration is unarguably man-made. They belong on a glider. The junction between the torso and its wings isn't entirely comfortable. Just as the surrounding landscape is a rather awkward fusion of the natural and the industrial, so the Angel never quite decides whether it is a product of nature or of technology.

Leaving this dichotomy unresolved was Gormley's stroke of genius. The steel behemoth stands there on the top of his low hill exuding eternal calm from some angles and high-tech tension from others. From some viewpoints he appears a totally benign presence, and from elsewhere there is a dark, almost threatening air to him. A lesser sculptor would have settled for something more pat. The Angel is the most impressive public sculpture of recent times because it manages to be both a subtle work of art that is constantly shifting its meaning, and an unmistakable landmark instantly recognisable from all angles. □

The Angel of the North is just off the A1 at Gateshead

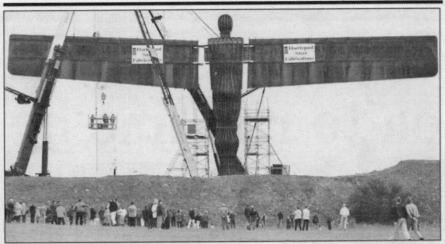

Flying folly: Some of those who came to gawp at the Angel of the North — but is it a monument devoid of meaning?

Big, brash, banal: truly a symbol of our age

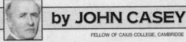

by JOHN CASEY

FELLOW OF CAIUS COLLEGE, CAMBRIDGE

SO THE Angel of the North now looms large over the landscape, erected at a cost of more than £800,000, thanks to funds handed out mostly by the Lottery, the European Union and Northern Arts.

The giant edifice has already attracted hundreds to gawp at it, while motorists driving down the A1 can hardly avoid seeing its wings and head towering over the hills and terraced houses. It is sure to cause a fatal accident, in which case its name will no doubt be changed to Angel of Death.

You are supposed to admire the Angel because it is very big and bold and excitingly symbolises New Britannia. Indeed it does, but not in the way its supporters imagine.

For this rusting angel is a symbol of our age, but only because a monument devoid of meaning seems the perfect representation of our modern times, with all their contorted values and empty beliefs.

It expresses the mindless gigantism of a nation about to spend £750 million on a millennium dome, without having decided what is to go in it, at a time when pensioners lie on hospital trolleys for hours waiting to see a doctor in our decaying health service.

The use of lottery money — that tax on the poor — is a special scandal. For one can be certain that this absurd folly in Gateshead is being replicated on a small, but equally banal, scale across Britain.

Not that there is anything wrong with follies. The British landscape has been enriched by many spendthrift eccentrics with their giant towers, fake medieval ruins and fantastical castles. But these were built for fun and with private money.

The Angel's creator, Anthony Gormley, doesn't think the Gateshead Folly is fun. He has solemnly explained that it has a special meaning for the 20th century — representing our discovery of flight, and with it our power to drop bombs.

Leaving aside the breathtaking banality of this statement, we discovered flight early in the century. What people have found towards the end of it is how works of art get attention simply for novelty value. Quality no longer matters.

Lifeless

The Angel, although big, is not actually bold. It is sexless — absurd in such a huge statue. (The common opinion that angels are sexless is incorrect. Every single one who is named in the Bible is male — Michael, Raphael, Gabriel etc).

The body, although well proportioned, is lifeless — and why do the huge wings look as though they are bi-plane wings with the lower half left out?

Art should provoke strong opinions. What is so very wrong with the Angel of the North is its lack of meaning. It is not a thing of beauty. It has no religious significance — there never was an Angel of Gateshead.

It will never be credited with the powers of the Cerne Abbas giant, on which women sit in the hope of becoming pregnant. This Angel is impotent either to fly or to fertilise — it is there simply to be gawped at because it is there.

There have been plenty of giant statues in modern and ancient times, but few quite as pointless. There is the world-famous colossal statue of Christ in Rio — but this is supposed to be Christ the King, who would protect Brazil and its greatest city.

Or there is the Valley of the Fallen, near Madrid, created by General Franco as a final resting place for all the Nationalists who fell in the Spanish Civil War. It is dominated by a cross on a gigantic scale but the symbolism is obvious — sorrow and suffering to an unprecedented degree, and the hope of reconciliation.

Giant Buddhas and colossal representations of Roman emperors, such as Nero and Constantine, all had a point — to awe people and to suggest that these god-like figures could offer protection to their subjects and devotees.

Even the pyramids of Egypt had a purpose. They were meant to preserve the mummified body of the Pharaoh and project his soul towards heaven, from which he would watch beneficently over his subjects. So the fantastic sums of money that were spent on the pyramids had a certain logic.

But such megalomania, even when commemorating our greatest heroes, has not been a British tradition. Nelson's column, designed in memory of a hero who had given his life for his nation, is huge but fits beautifully into the environs of Trafalgar Square.

The kind of gigantism we see in Gateshead is something we associate with the Third World — with the vainglorious triumphal structures put up by the Shah of Iran in Tehran or Saddam Hussein in Baghdad.

Ludicrous

But even those monstrosities had a purpose, if only to demonstrate the power of the dictators who built them. The Angel of the North celebrates nothing but the modern state's aptitude for relieving its citizens of their money and its inability to think of anything useful to spend it on.

The nearest equivalent in modern Europe was the colossal dome which was planned for Berlin by Hitler and his pet architect, Albert Speer — a building that was to be so vast that clouds would regularly have formed beneath the cupola. Luckily, defeat in war put an end to that folly — although his fellow dictator Stalin carried on in this monolithic architectural fashion.

What is so sad about this ludicrous statue is that it is in the North-East, for time was when the solid citizens of that part of the world would have been the first to howl with derision at the nonsense that has been wished upon them.

The Labour councillors who commissioned the statue thought it would 'put Gateshead on the map'. Gateshead was once very much on the map, as a mighty centre of engineering and shipbuilding. Renowned for its forthright folk, it was an area where working-class culture took itself seriously.

There were the working men's clubs, with libraries more extensive than those in some of our new universities, where men would expand their minds after a hard day's work by attending lectures on science, literature and the classics.

All that has gone. The libraries have mostly been sold off and turned into pubs and discos. The councillors of Gateshead, far from putting their town on the map, have merely been midwives to a giant whimsy, an expensive curiosity.

But until the absurd Greenwich dome is actually built, this huge metal monstrosity will be the most apt symbol we have of the inner emptiness, the sound and fury signifying nothing, of New Britannia.

Ann Marie Critchlow – There was once two fine children who had do go to bed one night they went up stairs But the saw an angel. Who are you they said I am the angel of the North. & I thought it was very good! By Ann Marie Critchlow 165 Rawling Road Gateshead Tyne and wear

Anthony
G.A.Smith.
CARR HILL
GHD

WOULD LOOK MUCH BETTER WITH GOLD OR SILVER PAINT. TO MAKE IT LOOK OUTSTANDING.

Gemma Tait – I thought the angel was going to be rubbish but when I went to see it I think it was a Brillent ~~piece~~ work of art.

SANDRA SOAB
G/HEAD.

Its absolutly brillient When you come from the South 2 see it it makes you feel like the Northern people are welcoming you with open arms. I love it. & it makes me proud to be from the North East

Q/ Is it a plane?
Is it a Bird?
Is it a Giant Scarecrow?
A/ no – it's the "Angel" of the north.

Keeps making me think of something from world war II But looks Better in photos – enjoyed the library photo Display –

O.K.
Big
Good

Mick ITS GROWING ON ME!

amazing
AMAZING

Absolutely Amazing
an inspiration to me

Angela Forsyth Thank you, thank you, thank you
(seraph design') Thank you for having the vision
 Thank you for ignoring the critics
 thank you for the most wonderful,
 inspiring piece of sculpture-right here
 in Gateshead. Thank you !!!

Barbara Winley Didn't think I would like it
Shaan but now I think it is Wonderful.
Eighton bankss

I thinks it Should be taller for
the money we spent on it.

Fred The man that designed it
 wants locked up. It is of no
 use to Gateshead what so ever.
 If Clarke Chapmans was still
 open or any other industry was
 supported by the money wasted
 on this rubbish the people of
 Gateshead would have had better
 value for money.

David Elf Having read thus far through this book, I can't
Gateshead help noticing that almost all the complaints are written
 by people who can scarcely spell, never mind
 conjugate verbs. The angel is Beautiful, but given

CRAIG - WANKY. It should be the Devil.

133

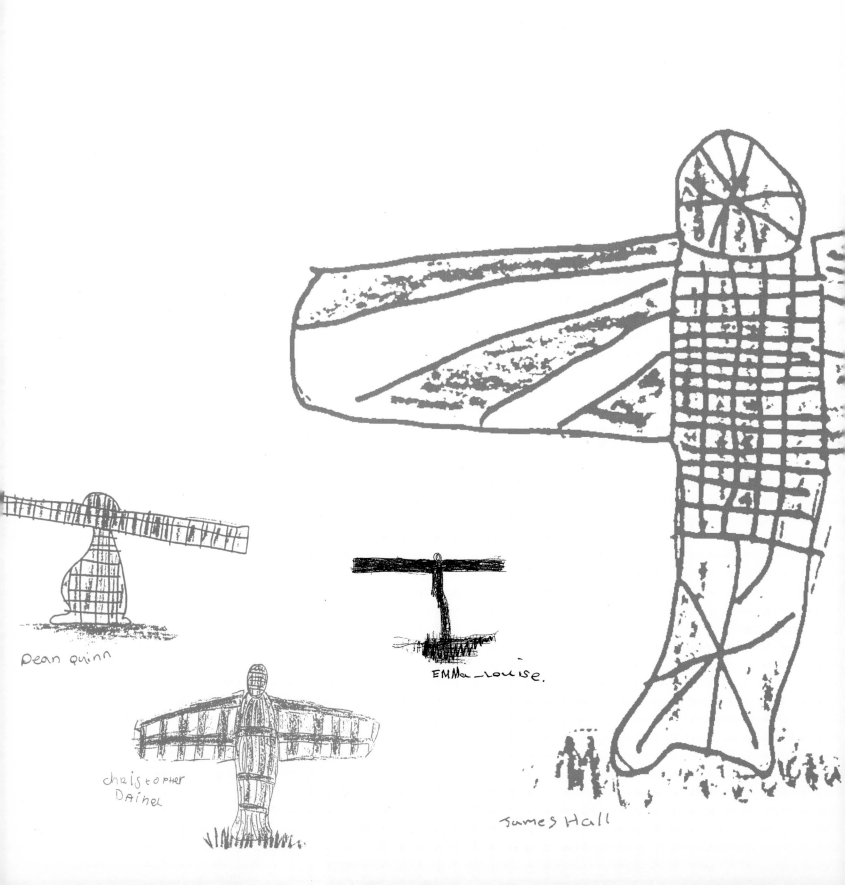

Dean Quinn

christopher
Dainel

EMMa _Louise.

James Hall

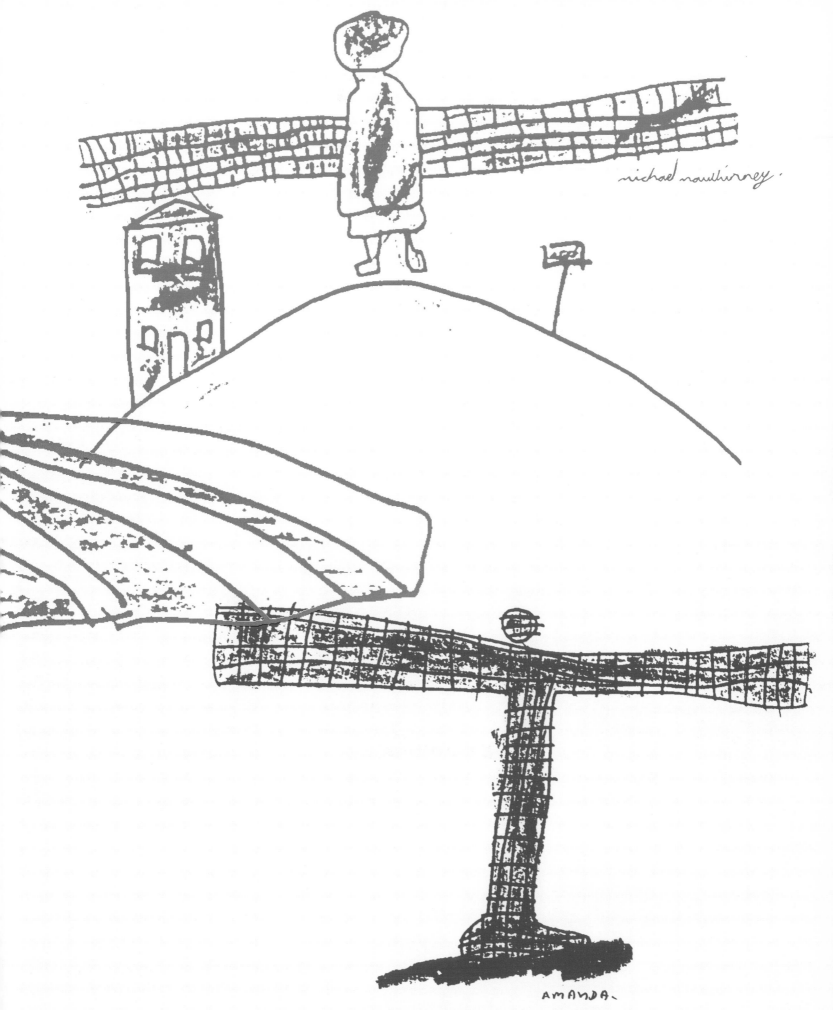

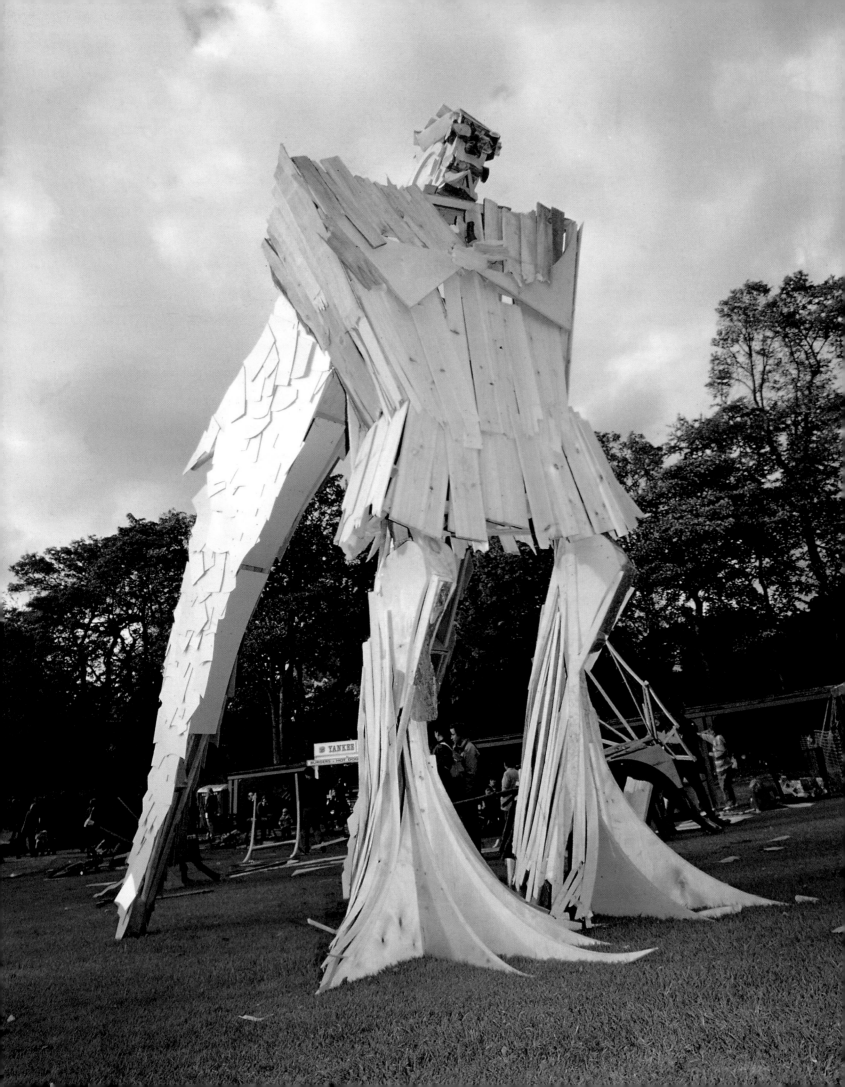

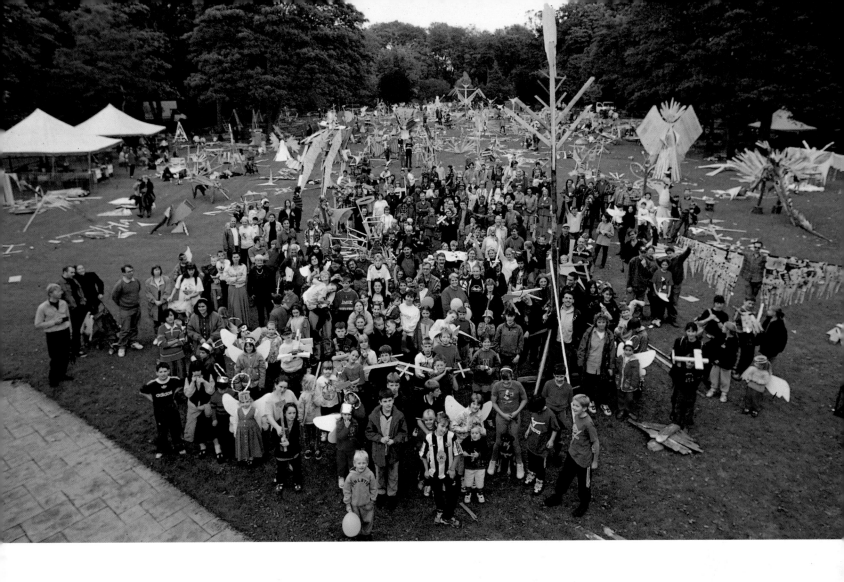

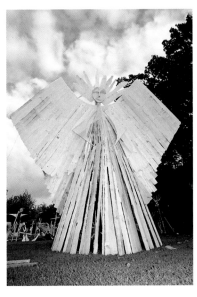

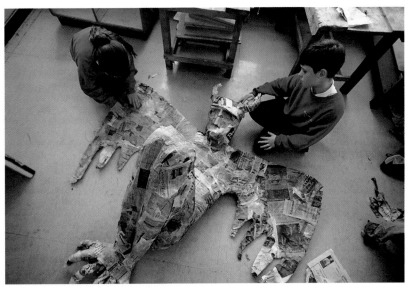

Angel of the North

A Landmark Sculpture for Gateshead by Antony Gormley

Listed below are some of the many hundreds of people who have been involved with the Angel sculpture, its commissioning, fabrication and education programme

Gateshead Council
Councillors and former Councillors who supported the project

George Gill, David Bollands, Sid Henderson, Pat Conaty, Patricia Murray, Bill Ainsworth, Joe Balls, Molly Bell, Joe Bonney, Alan Brazendale, Albert Brooks, Alan Brown, Eddie Burn, David Byrne, George Carpenter, Les Carr, Brian Coates, Sid Cowans, Bill Dick, Harry Dinning, Kevin Dodds, Frank Donovan, Martin Gannon, Bill Gordon, Malcolm Graham, Stuart Green, Linda Green, Joan Greenfield, Joseph Hattam, Mick Henry, Roger Highmoor, Mary Hills, John Hird, David Howdon, Terry Hudspith, Alf Johnson, June Joyce, Norman Lakey, John McElroy, June McFarling, Michael McNestry, Bernard McWilliams, Jim McWilliams, Bill Maddison, Ian Mason, Ian Mearns, Joe Mitchinson, Peter Mole, David Napier, Nick O'Neil, Joyce Pearson, Brian Richmond, Minnie Robson, Patricia Ronan, Stephen Ronchetti, Theresa Rook, Richard Rook, John Simpkin, Harry Smiles, Gordon Spring, Paul Tinnion, Jim Turnbull, Bryan Westgarth, John Wheatley, Pitch Wilson

And Council officers

Leslie Elton, Brian Cox, Chris Jeffrey, Mike Shaw, Roger Kelly, Bill Macnaught, Jerry Barford, George Snaith, Angela Law, Harry Ridley, Pauline McGurk, John Johnson, Ken Dodds, Austin Hattam, Mel Waller, Dave O'Neill, Ken Edge, Colin Stockwell, Kevin Connor, Tony Durcan, Mike White, Anna Pepperall, Karolynne Barker, Jean Laurie, Dawn Williams, Wendy Aitchison, Ednie Wilson, Lynn Knight, Adam Taylor, Ian Armstrong, Andy Todd, June O'Malley, Cathy Shield, Geoff Foots, Eileen Carnaffin, Bob Gallagher, Richard Stephen, Bob Blair, Ken Duckworth, Dennis Johnson, Steve Palmer, Bob Boyes, Malcolm Wolf, Robert Schopen, Kris Grey, Barbara Brewis, Iain Lynn, Katrina Keith, Rachel Chapman and others

Thomas Armstrong (Construction) Ltd
Installed foundations

Richard Hepworth
Bob Holt
Ian Appleby

Teesside Profilers
Cut the metal sections from the steel

Malcolm Wardman

Geomatics Dept University of Newcastle-upon-Tyne

Jon Mills
Ian Newton

Grafton Software
Converted data from Newcastle University Geomatics Dept into CAD model

Chris Lawrence
Ron Jamieson

Barnshaw Section Benders

Malcolm Cooper

Westgate Structural Engineers
Fabrication drawings for wings/joints

Brian Gilbraith
Peter Barry

Ove Arup & Partners

Mike Brown
Neil Carstairs
John Gregory
John Loader
John Thornton

XPD

Chris Thompson
Robin Mackie
Brian Wilson

Hartlepool Steel Fabrications
People who worked on the construction of the Angel

William Allen, Frederick Auton, Edward Avery, Malcolm Bannister, Geoffrey Boalch, Alan Boddy, Graeme Boddy, Wayne Bradley, James Campbell, Robert Carney, Krith Cheney, James Clark, Lynden Clark, Leonard Churchill, Michael Connor, Frank Cox, Paul Davison, James Dawkins, Kenneth Dennis, Geoffrey Dodd, Stephen Duck, James Duncan, Robert Doughty, James Elliott, Michael Fahy, Darren Flounders, Paul Garthwaite, Brian Greenan, Alan Hogg, Raymond Hogg, Frederick Huntley, Steven Kerridge, Malcolm Kirby, Peter Lilley, Ian Madden, Eric Maddison, Thomas Murray, Colin Neesam, Kevin Neil, Allan Neville Jnr, George Neville, Robert Neville, John Nicholson, David Nicolson, Frederick Palliser, Joseph Peek, Graeme Peek, Wilfred Pickstock, Kevin Pinchen, Mark Pinkney, Robert Pinkney, John Porritt, Stephen Relton, Mark Robinson, Stephen Robinson, Charles Robson, Stephen Salvin, David Scott, Beverley Scrimshaw, Victor Smith, William Stamper, Brian Stephenson, Michael Stokes, Brian Taylor, Ronald Thompson, Ronald Todd, Stephen Turner, Francis Ward, Colin Warren, Alan Willingham, Robert Willis, William H. Stalley, Dennis Rudd, Michael Wood, Robert Fishpool, Keith Longhorn, Alan Neville Snr, Keith Jackson, Gillian Storer, Lesley Cullen, Karen Neilson, Elizabeth Bolton, Joanne Hay, Yvonne DiCarlo, Mary Summers

The Funders

National Lottery through the Arts Council of England
European Regional Development Fund
Northern Arts
National Art Collections Fund
Arts Council of England (for 'Field')
Express Engineering
Silverscreen plc
Ibstock Ltd
Association for Business Sponsorship of the Arts
The Sponsors Club
Arts Council-British Gas 'Working for Cities'
Ove Arup & Partners (for the Schools programme)
GMB

Other Contributors

Bill Dunlop
Trevor Hearing and Studio Arts
Northern Sights
Bill Varley
Peter Davies
British Rail Property Board
University of Teesside IT Department
Bolton and Quinn
Jay Jopling and White Cube
Gainford Associates
Baltic Road Day Centre
Prime Time Writers Group
Ellen Phethean - Gateshead Council Libraries and Arts Writer in Residence
John Meagher and Nexus (Metro P.T.E.)
Belinda Williams and A19 Films
Shuttle Services
Andrea Shlieker
Chatsworth Studios

Northumbria Tourist Board
Gateshead Tourism Association
Shipley Art Gallery
Design Works
North Tyneside Council (for 'Engineering Art')
Performing Rights Society
Kathryn Tickell - composer in residence
Tyne and Wear Archives
Sandy Nairne
Pangolin Editions
Sir Anthony Caro
Load Haul
The Great North Forest
Tyne Tees TV
FPP Design
Lord Gowrie
Andrew Dixon
James Bustard
Peter Hewitt
Jo Beddows
Allan Sykes
David Bowe MEP
Hayes Davidson

Photographers

Fiona Bain
Henry Cummins, BHA Network
Colin Cuthbert
Trevor Ermel
Allan Glenwright
Sheila Gray, FORMAT
Gautier Deblonde
Sally-Ann Norman
North News & Pictures
Keith Paisley
Keith Pattison
Mark Pinder
Stephen White

Antony Gormley's Studio Assistants on the Angel of the North

Niall O'Hare
Richard Galpin
Jonathan Lakin-Hall
Vicken Parsons
Peter Moss
Vicky Putler

Angel Education 1996
Artists

William Pym & Julie Livsey

Schools

Birtley East Primary School
Teachers - Mandy Tellyn & Dawn Bellis
Pupils - Heidi Auld, Tracey Bonney, Sarah Conley, Sarah Farquharson, Cheryl Johnson, Lyndsay McKitten, Danielle Patterson, Samantha Pattison, Fay Robson, Nichola Shoesmith, Anna Stabler, Fiona Sylph, Ashley Turnbull, Amy Wareham, Donna Whitfield, Claire Wilson, Gregg Ablett, Thomas Candlish, Graham Coulthard, Paul Cowen, David Fearnley, Andrew Kendrick, James Moffat, Ian Pallister, Ian Pattison, Carl Pilkington, Keith Robson, William Thom, Keith Thompson, Anthony Willis, Jason Young

Harlow Green Junior School
Pupils with teacher Chris Sowden

Lyndhurst Comprehensive School
Pupils with teacher Geoff Marsden

Breckenbeds County Junior High School
Pupils with Headteacher Jan Day

St Edmund Campion RC Comprehensive School
Teacher - Maureen Jones
Pupils - Suzy Wanless, Carl Roadhouse, Faye Stavers,
Steven Robinson, Peter Crinnion, Jason Hutchinson,
Paul Spence, Mick Turnbull, Mo Jones, David Watson

Lord Lawson Comprehensive School
Pupils with teacher Wayne Hampton
Heathfield Comprehensive School
Pupils with teachers Val Fitzgerald & Rosie Langton

Gateshead College
Students with tutor Alison Rogers

Angel Education 1997
Artists
Felicity Watts & Lisa de Larny
with assistant Rob Turvey at Whickham Comprehensive

Schools

Heworth Grange Comprehensive School
Teacher - Mike Andrews
Year 10 pupils - Mark Bridgett, James McLaren,
Joanne Houghton, David Kehoe, Julia Rocks,
David McDonald, Mark Wilson, Lee Young,
Frances Aiken

Thomas Hepburn Comprehensive School
Teachers - Miss Zoe Linsley, Mrs J Thorburn
Pupils - Lee Jordison, Kevin Beattie, Steven Gifford,
Craig Boyle, Christopher Huline, Mareike Knuppel,
Lorraine Hogg, Louise Milburn, Gillian Allport, Dionne Bell,
Kate Connelly, Stephanie Gibson

St Thomas More RC Comprehensive School
Pupils with art teacher Maureen Storey

Whickham Comprehensive School
Ceramics Teacher - Katie Wilcock
Pupils - Vicky Shayshutt, Jayne Currie, Rachel McLure,
Melissa Holley, Helen Thompson, Andrew Burdon

Caedmon Primary School
Teachers - Audrey Thoroughgood, Mrs Johnson
Pupils - Amy Carr, Simon Carr, Adam Clarke, Kirsty Dunn,
Sarah Glover, Louisa Hui, Faye Johnson, Natalie Keall,
Shamima Khatun, Joanne Lisgoe, Stephen Marston,
Scott McDonald, Steven McTaggart, Sophie Morris,
Kerri Nicholson, Allan O'Connor, Michael Pattison,
Adam Pearson, Nisha Poontah, Mynur Rahman,
Elaine Robinson, Sarah Rowell, Donna Sanderson,
Claire Sproggan, David Stirling, Kirsty Thomas,
Bethany Venus, Carl Walker, Hannah Walker,
Helen Walsham, Natalia Whaley

Oakfield Junior School
Class 4L
Teacher - Mrs A. Lowden
Pupils - James Armstrong, Christopher Ball, Lauren Bell,
Danielle Boddy, Neil Dallas, Christopher Dellow, Victoria
Dixon, Marcus Donnison, Dutton Ross, Carmen Wu, Marc
Goundry, Christine Hannant, Andrew Jefferson, Lynn
Graham, Kate Maddison, Mark McGill, Sophia Pitt, Ruth
Robinson, Kris Scope, Joy Stafford, Karen Wilkinson,
Samantha Standfield, Shaun Todhunter, Faith Tormey

Class 4C
Teacher - Mrs Betty Holmes
Pupils - Charlotte Black, Sharna Bone, Siobhan Bone,
Kris Cherry, Oliver Clarkson, Rachael Cunningham,
Claire Codling, Danny Day, Robert Dunn, Steven Green,
Matthew Hall, Grant Heath, Vicky Johnson, Peter Lawley,
Daniel Madden, Jenni Monaghan, Emma Redford,
Atefe Rezaei, Richard Riley, Stephanie Robson, Lee Speed,
Mark Storey, Alexander Taylor, Michael Terrell,
Stephanie Topping, Louise Wilkinson

Joicey Road Special School

Glynwood Primary School

Digital Workshops
with photographer Lynne Otter
John Lindsay
Mr & Mrs Douglas
Jim Bussey
Christine Walker
Pamela Parrish

Angel Poems
Doris Palgrave
Jessie Horner
Agnes Deane
John Bulmer

Time Capsule Project
Artists
Simon Jones & Nicky Taylor

Participants

Harlow Green Junior School
Teachers - Susan Holmes & Chris Sowden

Harlow Green Infants School
Pupils with teachers Mrs Hack, Mrs Heslewood, Mrs Wilkie

St Anne's RC Primary School
Pupils with teacher Tony Smith

Allerdene Women's Group
Alma, Lillian, Joan, Alison, Elizabeth

The Angel View Inn
The Jolly Miller

Gateshead Family Sculpture Day
Angels and other Winged Creatures

Artists

Graham Bowes
Neil Canavan
Jos Mahon
Bruce Tuckey
Simon Jones
Graciela Ainsworth
Malcolm Smith
Keith Barrett

Schools

Chopwell Infants School
Furrowfield Special School
Joseph Swan Comprehensive
Carr Hill Primary School

Field for the British Isles
Greenesfield BR works, Gateshead

Gateshead Council Arts Team
Co-ordination with
Isobel Johnstone - Arts Council Collection Curator
Peter Stiff - Arts Council Collection Technician

Laying Out and Staffing

Shipley Art Gallery
Andrew Greg
Helen Joseph

University of Northumbria
Gary Fawcett
Ruth Gowland

Emma King
Matthew Smith
Caroline Moody Brown
Matthew Durkin
Simon Holloway
Andy Dodds

Volunteers

Simon Donald
Elinoah Eitani
Irena Dorney
Tom Dorney
Melissa Murphy
Julia Dean

Newcastle University Fine Art students

Education Visits to the Field

Gateshead College
Whickham County Comprehensive School
Harlow Green County Junior School
Dunston Hill County Primary School
Chopwell County Junior School
Wardley County Primary School
Brighton Avenue County Primary School
Windmill Hills County Primary School
High Spen County Primary School
Lingey House County Primary School
Kingsmeadow County Comprehensive School
Harlow Green County Junior School
Bede Community Primary School
The Drive County Primary School
Breckenbeds County Junior High School
Windy Nook County Primary School
Rowlands Gill County Junior School
Heathfield County Senior High School
Northumberland College
Bedlingtonshine High School/Realschule Schalksmichle
Joicey Road School
Cedars School
Lord Lawson Comprehensive School
Queen Elizabeth Sixth Form College
Hewburn School
Poole House Durham School
Marley Hill Primary School
Leeds University

Greenesfield Angel Maquette Exhibition
University of Northumbria at Newcastle Volunteers
Caroline Jackman
Melanie Thomas
Lyndsey Fielding

This project has been part-financed
by the European Community
European Regional Development Fund

Captions & Credits

1 Sky: Sally-Ann Norman

6/7 Esso Hibernia being launched on the Tyne 1966 © Newcastle Libraries

8/9 First sustained controlled flight by Orville Wright of the Wright Glider, with Wilbur in attendance, at Kill Devil Hills, Kitty Hawk, North Carolina, 1903 © Hulton Getty

10/11 Eastwood Colliery Notts circa 1910 © Public Records Office

12/13 Antony Gormley making the body mould for the Angel: Gautier Deblonde

16 Early sketches from 1994-5 of the Angel by Antony Gormley

17 Sketches from 1995-6 of the Angel in the landscape by Antony Gormley

18/19 View north on the A1 outside Gateshead: Sally-Ann Norman

24/25 Angel on 15 April 1998: Sally-Ann Norman

30 Making the second 1:20 maquette, summer 1996 (top series): Gautier Deblonde; Making the body mould (bottom series): Gautier Deblonde

31 Making the body mould (top left and right): Gautier Deblonde; The reduced body form mould (bottom left): Gautier Deblonde; The first idea, December 1994 (bottom right): Mike White

32/33 Studio view, January 1996, with reduction of final body form: Gautier Deblonde

34/35 Making the final 1:10 maquette - working out the rib intervals for the wings: Gautier Deblonde

36/37 Constructing the 1:10 body form and fitting the ribs to the final maquette (all photographs): Gautier Deblonde

38/39 Tenderers in the studio, March 1997 (all photographs): Henry Cummins, BHA Network

42/43 Digital imaging by XPD, data supplied by Grafton Software

44/45 Engineers' drawings of elevation and cross-sections of the Angel, supplied by Ove Arup & Partners

46/47 Engineers' drawings of the foot, supplied by Ove Arup & Partners

50 The fifty-two holding down bolts being lowered into place: Keith Paisley

51 Steel and concrete foundations taking shape: Keith Paisley; diagram: Bob Boyes

56/57 First delivery of Corten steel to Hartlepool Steel Fabrications, 21 July 1997: Sheila Gray, FORMAT

58 Meetings with Hartlepool Steel Fabrications (top four photographs): Mark Pinder; Making the first wing (lower two photographs): Keith Pattison

59 The first wing in construction: Keith Pattison

60/61 Steel stencils after cutting the Angel ribs at Teesside profilers: Mark Pinder

62 Detail of wing construction (top left and right photographs): Keith Pattison; Detail of body diaphragm (top middle photograph): Keith Pattison; Cutting sacrificial ribs for the head (lower photograph): Mark Pinder

63 Turning the Angel body at Hartlepool (top two left-hand photographs): Keith Paisley; Sections of the inner core (top right-hand photograph): Keith Pattison; Constructing the wing detail (lower right-hand photograph); Detail of foot with sacrificial ribs (first photograph lower left): Keith Paisley; The lower body seen from the chest diaphragm (second photograph lower left): Keith Pattison; The connecting bolts (third photograph lower left): Keith Pattison; Detail body diaphragm (fourth photograph lower left): Keith Pattison; Taking body from shed before turning over (bottom photograph): Mark Pinder

64/65 Cutting calf ribs (foreground), constructing lower body (background): Keith Paisley

66/67 Construction: welding and cutting (top series from left to right): first two photographs, Keith Paisley; remaining three photographs: Keith Pattison; Construction and inspection (bottom series from left to right): second and fifth photographs, Mark Pinder; remaining photographs, Keith Pattison

68/69 Exoskeleton of head and upper chest: Keith Paisley

70 Construction at Hartlepool Steel Fabrications (top row left to right): first and second photographs, Keith Paisley; third photograph, Keith Pattison; fourth photograph, Keith Paisley; fifth photograph, Keith Pattison; (middle row left to right): first photograph, Keith Pattison; second photograph, Keith Paisley; third photograph, North News and Pictures; bottom photograph, Keith Paisley

71 Construction of the head and body at Hartlepool Steel Fabrications (left column from top): first and third photographs, Keith Paisley; second photograph, Keith Pattison; (right column from top): first, second, third and fourth photographs, Keith Pattison; fifth and sixth photographs, Keith Paisley

72/73 Checking the final profiles on the body: Keith Pattison

74/75 Head frame: Mark Pinder

76/77 Fork-lift truck driver returns from lunch (top series): Keith Pattison; Body prepares to leave the shed (bottom series): Keith Pattison

78/79 Wings prepared to receive the body: Keith Paisley

80/81 Marriage of wings and body: Keith Pattison

82/83 Aerial view of trial fitting

84/85 Angel on the 14-axled, 56-wheeled truck: Keith Paisley

86/87 On the road: Keith Pattison

92 First illustration, Winged figure (1952), by kind permission of Kenneth Armitage © Kenneth Armitage; second illustration, A Case for an Angel (1990), by Antony Gormley © Antony Gormley; third illustration, Fulcrum (1987), by Richard Serra © Wordsearch Communications; fourth illustration, Once upon a Time (1990), by Richard Deacon © Lisson Gallery; fifth illustration, Constructed Head no. II (1916/1966), Tate Gallery Collection, London (CR47) © Nina Williams; sixth illustration, wind turbines at Hetton-le-Hole © Border Wind

93 Angel being lifted: © David Rose & The Independent

94/95 Lowering the body onto the bolts, 8.10 am, 15 February 1998: Sally-Ann Norman; Tightening up (right-hand column from top): first and second photographs, Sally-Ann Norman; third photograph, Keith Pattison

96 Right wing lowered into place: Sally-Ann Norman

97 Aligning the right wing with the body (top left photograph): Keith Pattison; Fixing the bolts (top right photograph): Sally-Ann Norman; onlookers (bottom photograph): North News and Pictures

98 Second wing offered up, 4.30 pm, 15 February 1998: Keith Pattison

99 Right wing bolted into place: Sally-Ann Norman

100/101 View from a helicopter: North News and Pictures

102/103 The law in attendance, 16 February 1998: North News and Pictures

107 Egyptian, Assyrian and early Christian angels from Sacred and Legendary Art vol. I, Mrs Anna Jameson, 1906

108 Driving past (all photographs): Bob Boyes

109 View from Bob Whittaker's window (all photographs): Bob Boyes

110/111 The Angel's view: Sally-Ann Norman

112/113 Football under the Angel's wing: Sally-Ann Norman

114/115 View from Team Valley trading estate: Sally-Ann Norman

116/117 Cowan Gardens, Gateshead, 3 April 1998: North News and Pictures

118/119 From Harlow Green: Sally-Ann Norman

120/121 Early visitors: Sally-Ann Norman

122/123 View from the railway: Sally-Ann Norman

124/125 Team Valley at dusk: Sally-Ann Norman

126/127 Headlines

128 'The Angel Has Landed' © Linda Richards, 19 February 1998, Evening Chronicle, Gateshead; Angel photograph © Andy Lamb 1998

129 'On the side of the Angel' © Peter Heatherington, 10 January 1998, the Guardian; Angel photographs © Will Walker 1998

130 'This one's got wings' © Waldemar Januszczak, 22 February 1998, The Sunday Times; Angel photograph © Will Walker 1998

131 'Big, brash, banal: truly a symbol of our age' © John Casey, 17 February 1998, Daily Mail; Angel photograph © Jeff J. Mitchell, Reuters

132/133 Visitors' book from exhibition at Gateshead Central Library, 13 February - 28 March 1998

134/135 Drawings by pupils of Furrowfield Special School

136 Gateshead's annual Sculpture Day in Saltwell Park: Mark Pinder

137 Education work in schools (lower right photograph): Mark Pinder; Gateshead's annual Sculpture Day in Saltwell Park (all remaining photographs): Mark Pinder

142 Small, plaster angel made for the child of a friend (1987): Gautier Deblonde

143 Untitled: Andy Altmann

144 Sky: Sally-Ann Norman

Biographical details of the contributors:

Antony Gormley is credited with revitalising the figure in contemporary sculpture, infusing it with a radical subjectivity, taking the moulds for his work directly from his own body. Since his first one-man show at the Whitechapel Art Gallery in 1981 he has exhibited worldwide. In 1994 he was awarded the Turner Prize. The emotional impact of the Field for the British Isles, in which 40,000 hand-sized terracotta figures return the spectators' gaze, has received international acclaim. He has made challenging public works, most notably the 10-metre-high granite Havmann that stands on the seabed of a fjord just below the Arctic Circle in Norway. In his most recent major installation, Another Place (1997), 100 solid iron body-forms face the horizon over three square kilometres of the tide plain at the mouth of the Elbe river in Germany.

Mike White has been Assistant Director of Arts for Gateshead Council's Libraries and Arts Department since 1988. He and Anna Pepperall provided the day-to-day liaison with Antony Gormley throughout the commission. The Council's participatory arts programme covers all arts forms with particular expertise in public art, artists' residencies and arts in health.

Iain Sinclair is a poet and essayist. His novel, Downriver, won the James Tait Black Memorial Prize and the Encore Award. His most recent works are Lights Out for the Territory, a book of speculative London essays, and Slow Chocolate Autopsy, a collection of stories (illustrated by Dave McKean).

Beatrix Campbell is a writer and broadcaster whose career as a journalist began in 1967. In the 1980s she worked for Time Out magazine and helped to set up City Limits in 1981. Since then her work has appeared in the Independent, the Guardian, the Scotsman, the New Statesman and Marxism Today. Her award-winning books and documentaries include Wigan Pier Revisited, 'Listen to the Children', and The Iron Ladies. A feminist activist, she co-founded the Women's Liberation journal, Red Rag. She is Visiting Professor of Women's Studies at the University of Newcastle-upon-Tyne.

Stephanie Brown lives in Northumberland. She trained as a sculptor before taking an MA and a PhD in art history at the Courtauld Institute. She has published widely on the visual arts and recently curated 'Northern Rock Art: Prehistoric Carvings and Contemporary Artists' (Durham Art Gallery, 1996) and 'West African Art' (Hatton Gallery, Newcastle University, 1997-8).

Gail-Nina Anderson is a freelance arts journalist and art historian, currently teaching at Sunderland College. Gail has a PhD in art history from the University of Nottingham, and lectures widely on late nineteenth-century painting. Her publications include Heaven on Earth: The Religion and Beauty in Late Victorian Art and The Pursuit of Leisure. Gail lives in Newcastle-upon-Tyne and is a regular contributor to the arts publication Northern Review.

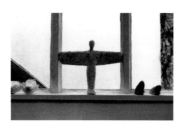

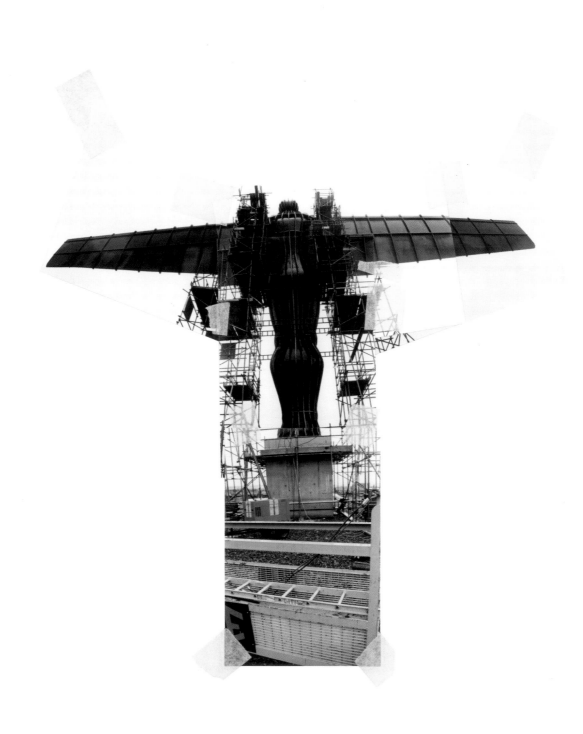